Calligraphy

FOR

DUMMIES®

by Jim Bennett

WILEY

John Wiley & Sons, Inc.

Calligraphy For Dummies®

Published by
John Wiley & Sons, Inc.
111 River St.
Hoboken, NJ 07030-5774
www.wiley.com

Copyright © 2007 by John Wiley & Sons, Inc., Hoboken, New Jersey

Published simultaneously in Canada

No part of this publication may be reproduced, stored in a retrieval system, or transmitted in any form or by any means, electronic, mechanical, photocopying, recording, scanning, or otherwise, except as permitted under Sections 107 or 108 of the 1976 United States Copyright Act, without either the prior written permission of the Publisher, or authorization through payment of the appropriate per-copy fee to the Copyright Clearance Center, 222 Rosewood Drive, Danvers, MA 01923, 978-750-8400, fax 978-646-8600. Requests to the Publisher for permission should be addressed to the Permissions Department, John Wiley & Sons, Inc., 111 River Street, Hoboken, NJ 07030, 201-748-6011, fax 201-748-6008, or online at http://www.wiley.com/go/permissions.

Trademarks: Wiley, the Wiley Publishing logo, For Dummies, the Dummies Man logo, A Reference for the Rest of Us!, The Dummies Way, Dummies Daily, The Fun and Easy Way, Dummies.com and related trade dress are trademarks or registered trademarks of John Wiley & Sons, Inc. and/or its affiliates in the United States and other countries, and may not be used without written permission. All other trademarks are the property of their respective owners. John Wiley & Sons, Inc., is not associated with any product or vendor mentioned in this book.

LIMIT OF LIABILITY/DISCLAIMER OF WARRANTY: THE PUBLISHER AND THE AUTHOR MAKE NO REPRESENTATIONS OR WARRANTIES WITH RESPECT TO THE ACCURACY OR COMPLETENESS OF THE CONTENTS OF THIS WORK AND SPECIFICALLY DISCLAIM ALL WARRANTIES, INCLUDING WITHOUT LIMITATION WARRANTIES OF FITNESS FOR A PARTICULAR PURPOSE. NO WARRANTY MAY BE CREATED OR EXTENDED BY SALES OR PROMOTIONAL MATERIALS. THE ADVICE AND STRATEGIES CONTAINED HEREIN MAY NOT BE SUITABLE FOR EVERY SITUATION. THIS WORK IS SOLD WITH THE UNDERSTANDING THAT THE PUBLISHER IS NOT ENGAGED IN RENDERING LEGAL, ACCOUNTING, OR OTHER PROFESSIONAL SERVICES. IF PROFESSIONAL ASSISTANCE IS REQUIRED, THE SERVICES OF A COMPETENT PROFESSIONAL PERSON SHOULD BE SOUGHT. NEITHER THE PUBLISHER NOR THE AUTHOR SHALL BE LIABLE FOR DAMAGES ARISING HEREFROM. THE FACT THAT AN ORGANIZATION OR WEBSITE IS REFERRED TO IN THIS WORK AS A CITATION AND/OR A POTENTIAL SOURCE OF FURTHER INFORMATION DOES NOT MEAN THAT THE AUTHOR OR THE PUBLISHER ENDORSES THE INFORMATION THE ORGANIZATION OR WEBSITE MAY PROVIDE OR RECOMMENDATIONS IT MAY MAKE. FURTHER, READERS SHOULD BE AWARE THAT INTERNET WEBSITES LISTED IN THIS WORK MAY HAVE CHANGED OR DISAPPEARED BETWEEN WHEN THIS WORK WAS WRITTEN AND WHEN IT IS READ.

For general information on our other products and services, please contact our Customer Care Department within the U.S. at 877-762-2974, outside the U.S. at 317-572-3993, or fax 317-572-4002.

For technical support, please visit www.wiley.com/techsupport.

Wiley also publishes its books in a variety of electronic formats. Some content that appears in print may not be available in electronic books.

Library of Congress Control Number: 2006939445

ISBN: 978-0-470-11771-2

Manufactured in the United States of America

V006618_052318

About the Author

Jim Bennett has been teaching calligraphy for about 30 years. He has taught at every level from kindergarten through college and has introduced thousands of people to calligraphy. Although he lost count some time ago, he suspects that he must hold a record for the number of students he has taught in the classroom, by correspondence, and through the Internet.

Jim has a B.F.A. degree from Virginia Commonwealth University and an M.F.A. degree from the University of North Carolina at Greensboro. Among the awards he has earned are the Virginia Artists Certificate of Distinction and the Ohio Art Education Association's Distinguished Educator Award in 2003.

In 1982, Jim self-published a popular instruction manual titled "You Can Do Calligraphy." He also developed a complete Italic handwriting curriculum for grades K through 5 for Wakefield School in Virginia, created a calligraphy correspondence course for Lord Fairfax Community College, and pioneered calligraphy lessons on the Internet. His calligraphy website (www. studioarts.net/calligraphy) has had almost one million visitors. He is the founder and manager of the original Calligraphy Webring which is comprised of about a hundred of the finest calligraphy websites internationally.

In addition to calligraphy, Jim worked for several years as a portrait artist under the name Bennecelli. He has also painted murals. Recently, he has been developing art-related projects based on adventure themes that math teachers can use to enhance math instruction.

Jim is married to his college sweetheart and lives in Cincinnati, Ohio. He has four grown children, six grandchildren, and two cats.

About the Author

Jim Bennett has been teaching calligraphy for about 30 years. He has taught at every level from kindergarten through college and has introduced thousands of people to calligraphy. Although he lost count some time ago, he suspects that he must hold a record for the number of students he has taught in the classroom, by correspondence, and through the Internet.

Jim has a B.F.A. degree from Virginia Commonwealth University and an M.F.A. degree from the University of North Carolina at Greensboro. Among the awards he has earned are the Virginia Artist Certificate of Distinction and the Ohio Art Education Association's Distinguished Educator Award in 2003.

In 1992, Jim self-published a popular instruction manual titled "You Can Do Calligraphy." He also developed a complete Italic handwriting curriculum for grades K through X for Wakefield School in Virginia, created a calligraphy correspondence course for Lord Fairfax Community College, and pioneered calligraphy lessons on the Internet. His calligraphy website (www.studioarts.net/calligraphy) has had almost one million visitors. He is the founder and manager of the original Calligraphy Webring which is comprised of about a hundred of the finest calligraphy websites internationally.

In addition to calligraphy, Jim worked for several years as a portrait artist under the name Renacelli. He has also painted murals. Recently, he has been developing art-related projects based on adventure themes that math teachers can use to enhance math instruction.

Jim is married to his college sweetheart and lives in Cincinnati, Ohio. He has four grown children, six grandchildren, and two cats.

Dedication

This book is dedicated to my wife, Karen, whose encouragement and patience are truly super-human and to our wonderful children, Mark, Michael, Sharon, and Carrie who make me proud to be a father.

Author's Acknowledgments

I want to give special thanks to Jennifer Connolly, my amazing project editor who caught the vision for this book, made insightful suggestions about how to present the material, and helped make sure that I had all my writing and art submitted on time.

Thanks go to Mike Lewis and the team at Wiley who selected me to write this book and decided that this book was special enough that the practice pages should be presented differently from any *For Dummies* books that had ever been published previously.

I am grateful for the encouragement, words of wisdom, and guidance that my agent, Barb Doyen, has given me.

I also appreciate the interest and encouragement expressed by my fellow teachers at Cincinnati Christian Schools. You truly are an inspiring group of people to work with.

Publisher's Acknowledgments

We're proud of this book; please send us your comments through our Dummies online registration form located at www.dummies.com/register/.

Some of the people who helped bring this book to market include the following:

Acquisitions, Editorial, and Media Development

Project Editor: Jennifer Connolly

Acquisitions Editor: Mike Lewis

Copy Editor: Jennifer Connolly

Technical Editor: Christine Rogers

Editorial Manager: Michelle Hacker

Editorial Supervisor: Carmen Krikorian

Editorial Assistant: Erin Calligan, Joe Niesen, Leeann Harney

Cover Photo: Tom Grill/Corbis

Cartoons: Rich Tennant (www.the5thwave.com)

Composition Services

Project Coordinator: Jennifer Theriot

Layout and Graphics: Carrie A. Foster, Denny Hager, Stephanie D. Jumper, LeAndra Hosier, Ronald Terry

Anniversary Logo Design: Richard Pacifico

Proofreaders: Melanie Hoffman, Betty Kish

Indexer: Galen Schroeder

Publishing and Editorial for Consumer Dummies

Diane Graves Steele, Vice President and Publisher, Consumer Dummies

Joyce Pepple, Acquisitions Director, Consumer Dummies

Kristin A. Cocks, Product Development Director, Consumer Dummies

Michael Spring, Vice President and Publisher, Travel

Kelly Regan, Editorial Director, Travel

Publishing for Technology Dummies

Andy Cummings, Vice President and Publisher, Dummies Technology/General User

Composition Services

Gerry Fahey, Vice President of Production Services

Debbie Stailey, Director of Composition Services

Contents at a Glance

Contents at a Glance

Table of Contents

Part II: The Amazing, Incredible Italic Alphabet41

Introduction

• •

Welcome to *Calligraphy For Dummies.* In this book, I explain how to get started doing calligraphy. I focus on the basics for people who would like to learn how to do calligraphy but have little or no prior experience. Even so, there are plenty of things here to challenge anyone who is ready to go beyond the basics. Regardless of your age or ability, whether you're an elementary student or a retiree, there's something in this book for you.

For many people calligraphy is something they admire from afar, wish they could do, but really don't see themselves ever becoming good at. They may even secretly wish they could do calligraphy, but something has held them back. Perhaps they feel a twinge of self-doubt. After all, doesn't it take talent or artistic ability to do calligraphy? That's exactly what many people think.

I look at it differently. I believe that anyone with the desire to learn calligraphy can do so. I have seen this proved time and time again among my students. Students with little or no apparent talent, but a lot of desire have done well. I have had students with severe disabilities and even with manual impairment excel in calligraphy.

One young man sticks out in my memory. He had such a severe nervous disorder that his hands shook uncontrollably. In order to do calligraphy, he would have to use both hands to steady his pen. What he lacked in manual skill, he made up for with desire and persistence. His calligraphy was good enough within a year that he was doing all the overhead transparencies of worship songs for his church which happened to be one of the larger churches in his city.

I have learned through teaching that to do well in calligraphy is not primarily a matter of talent. Calligraphy is a skill that anyone who can write can learn to do.

Can you do calligraphy? Yes, I firmly believe you can, and, not only that, I believe you will discover that calligraphy can become for you whatever you want to make out of it — from an enjoyable and relaxing hobby to a serious avocation to the source of a good income. That is the major premise of this book.

About This Book

I organize *Calligraphy For Dummies* in exactly the same way that I teach calligraphy in the classroom. This book is essentially two courses in one — an introduction to calligraphy, which covers the basic alphabets, and intermediate calligraphy, which expands upon the basic alphabets and presents a number of projects.

You won't be able to do calligraphy simply by reading this book. Calligraphy is a hands-on activity, and this book gives you plenty to put your hands on! To do calligraphy means that you have to practice, but I promise that the practice is enjoyable, because you get to see your progress each step of the way. Lots of examples and practice exercises guide you step-by-step so you can see exactly what you're supposed to do and how to do it. It won't take you long to see that you're actually doing calligraphy.

One of the nicest things about this book is you can go at your own speed. In a classroom, everyone moves along at just about the same rate. Here you can go slower or faster as you see fit. You decide what the best pace is for you. You're not working for a grade; you're working for yourself.

The practice activities involve your tracing over letters that I have made for you and then copying them in spaces that are provided. The trace and copy practice is almost like I am right there beside you helping and guiding you each step of the way.

In a number of places throughout the book, I tell you to photocopy the practice pages so that you can have multiple chances to practice the same exercises. You may want to keep the practice pages in the book free of writing so you can use them as masters. That way you can do the particular practice exercise over and over as many times as you want. And be sure to take full advantage of all the practice in the appendix. You can find many expanded exercises there to use. If you prefer, you can also download the exercises from www.dummies.com/go/calligraphy.

Conventions Used in This Book

To make it easy for you to navigate from chapter to chapter I've used some conventions throughout this book to make your practice as easy as possible and to make sure you're not left wondering if you've missed something along the way. This makes everything consistent and simple to understand.

- ✔ **Getting a read on the letters:** Whenever I refer to a letter, I put it in Italics and I always refer to it in the lowercase form (for example, the letter *e*). Because treating capitals this way can get tricky (some of them begin to look alike when they're italicized), I still refer to capital letters in the lowercase form (for example, capital *e*).

- ✔ **Finding the practice:** The chapters contain some short practice exercises to get you started, but for more practice, you have full page practice exercises in the appendix in the back of this book. This way you have the instructions all contained in as few pages as possible and not spread out through the practice pages. The short chapters make it easy for you to find something in the instructions if you need to go back and reread. Having the full-page practice exercises altogether in the back of the book also makes it easy to photocopy the pages from the appendix.

- ✔ **Following the guide lines:** The guide lines that I've drawn for the practice exercises have black lines, gray lines, and rectangles. One set also has dashed lines. The black lines divide each section of writing. The rectangles indicate where the body of the letters is to be drawn. The dashed lines indicate slant. The guide lines show you exactly where to make the letters and what size they should be. There are tons of examples in case you forget.

- ✔ **Doing the practice exercises:** The practice in this book is a combination of trace and copy exercises. Letters printed in black are the examples. If letters are printed in gray that means you're supposed to trace over them. Blank spaces are provided for copying. Tracing and copying is a powerful way to practice. The tracing part especially is almost like having me right there guiding your pen and showing you how it's done.

- ✔ **Understanding text in** monofont: From time to time I suggest you seek out sources on the Web. Whenever you see a Web site, it will be in monofont so it's easy to recognize.

Foolish Assumptions

I have tried to avoid technical jargon. Whenever there's a choice between a specialized calligraphy term that only calligraphers would use and a word that everyone understands, I've opted to use the more commonplace word. For example, I use the terms capital letters and lowercase letters throughout this book instead of calling the letters majuscules and minuscules. I assume that if you pursue calligraphy in greater depth, you'll pick up all the specialized terminology.

When writing this book, I'm assuming that you fall into one of these categories:

✔ You haven't a clue what calligraphy is all about but you are intrigued by this book and are curious to find out more.

✔ You know what calligraphy is, you've admired it and would love to learn how to do it, but have little or no experience.

✔ You've already done some calligraphy, and you're looking to improve your skills.

✔ You fit everything in the previous category, plus you are interested in selling your calligraphy.

How This Book Is Organized

Like all the other books in the *For Dummies* series, this book is divided into parts. The parts enable you to pinpoint exactly where you want to start or where you want to revisit. Each part covers a general topic and builds on the material covered in the previous parts. The book begins with the easy stuff and builds toward some of the challenging ways you can use calligraphy. The important calligraphy topics divide up nicely into the following five parts.

Part I: Yes, You Can Do Calligraphy!

The title to this part really says it all. If you're feeling the least bit intimidated by the idea of trying to do calligraphy, this part will help you get over those negative feelings. There are a lot of positives that accompany doing calligraphy.

What does it take to do calligraphy and what are some of the benefits to be gained are two questions that are answered in Part I. This part of the book gives you a "big picture" overview of what calligraphy is all about and some of the rewards you can experience.

This first part is all about how you get started. It describes the different kinds of pens, ink, and paper you can use and where you can find them. It also walks you through some of the basic steps for using and taking care of your materials — especially the calligraphy fountain pen which is the perfect writing instrument for beginning calligraphy. In this part I explain the "in's and out's" of dip pens and the special techniques for using them. You also find out why I refer to the calligraphy pen as the calligrapher's "magic wand."

Part II: The Amazing, Incredible Italic Alphabet

The first alphabet covered in this book is Italic, and it's important enough that all of this part is devoted to the one alphabet.

Italic is your beginning because it is by far the most popular and useful style of calligraphy. Part II gives you a style of calligraphy that is beautiful, functional, and can be lettered rapidly. With this one alphabet you have a style that can be used for anything you'd ever want to do in calligraphy.

Doing calligraphy means that you know two things — how the letters are formed and how a calligraphy pen is used. To make mastering both of these as easy as possible, the two are covered separately. At first you practice the shapes of the letters using a regular marker pen. Once you have the letters down pat, you get to make those same letters using the calligraphy pen. At that point, you're doing real calligraphy!

Once you have the basics of the Italic alphabet, I give you ways you can continue to improve, create variations, add embellishments, and even use Italic as your everyday handwriting style.

Part III: Expanding Your Repertoire

This part shows you how to do five more extremely useful alphabets: Blackletter, Roman, Manuscript, Uncial, and Copperplate. In addition, there is a chapter on how to do outlined and decorated letters. These alphabets not only expand the number of alphabets that you can do but also "round out" your calligraphy skills so you have a solid foundation on which to continue to build your skills.

Each of these alphabets presents a different style and can be used to express different feelings. Blackletter is appropriate when you want an ancient and official look. Roman is classical, solid, and strong. Manuscript is easy to read. Uncial is artistic and expressive. Copperplate embodies elegance with flair.

With the completion of this part you can do six basic alphabets, Italic plus the five new alphabets. With these six alphabets, you have the building blocks for being able to letter virtually any other style.

Part IV: Popular Projects

Once you can do calligraphy, what are some of the things you can create? This is the question that I answer in Part IV.

In this part, I cover how to do some of the projects that most people are eager to try with their newly acquired skills. The first thing that most people want to do is design a quotation, and I show you some of the "tricks of trade" for turning a quotation or favorite saying into a thing of beauty. The design techniques you learn here are useful for doing all kinds of projects.

I also walk you through the steps for lettering a poster or sign, creating a certificate or award, designing a monogram, adding different kinds of borders to your calligraphy, addressing envelopes, making plaques, and, if you're already doing other kinds of art, I give you ideas and show you examples of how you can combine your calligraphy with other art media.

This part of the book enables you to create some really nice things with your calligraphy where you can feel a real sense of accomplishment. Some of the projects make excellent gifts. Some of the projects, such as certificates, provide you with things you might do on a commission basis. There is enough information in this part of the book to get you started and keep you going for years.

Part V: The Part of Tens

This final part gives you some valuable tips. The first chapter in this part describes ten ways you can use calligraphy for a wedding. If you're thinking about using calligraphy for your own wedding or the wedding of someone you know, these ten tips are very useful. Next is a selection of ten, fun alphabets that expand your skills. You can use several of these alphabets to create the "look" of other alphabets such as Chinese and Greek. The final chapter is all about a subject that interests a lot of people, how to make money doing calligraphy.

Icons Used in This Book

I include some icons in this book to flag important information. Keep an eye out for these as you read.

Want to know how do something better, easier, or faster? Just look for info attached to this icon.

Let's see, you have to remember stroke sequence, what angle to hold your hand . . . well, the list may seem endless, but this icon points out some really important info that you just can't miss.

With this icon, I let you know of potential dangers you may come across.

When you see this icon, you know you can flip back to the appendix and find more practice for whatever section you're working on.

Where to Go from Here

Don't treat this book like a textbook. Think of it as an adventure or an excursion through a land full of exciting things to see and do. Thumb through the pages; look over the table of contents; visit a few of the attractive spots. You don't have to stick with the tour guide; you can jump around from place to place at your own pace.

If you are a beginner to calligraphy, you may prefer to start at the very beginning and work your way through each chapter in sequence. That's exactly how it would be if you were a student in my calligraphy class. If you follow this plan, I strongly recommend that you do all the chapters and every practice exercise in Part I and the first two chapters of Part II. Devour them. Don't skip over anything. If you run into trouble in any area, spend extra time practicing before you move ahead to the next thing.

If you can already do some calligraphy, you can jump around from one part of the book to another. I do recommend that you take a look at the sections that show how to refine your skills and spot errors. The projects should also be interesting to you.

Icons Used in This Book

I include some icons in this book to flag important information. Keep an eye out for these as you read.

Want to know how do something better, easier, or faster? Just look for info attached to this icon.

Let's see: you have to remember stroke sequence, what angle to hold your hand . . . well, the list may seem endless, but this icon points out some really important info that you just can't miss.

With this icon, I let you know of potential danger you may come across.

When you see this icon, you know you can flip back to the appendix and find more practice for whatever section you're working on.

Where to Go from Here

Don't treat this book like a textbook. Think of it as an adventure or an excursion through a land full of exciting things to see and do. Thumb through the pages, look over the table of contents, visit a few of the attractive spots. You don't have to stick with the tour guide; you can jump around from place to place at your own pace.

If you are a beginner to calligraphy, you may prefer to start at the very beginning and work your way through each chapter in sequence. That's exactly how it would be if you were a student in my calligraphy class. If you follow this plan, I strongly recommend that you do all the chapters and every practice exercise in Part I and the first two chapters of Part II. Devour them. Don't skip over anything. If you run into trouble in any area, spend extra time practicing before you move ahead to the next things.

If you can already do some calligraphy, you can jump around from one part of the book to another. I do recommend that you take a look at the sections that show how to refine your skills and spot errors. The projects should also be interesting to you.

Part I
Yes, You Can Do Calligraphy!

The 5th Wave By Rich Tennant

If at first you don't succeed, try, try, agan.

To eror is human

Forgive, and Forgive.

"That's my first piece of calligraphy. I keep it for inspiration."

In this part . . .

Part I is all about getting started. Getting started right is the key to doing well. Getting started is easy if you have the right materials and an easy, step-by-step plan to follow. That's precisely what this part introduces. Once you get started, you'll be amazed to see how rapidly you are able to make progress.

First you see exactly why calligraphy has become so popular and how you really don't need talent, a lot of costly supplies, or most of the other things that make it difficult to do many other kinds of art. You see that calligraphy is a skill that anyone who can write can learn.

Next, you look at the different kinds of pens, ink, and paper you can use and where you can find them. You get to know the basic steps for using and taking care of your materials so they will last. You also discover the neat trick that you can do with the calligraphy pen and why I refer to it as the calligrapher's "magic wand."

Finally, this part shows you how the "trace and copy" method works and why it is so effective. You get a clear picture of the steps you take to reach your goal.

By the time you finish this part of the book, you should be excited about what you can accomplish. Who knows? With a little persistence, you may discover artistic abilities you never knew you had.

Chapter 1

Doing Calligraphy Can Be as Easy as ABC

In This Chapter

▶ Appreciating what calligraphy is all about
▶ Learning calligraphy
▶ Following a step-by-step approach
▶ Exploring the possibilities of what calligraphy offers

*C*alligraphy literally means "writing that is beautiful," but saying that calligraphy is beautiful writing, really doesn't give you the complete picture. Calligraphy truly is an art form, but despite what you may think, anyone can do calligraphy. It's not difficult at all. Calligraphy just requires you to shift your thinking a bit.Given enough practice, patience, and eagerness to slow down from life in the fast lane, you can pick up the skills you need to do calligraphy.

You probably haven't paid much attention to handwriting (meaning the actual formation of letters on paper), since your last lesson in handwriting way back in elementary school. You probably just jot down a list, dash off a note, initial a memo, and then rush off to the next thing you have to do without thinking about what your handwriting looks like.

One of the truly wonderful things about calligraphy is that it forces you to slow down. Calligraphy requires a slower pace. Calligraphy requires that you take time to look at small details. Calligraphy is all about taking something very commonplace — handwriting — and raising it to a higher level of appreciation. That's one of the appealing things about taking up calligraphy. Indeed, calligraphy can be very therapeutic.

In addition to its therapeutic value, you can use calligraphy in an endless number of ways. The potential is tremendous. You can use calligraphy for anything from award-making to scrapbooking. Invitations, signs, posters, charts, plaques, labels, thank-you notes, and greeting cards are just a few of the uses for calligraphy. Anything that you can think of where elegantly penned letters will add quality is an opportunity to use calligraphy. Most of all, calligraphy can be a way for you to discover new talents and abilities.

You Don't Have to Be a Rembrandt . . .

So you're really attracted to calligraphy and would love to create something beautiful, but you're a little shy about taking it up. Below, I list some reasons you may be shying away from calligraphy, and I explain why these reasons shouldn't stop you:

✔ **You lack the talent and ability to do calligraphy.** Calligraphy is an art form that requires little or no talent. Talent can be an advantage, but what is really most important in order to do well in calligraphy is patience and attention to detail. Because of

this, learning to do calligraphy is nothing like learning to draw or paint. Calligraphy is truly a skill that you hone through practice; talent isn't needed. Remember: With calligraphy, like every other skill, there are going to be some people who are better at it than others, but you have to please just one critic in this theater — yourself.

✔ **You're too old or young to learn calligraphy.** Age isn't a barrier in calligraphy. I've had students as young as second and third graders who have excelled in calligraphy, and on the other end of the spectrum, I've seen many seniors with a lot of "snow on top" (a group of which I'm proud to say I'm a member) do some truly impressive work.

✔ **You can't afford the equipment to do calligraphy.** You don't have to spend a bundle on art supplies. In calligraphy, you won't need to buy a lot of expensive materials like you would for many other forms of art. You only need a few supplies, such as pens, ink, paper, and a few basic drafting type materials such as a T-square, tape, pencils, and erasers. Plus, the pens can last almost forever and the things that you use up and need to replace, like ink, are really inexpensive.

✔ **You don't have enough space to do calligraphy.** You don't need an elaborate studio space to do calligraphy. A pen, some ink, a piece of paper, and a surface to write on are all you need. If you carry your pen with you, you can do calligraphy almost anywhere and at anytime.

. . . and, that's not all! (If I'm beginning to sound like an infomercial, I do apologize for my enthusiasm.)

The biggest selling point of all is how much fun it is to do calligraphy. Calligraphy is something where you can begin to see real accomplishment in a very short time. The more you learn about calligraphy, the more rewarding it can become.

. . . But You Do Have to Be Circumspect

So, what does it take to become a good calligrapher? Glad you asked:

✔ **Patience:** Calligraphy is definitely not something that you can rush through — it requires a slow pace. Calligraphy is something where there are never any medals given for speed.

✔ **Control and precision:** All the emphasis is upon the control and precision with which the letters are formed. You can find hours of enjoyment in practicing the letters as you acquire the control and precision needed to do calligraphy.

✔ **Practice:** You won't gain patience or control and precision without a little practice. I've given you many opportunities in the alphabet chapters to practice basic strokes, letters, and words, but you can find even more practice in the appendix.

Good calligraphers are students of the history of the alphabet. They have a knowledge and appreciation of how the written letters have evolved over centuries. They also have a knowledge of the tools and materials that have been used for writing. They see themselves as the latest generation of scribes in a long procession of men and women who have practiced this art. They see themselves both preserving the traditions and craftsmanship of the past as well as breaking new ground for the future. Although it's certainly beyond the scope of this workbook (or the scope of any one book for that matter) to present a complete history of writing in all its various forms, I do give you some brief historical notes for each alphabet. Plus you can find many excellent books on the subject and numerous Web sites (like mine — www.studioarts.net/calligraphy) where you can find nuggets of information. For additional information, a good book to begin with is a classic, *Writing & Illuminating & Lettering* by Edward Johnston, who is considered to be the "father of modern western calligraphy." This book should be a part of the library of anyone who is at all serious about calligraphy.

You Can Really Do Calligraphy!

Do you have doubts whether or not you can do it? Let me give you a test. If you can pass this test, you have all the ability you need to succeed. To take this test, all you'll need is a regular ballpoint or gel pen.

In the Figure 1-1, there are three boxes. In the first box there is an X drawn in black. In the middle box is the same figure drawn in gray. The box on the right is empty. Now here's the test — trace over the X that's drawn in gray so it looks like the one that's black. Then in the empty box copy the same shape again.

Figure 1-1:
Try to make all three boxes look alike.

How did you do? Do the X's in all three boxes look about the same? If you can do this, then you can do calligraphy.

This simple trace and copy exercise introduces the main idea of how this workbook is set up. With each alphabet, you'll have the opportunity to trace and copy the letters first individually and then in combination in words, plus you can find extended practice exercises in the appendix.

The best way to use the trace and copy practice pages in this workbook is to photocopy them so you can practice over and over again or download the practice pages from www.dummies.com/go/calligraphy.

Strike a Pose

No, I'm not about to take your picture to put on your official Calligraphy Member ID. Instead, I discuss in the sections that follow two important postures to focus on when doing calligraphy: your physical posture and how you hold your pen.

Getting your posture right

The position in which you sit when you write has a big influence on your ability to control your pen or pencil. If your posture is cramped, you won't have the complete control and freedom of movement in your writing hand that you would have if your posture were not cramped.

What is the best way to sit? Figure 1-2 is an example of the kind of posture that is most conducive to control and freedom of movement. Keep it simple and follow these tips:

- ✔ Sit in a way that makes control and precision possible.
- ✔ Sit comfortably with both feet on the floor and lean slightly forward over your work. Be careful not to lean too far forward as this inhibits arm movement.

> ✔ Your desktop should be tilted so that your paper can be positioned straight up and down and not canted to the side. Using a lap board is an easy and inexpensive way to have a slanted work surface.

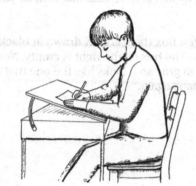

Figure 1-2:
Correct
posture.

Holding your pen

Just as important as your posture is how you hold your pen. Although Chapter 3 covers in depth the best way to hold the pen, I give you the basic idea in this section.

Essentially, the best pen hold is one where you don't tire. Many people today have acquired the habit, unfortunately from using ballpoint pens, of gripping the pen so tightly that they get what is called "writer's cramp." Many of them have a callus on one or more of the fingers of their writing hands.

If you get "writer's cramp" and/or you have a callus on your finger, those are sure signs that you are gripping your pen too tightly. Doing calligraphy may help you eliminate that bad habit. The pen does not have to be squeezed tightly. It is possible to write without suffering from writer's cramp.

Is it possible to break old habits and learn to hold your pen differently? I believe it is. My own experience shows me it is.

Years ago, before I took up calligraphy, I have to confess that I had developed the bad habit of holding my pen with an iron grip. After writing for any length of time, my hand would ache so much that I would have to stop periodically and shake it out to relieve the pain and stiffness. I also had a big callus on a knuckle of my middle finger.

Today I have none of these problems. Forming the habit of holding a pen in a more relaxed grip has been a really positive side effect of practicing calligraphy. Over time, the old habit of gripping the pen tightly has been replaced by a new habit of holding the pen in a more relaxed and less tiring manner. Hopefully, if you have the same bad habit I had, you will see a similar change.

Trace and Copy: A Sure-Fire Approach to Picking Up Calligraphy

In this book, I show you how to do six alphabets which can be expanded upon to make virtually thousands of variations. My purpose is to help you build a strong foundation from which you can expand your calligraphic skills. However, I'm not going to assume

that you know anything about calligraphy. Instead, I guide you step by step through the complete process from the simplest stuff to the more challenging projects.

When guiding through each alphabet, I use the time-tested method — trace-and-copy — in this workbook The trace and copy method is simple and powerful and is used to teach young children to write. The reason I've chosen to use this method is simple — it works. This *trace-and-copy method* works just as it sounds: You trace letters and then copy them freehand in the space provided.

To make the most of your practice in this workbook, follow these guidelines:

- ✔ **Don't write on the practice pages in this book.** Photocopy the pages, download the files from www.dummies.com/go/calligraphy, or place paper over the book and copy them. That way you will always have a clean master from which you can make as many copies as you need. You can repeat a practice lesson as many times as you want.

- ✔ **Don't ignore the tracing.** When you do the practice pages, if you're like most people, you'll like the copying part more than the tracing. Copying is more fun; tracing might seem pointless. I have seen some students skip over the tracing altogether and do only the copying. Tracing is important because it's almost as if I'm there beside you, guiding your hand to show you how it's done correctly.

- ✔ **Practice the exercises as written.** For example, if a practice exercise alternates between tracing and copying, please do the exercise just that way. Don't do all the tracing and then all the copying. I purposely designed each exercises to maximize your practicing and skill building. Here's how they're designed to help:.

 - • Sometimes you'll see gray letters with blank spaces in between where the letters can be copied. This means to alternate tracing and copying. This serves an important purpose when you are beginning to learn the letters of an alphabet. Every time you trace in between copying, you have a little review of the correct way to draw the letter. Tracing between copying aids in seeing any mistakes you might be making. To give you even more practice, I often add a blank line under the tracing.

 - • Other times you'll see an entire line of letters or words to trace with a blank line underneath for copying. A line of tracing above a blank line allows you to practice the words and spacing.

- ✔ **Follow the guidelines.** What do guidelines look like? Think back to the paper you used when you were little and you first learned to write. Remember how there was a bottom and top line and a dotted line running through it? Those were your guidelines. Although calligraphy guidelines look different from that, the same idea applies. You need to draw letters, not inside the guides, but so that the letters touch the guides. Doing so ensures your letters are straight and even. In Chapter 3, I show you how to draw your own guides.

- ✔ **Keep a positive attitude.** You are embarking upon an exciting journey — you could even say, an adventure. Keep that in mind. As an artist, I have experience working in many media and styles from sculpture to painting and printmaking, from abstract to realism. I have worked as a portrait painter and have owned an art gallery and frame shop. But, of all the things I have done as an artist, the most rewarding has been calligraphy. Calligraphy has given me more personal satisfaction and has opened more doors for me than anything else I have done in art. Those rewards are available to you too.

Taking Your Skills Further

Although I take you through the six basic alphabets in this book (from which you create endless variations), I also give you a chance to dabble with some more complicated

alphabets and projects. You can do several things with calligraphy other than just weddings (although I cover wedding ideas in Chapter 18). You can create quotations (see Chapter 14), posters and signs (see Chapter 15), as well as certificates (see Chapter 16). Take a peek in Chapter 17 to find inspiration and ideas for an assortment of projects you can try with your new calligraphy skills. If you're wanting to check out something a little more lighthearted, try the ten fun alphabets in Chapter 19, and if you're ready to make some money with those skills, Chapter 20 helps get you started.

Chapter 2

Peeking Inside the Calligrapher's Toolbox

Getting started with the right materials is important, but it's not always easy to know what the right materials are. If you've ever gone into an arts and crafts supply store looking for calligraphy supplies, it's likely that one of three things happened — the store either had no calligraphy supplies at all or they had a really small section with some markers and maybe a calligraphy set or they had such a huge selection of pens, inks, papers, and all kinds of doo-dads that you didn't know what to buy. In any case, you may have left the store without buying anything and probably feeling somewhat bewildered.

These kinds of experiences can be discouraging, but take heart. Getting the right materials is not difficult. In this chapter, I want to help you unravel the mystery of what materials to buy so when you go to the store or do your shopping on the Internet, you'll know exactly what to look for. I want to help you get started with the right materials — materials that are pretty easy to find, easy to use and, with reasonable care, should last you for a long time.

Finding the Right Materials

Where can you find calligraphy materials? They're actually pretty easy to find. Many arts and crafts stores as well as some stationery stores have a selection of calligraphy items. If you know in advance exactly what you need, it will make shopping a snap. You can make your shopping list from this chapter and then check the stores in your area.

The easiest place to find calligraphy supplies is on the Internet. Today, this is where most of the professional calligraphers shop. It's a simple, safe, and no-hassle way to get anything you need. The best source online is John Neal Booksellers at www.JohnNealBooks.com.

If you go to his website, you'll see that John Neal has an online catalog as well as a catalog in PDF format that you can download and print. You can place a secure order online or, if you prefer, you can order by phone, fax, or e-mail. And, yes, they do have a toll-free number (800-369-9598). If you have a question, the people at John Neal are both knowledgeable and helpful. You will usually receive your order in just a few days. My experience ordering from John Neal has been entirely positive.

Two other online stores that I have ordered from who have excellent selections of calligraphy supplies are www.DickBlick.com and www.MisterArt.com. Mister Art frequently offers impressive discounts. Both Dick Blick and Mister Art are online art supply superstores.

Choosing the Right Pens

You have a choice of three kinds of pens — markers, fountain pens, and dip pens. Each of these is good for a particular kind of work. Each has its advantages and limitations.

Markers are useful for those "quick and dirty" jobs where you need to do a job in a hurry, such as on-the-spot lettering of stick-on name badges. A fountain pen makes learning calligraphy easy. It enables you to carry your calligraphy studio with you wherever you go. In fact, a fountain pen will enable you to do some very nice calligraphy. A dip pen will enable you to do your best quality, finished work in India ink in the largest range of sizes. I discuss all three options in the sections that follow.

Pen parts

Pens aren't at all complicated. Their basic design is simple, efficient, and centuries old. A good pen delivers the ink in an even flow and should make it easy for you to create strokes. The pen should glide smoothly on the surface of the paper.

This list should help get you better acquainted with your calligraphy pens:

- ✔ **Nib:** This is the name that calligraphers call the part of the pen that everyone else refers to as the pen point. Calligraphy nibs have a flat edge similar in appearance to a flat screwdriver and come in a variety of sizes. Markers have nibs that are permanently attached. Fountain pens have nibs that are interchangeable and screw into the barrel of the pen. They usually come in sets. Dip pens have steel nibs that slide into a curved slot in the end of a pen handle. The selection of sizes is much bigger than for fountain pen nibs. Dip pen nibs are available individually.

- ✔ **Cartridge:** All the popular calligraphy fountain pens use ink cartridges. Cartridges are the newest addition to the design of calligraphy pens and make using the pen simple and virtually mess-free. The biggest problem with cartridges is getting a new pen started writing. The ink has to flow from the cartridge down to the tip of the pen before it will write, and that does not happen automatically. Sometimes you have to work at getting the pen started.

- ✔ **Adapter:** This takes the place of ink cartridges and makes it possible for you to fill your fountain pen with ink from a bottle. Perhaps I'm "old school," but I believe it is a good idea to be able to fill your pen from a bottle and not rely on using cartridges in your pen. The cartridges are small and easy to misplace; the bottle isn't. Although filling the pen from a bottle has a greater potential for creating a mess than using cartridges, a pen that is filled from a bottle will start writing faster than pens that have cartridges. I recommend that anyone buying the Manuscript pen also gets the adapter and a bottle of ink.

- ✔ **Handles or Pen Holders:** Dip pens have handles which are simple wooden or plastic shafts ranging in length from about 5 to 7 inches. The nibs can be inserted in the ends. Select a handle that fits your nibs and feels comfortable in your hand. Varnished wooden handles are the best choice. Plastic is okay. Avoid painted handles, because the paint will eventually chip away.

- ✔ **Reservoir:** Most dip pen nibs are designed to be used with this small attachment that holds the ink. This is called a reservoir. It is frequently made of brass that is

soft enough to be shaped with your fingers. Some dip pen nibs have a reservoir on top and some have it on the bottom. Most of the reservoirs can be removed from the nib to make cleaning easy. At least one kind of nib has a reservoir that cannot be removed.

Markers

Markers are great when time, not quality, is a consideration. You wouldn't want to use a marker to letter a certificate, but a marker would be perfect for small tasks such as writing a note to a friend or co-worker or posting a reminder to yourself or for family members. Markers are also excellent for children.

Markers have many limitations:

- ✔ **You really can't produce good quality work with a marker.** The writing tip is simply not fine enough to make the sharp edges and fine hairlines that a good pen will give you. I must add, however, that the quality of markers is constantly improving, and the markers today are far superior to the ones of just a few years ago.

- ✔ **Ink fades with age.** However, the ZIG markers offer permanent, archival quality ink.

- ✔ **Markers tend to dry out quickly.**

- ✔ **The tip deteriorates.** Even with careful use, the tips on the markers have a tendency to lose their sharpness. The chisel-edge becomes blunted with use.

- ✔ **Markers write, even when you're holding them wrong.** I usually recommend that people not attempt to learn calligraphy using markers. In learning calligraphy, it is necessary to practice the correct way to hold the pen to produce the desired strokes and shapes. A calligraphy fountain pen or dip pen helps a person learn how to hold the pen correctly, because it will not write otherwise. The problem with the marker is it will write no matter how you hold it.

In spite of their limitations, markers are extremely useful. I use them all the time. The main advantage of markers is how handy they are. They are the ultimate no-fuss-no-muss calligraphy pen. And when they run out of ink, you simply toss them in the trash.

When you're buying markers, test them in the store first. You never know unless you test it if a marker has already dried out. Also, make sure that your markers are tightly capped when you're not using them. Use force when you recap a marker to make sure the cap is snug.

The markers I have listed here are just a few of the most reliable ones that I have found. If you want to know what any of these markers look like, you can find full-color pictures of all the ones I've listed here on the Internet at one or more of the Web sites I mention in this chapter. All of these markers come in a variety of colors:

- ✔ **The Itoya doubleheader:** This marker lets you write with both ends. The smaller tip is 1.7mm and the larger one is 3.5mm.

- ✔ **Marvy 6000 Calligraphy Marker:** This marker is my personal favorite. The tip gives nice sharp lines, and the ink is dark. This marker comes in three sizes — 2.0mm, 3.5mm, and 5.0mm.

- ✔ **Niji Calligraphy Marker:** The ink in this marker is especially dense. Niji Calligraphy Markers are available in sets of three. The tips are 2mm, 3.5mm, and 5mm. I don't believe you can buy these markers individually.

- ✔ **Speedball Elegant Writer:** This marker was one of the first to be designed to approximate the calligraphy pen. The tip sizes have the names, X-Fine, Fine, Medium, and Broad.

- **Staedtler Calligraph duo marker:** This marker writes with either end! One end has a 2mm chisel tip and the other a 5mm tip. This marker comes in a variety of colors, and the ink is waterproof. Staedtler products are all excellent quality.

- **The ZIG Calligraphy Marker:** This marker was designed primarily to meet the needs of scrapbookers and represents a big step upward in the quality of a marker. The ink is permanent and archival quality (which means that it will not fade or change color, and because the ink is acid-free, it will not harm the paper that it is written on). There is an assortment of colors as well. One end of each marker is 2mm round for drawing and the other is 5mm chisel shaped for calligraphy.

Fountain pens

Fountain pens offer you several advantages. I recommend that anyone who wants to learn calligraphy start off with a fountain pen. The fountain pen is simple and easy to use. Once you have the hang of how to use a fountain pen, you can step up to the dip pen. I don't recommend starting off with the dip pen, because it requires constant filling and some special techniques that you can bypass with the fountain pen. For information about the dip pen see Chapters 3 and 15.

Fountain pens are excellent for practice, letter writing, and small jobs where you don't need especially large letters. You can carry your fountain pen with you so you're prepared to do some calligraphy on the spot wherever you happen to be. Fountain pens have a good selection of nib sizes and are available with both ink cartridges as well as reservoir adapters which allow you to fill your pen from a bottle of ink.

Fountain pens do have their limitations:

- **The ink is not as dark or permanent as the dip pen inks.**

- **Fountain pens cannot produce calligraphy of the same quality as dip pens.**

- **Fountain pens are a little pricier than markers and dip pens.**

- **Fountain pen nib sizes have not been standardized.** The most common names for the different size nibs are fine, medium, and broad, but the actual sizes can vary tremendously from one brand to another. A medium nib for one brand may be a broad nib for another brand.

There are innumerable calligraphy fountain pens currently on the market. They generally range in price from under ten dollars to over fifty dollars.

The fountain pen that I and many other calligraphy teachers are currently recommending is the Manuscript brand pen. It offers good quality, has the right "feel" to it, and is relatively inexpensive. It is also widely available in both right-handed and left-handed versions. As strange as it may sound, there are actually right- and left-handed pens. The left-handed pens have a nib edge that is cut at an oblique angle.

The practice exercises in this book are designed to work with the Manuscript pen (Chapter 3 discusses this pen in more depth). That is not to say that you cannot use other kinds of pens for the practice pages. Just make sure that the nib you are using is the same size as the nib I recommend. Finding the right size should be fairly easy because I tell you before each of the practice exercises which Manuscript nibs to use and what the mm equivalents are for these nibs. Measure the width of your pen nibs and see how they correspond to the Manuscript nibs. If you're using the Manuscript pen, the nibs you need for the exercises in this book are the medium, broad and 2B nibs.

Fortunately, Manuscript pens come in several sets that contain the three nibs you'll need (plus more) and the adapter. The best set I've seen is the Manuscript Calligrapher's

Deluxe Set (available from John Neal Booksellers). If you can't find a set that has everything you need, you can usually get the pen in a simple set, additional nibs, and an adapter separately.

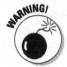

Never ever use a waterproof ink in your fountain pen. Use only nonwaterproof inks that are formulated especially for fountain pens. Waterproof inks can do permanent damage to your pen. If they dry in the pen, the pen will be clogged and probably cannot be cleaned. Also, because waterproof inks have varnish in them, they can expand when dry. This can wreck the fine slit in the nib.

If you're left-handed

If you're left-handed, you have a choice of whether to get a right-handed or left-handed pen. Before you buy a pen, decide which is going to be best for you.

If you're a lefty, you should choose one of the three positions that are pictured in Figure 2-1. It should be the position that is most comfortable and easiest for you to maintain as you write. The hand position you choose will be the position, you use to do all your calligraphy.

Figure 2-1:
Three
options
for left-
handers.

If you choose the position on the far left, you should get a left-oblique (left-handed) pen. If you pick either of the other two positions, you should use the same kind of pen that right-handers use.

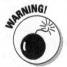

If you select the position on the far right, you will have to use caution that you don't drag your hand through the ink.

Dip pens

The main advantage of the dip pen is that it will allow you to use inks which you cannot use in a fountain pen. Dip pens will also enable you to produce a much finer quality calligraphy in terms of sharp, crisp looking letters.

Dip pens are inexpensive, are easy to take care of, and will last for years. The dip pen nibs that I use are about thirty years old and show no signs of wearing out. The only thing that I've ever had to replace are the handles.

When it comes to listing the disadvantages of dip pens, I can really think of only one — the dip pen is not something that you can carry around in your pocket or purse very easily (or very safely). As an example, one of my students put her pens and ink in her purse to bring them to class. The only problem was that the lid on the bottle of ink was not screwed on very tightly. You can imagine the mess she had when she got to class and opened her purse!

If you want to practice all the alphabets in this book, you will need two kinds of dip pens. One kind has a broad-edged nib which is used for most of the alphabets. It is the counterpart to the fountain pen that I described above. The other is an oblique pen which is used only for the Copperplate style. (See Chapter 13 for information about Copperplate.)

Broad-edged pens

Select your pen according to the nib. I can recommend that you choose from three kinds of broad edged nibs — Mitchell type nibs, Brause nibs, and Speedball C-series nibs (see Figure 2-2). All three of these are available in right and left-handed versions; I discuss each of them in the following list (I describe them in the order they appear in Figure 2-2):

Figure 2-2:
The Mitchell-type nib with the reservoir shown beside it, the Brause nib, and the Speedball C-Series nib.

- **Mitchell Roundhand:** The Mitchell Roundhand nib is my first choice. This nib has a wonderfully soft "touch." It is a nib that requires very little pressure. It is a pleasure to use.

 The Mitchell Roundhand type nib is steel and has a dimple in the top for filling with ink (I explain how in Chapter 3). It also has a brass reservoir which attaches underneath the nib. The brass is soft enough that you can easily bend it to fit the nib.

 You should get a complete set of these nibs with a reservoir for each nib. The first thing you should do is check the fit of the reservoir. It should slip onto the nib snugly. The "tongue" of the reservoir should touch the underneath side of the nib close to the broad edge.

 Manuscript also manufactures a nib that looks exactly like the Mitchell Roundhand nib. They call their nib Chronicle. It is available in sets with a wooden handle.

- **Brause:** This is also a steel nib. The reservoir which is also steel is on top. The Brause nib has a firmer feel than the Mitchell nib. If you have a tendency to press down, Brause is probably a better choice.

- **Speedball C-Series:** This steel nib has a brass reservoir permanently attached to the top. If you get this nib, make sure that the reservoir is not flat against the nib. It should be slightly raised in the middle so it can hold ink.

 Since you cannot take this nib apart to wipe it clean, you will have to rinse the nib thoroughly under running water and dry it completely after you use it.

Oblique pens

If you're interested in doing Copperlate (see Chapter13), you need to get an oblique pen holder and some pointed nibs (see Figure 2-3). These are usually sold together. Speedball makes a plastic oblique pen which is fine. It's available for left-handers.

Figure 2-3:
The
Speedball
Oblique
Pen shown
with a
pointed nib.

Got The Right Ink?

Buying ink is simple if you remember one simple thing — don't use waterproof ink. Use only nonwaterproof inks. Here are my recommendations:

✔ **For fountain pens:** An excellent ink for fountain pens is Pelikan 4001 ink. This ink will not clog your pen and flows easily. It's a dye ink, which means that it is not as dark and opaque as a carbon pigment ink, but it's still an excellent ink that is recognized by calligraphers around the world.

✔ **For dip pens:**

• Higgins Eternal black ink (sometimes humorously called "Higgins Infernal"): This is best for Copperplate. Since you have to dip the oblique pen into the ink, you need a bottle that has a wide enough mouth so you can get the end of the pen in and out easily. The Higgins ink bottle is just right for the job..

• Pelikan Fount India: The Fount India has the advantage of coming with a dropper stopper which is handy for filling the pen.

Selecting the Right Paper

If you're just starting out, you'll need practice paper. A good quality photocopy paper usually works very well.

When you're trying to select paper, it works best if you can actually test the paper with your pen. Many papers have a soft surface, and the ink will bleed. What you want is a paper on which your calligraphy will look sharp and crisp.

The thickness of the paper is an important consideration. If the paper is translucent enough, you can use a sheet with guide lines underneath. Otherwise, you will have to draw guide lines on the paper in pencil and erase them when you are finished.

You should try:

✔ **Strathmore 300 and 400** series paper is reasonably priced and comes in pads, if you want paper that is larger than standard letter size.

✔ **Pentalic Paper for Pens** is a higher quality paper that comes in various size pads. This is an archival-quality paper (meaning that it will not turn brown or get brittle with age) that has a smooth, hard surface. It is excellent for all kinds of calligraphy, including Copperplate.

Additional Materials You Need

Following is a list of additional materials that you'll probably find useful in doing calligraphy. This list does not include other art materials that you may want to incorporate into your calligraphy. For example, if you do watercolor painting, you would certainly want to use watercolors together with your calligraphy. Here I just list the basics:

✔ **Pencils:** You'll definitely need a few good quality, hard lead pencils.

✔ **Erasers:** Don't get a pink eraser; get a white eraser that does a good job erasing pencil but is not abrasive to the paper. Magic Rub and Staedtler are my favorites.

✔ **Drafting tape:** This tape looks like regular masking tape, but it isn't as sticky. You can remove it without tearing your paper. Use drafting tape to hold your paper in position on your board.

✔ **18-by-24-inch (or larger) drawing table or rectangular board:** A drawing table or lap board is a real necessity. You need to be able to tilt your work surface so you can see what you're doing straight on – not from an angle. If you don't have a drawing table, a lap board works perfectly well. Masonite boards are a favorite. Just make certain that the edges are completely smooth so they won't snag your clothing. See Figure 2-4 to find out how to use a lap board correctly.

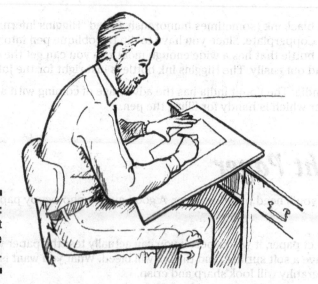

Figure 2-4:
The correct
way to use
a lap board.

✔ **24-inch or larger T-square:** A T-square is needed for drawing guide lines.

✔ **Inch and metric ruler:** A ruler is needed for measurement, design, and placement.

✔ **30–60 plastic triangle:** A triangle is useful in drawing guide lines.

✔ **Paper towels:** Keep paper towels handy for cleanup.

✔ **Storage boxes:** Sectioned plastic storage boxes with snap-on lids — the kind that fishermen use for lures — are great for storing pen nibs. You can find these in most sporting goods stores.

Taking Care of Your Materials

Calligraphy materials are really easy to take care of. Follow these few suggestions and your materials should last for years:

✔ **Take a few minutes to clean up and put things away whenever you're finished.**

✔ **Store nibs and small items in plastic boxes with compartments.**

✔ **Soak a nib overnight in water and dry it if ink ever dries in one of your fountain pen nibs.** Usually, this is not totally necessary especially if you are using Pelikan 4001 fountain pen ink. If the ink ever dries in one of my pens, I simply refill the pen from the bottle, and it's ready to go!

✔ **Scrub dip pen nibs gently with toothpaste when they're new and have oil on them from the factory and any time they become encrusted with dried ink.**

✔ **Wipe your pen nibs clean and store them in a dry place.** Most dip pen nibs, especially the ones that you can take apart, can be cleaned this way. I rarely wash my dip pen nibs.

✔ **Store your paper in a place that's dry and free of mice and insects that eat paper.** The enemies of paper are moisture and pests.

✔ **Store your paper flat so it doesn't acquire a bend in it.**

Taking Care of Your Materials

Calligraphy materials are really easy to take care of. Follow these few suggestions and your materials should last for years.

- Take a few minutes to clean up and put things away whenever you're finished.
- Store nibs and small items in plastic boxes with compartments.
- Soak a nib overnight in water and dry it if ink ever dries in one of your fountain pen nibs. Usually, this is not totally necessary, especially if you are using quality 400 formula pen ink. If the ink ever dries in one of my pens, I simply refill the pen from the bottle, and it's ready to go!
- Scrub dip pen nibs gently with toothpaste when they're new and have oil on them from the factory and anything else they become encrusted with dried ink.
- Wipe your pen nibs clean and store them in a dry place. Most dip pen nibs, especially the ones that you can take apart, can be cleaned this way. I rarely wash my dip pen nibs.
- Store your paper in a place that's dry and free of odors and insects that eat paper. The enemies of paper are moisture and pests.
- Store your paper flat so it doesn't acquire a bend in it.

Chapter 3

Putting Your Pen to Paper

. .

In This Chapter

▶ Looking at the parts of the Manuscript fountain pen

▶ Using a Mitchell Roundhand dip pen

▶ Getting your board set up

▶ Drawing and using guide lines

▶ Getting started

. .

*B*efore you actually begin lettering some of the alphabets in this book, make sure you're familiar with a few simple things, such as how to fill the pen, how to get the pen to write correctly on the paper (not always as easy as it may sound), and how to take care of your pens. These are the kinds of things I want to touch upon in this chapter. I'll explain the basics of using both the fountain pen and the dip pen.

I especially want to help you if your pen is giving you problems. I will also explain how to use the guide lines and how to create your own guide lines for calligraphy.

If you are uncertain about what kind of pen to use or what kind of ink to use in the pen, please refer to Chapter 2 where I describe the materials. Remember, never use waterproof inks in your fountain pen.

Using a Fountain Pen

I recommend that everyone who is beginning calligraphy start out using a fountain pen. The fountain pen makes practicing with a broad-edge pen as hassle-free as possible. Once you can handle the fountain pen, you are ready for the challenge of using a dip pen. See Chapter 2 for information on selecting a dip pen. Read the information below about how to fill a dip pen, and, when you're ready, read in Chapter 15 about some special techniques in using the dip pen.

When you bought your fountain pen it may have come in a package unassembled. Before you do any of the practice work that is shown in this workbook you need to put the parts of the pen together, make certain that the pen has ink in it, and make sure that the ink actually flows out of the pen onto the paper the way it should.

Putting the pen together is pretty easy, but frequently getting the pen to write is somewhat of a problem. The pen is not always cooperative. You also have to hold the pen a special way to get it to write. I cover all these issues in the sections that follow.

In Chapter 2 I recommended that you use the Manuscript brand fountain pen as your first calligraphy pen. It is inexpensive, offers a good selection of nib sizes, is available in both right- and left-hand versions, can be used as a cartridge pen or as a pen that you fill from a bottle, and it is a pretty good quality pen for the low price.

Examining the parts of the pen

Take off the cap of your fountain pen and look over the parts. Each part of the fountain pen has a name, and it's helpful to know these names. The fact is, you can use names like "thing-a-ma-jig" if you want to. Don't worry, the calligraphy police won't come and arrest you if you confuse a nib with a barrel, but it makes communication a whole lot easier if you're speaking the same language as the guy behind the counter at the arts and crafts supply store.

Figure 3-1 shows you the following parts of a fountain pen:

- ✔ **Barrel**
- ✔ **Ink cartridge** (or **adapter,** depending upon which type of pen you have)
- ✔ **Nib** (no true calligrapher ever calls it a pen point)
- ✔ **Cap**

Figure 3-1:
The parts of a fountain pen.

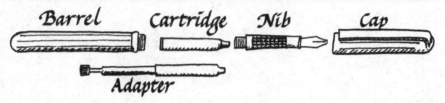

Barrel *Cartridge* *Nib* *Cap*

Adapter

For this chapter, I use the 2B nib which is approximately 1½mm in width.

You can choose between two types of fountain pens:

✔ **Cartridge:** With a a cartridge pen, you just insert the ink cartridges and the pen's filled with ink. The advantages are the ease and convenience and the fact that there is no mess. The disadvantage is it is frequently difficult to get the pen to write, because the ink has to flow out of the cartridge into the pen and down to the end of the nib.

✔ **Reservoir adapter:** In place of the cartridge, this pen has a little pump mechanism inside the pen that enables you to fill the pen from an ink bottle. The advantages are the pen is ready to write immediately after you fill it and the bottle of ink is harder to misplace than the small cartridges. The disadvantages are the bottle of ink is not especially easy to carry with you and there is a greater possibility of getting ink on your fingers or even having an accident and spilling the ink.

Filling the pen — Fill 'er up!

How you fill your fountain pen depends on which type you have. Read the instructions that came with your pen to make certain you know exactly how filling the pen works for your particular pen. I include some general directions for filling both pen types in this section, but the instructions that came with your pen are the final word for filling your pen.

If you're using a cartridge pen, first notice that the cartridge has two different ends — usually one end is flat and the other is tapered — so be sure you have the cartridge headed the right direction when you put it into the barrel (see Figure 3-2 for an example). If you're using the Manuscript pen, just place the two cartridges back to back (the flat ends will be touching) so that the first cartridge acts like a spacer in the barrel. Then simply drop the cartridge(s) into the barrel and screw on the nib. When you screw on the nib, it should puncture the cartridge just right.

Figure 3-2:
Filling a cartridge pen.

If you are using a pen with a reservoir adapter, which is my recommendation, you need to fill it from an ink bottle. All adapters have some kind of pump mechanism. Read the instructions to see if yours is the plunger type, the kind you squeeze from the sides, or the kind where you turn a knob. The Manuscript pen, for example, has a plunger type adapter. Push it in, put the nib into the ink, and slowly pull the plunger out.

When you fill the pen, it is best to submerge only the nib into the ink, but make certain it's completely submerged (see Figure 3-3). If you dip it too far into the ink, you might have a little mess. If you don't dip it far enough into the ink, it will not fill completely. Once the pen is filled, wipe away the excess ink with a paper towel.

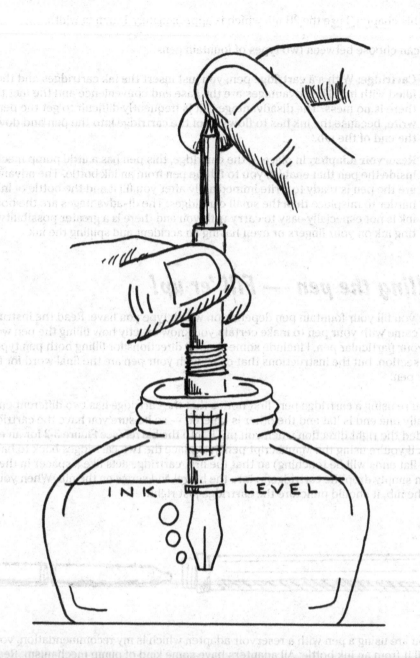

Figure 3-3:
Filling a pen
that has an
adapter.

Getting a grip on (actually, off) your pen hold

Regardless of whether you're using a fountain or dip pen, you must hold it properly when doing calligraphy. Practice the correct way to hold the pen using a fountain pen. When you take up the dip pen, use the same hold. If you're accustomed to writing with a ballpoint pen, you may have acquired a few not-so-good writing habits. The most common is gripping the pen too tightly. A tense pen hold can inhibit the control you need to do calligraphy. Such a hold can also quickly produce fatigue or writer's cramp. Figure 3-4 shows a tense pen hold, the incorrect way to hold a pen.

The tense pen hold (as seen in Figure 3-4) shows the index finger angled upward and the middle, ring, and little fingers curved tightly into the palm of the hand. If your habit is to hold the pen anything like this, I encourage you to make an effort to relax and work on developing a new, better habit, which I show you in Figure 3-5.

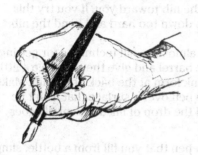

Figure 3-4:
A tense
pen hold.

Figure 3-5 shows the ideal pen hold — firm but relaxed. The index finger is curved just slightly, and the middle, ring, and little fingers are curved gently underneath.

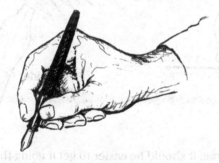

Figure 3-5:
The ideal
pen hold.

Please study this illustration of the correct way to hold the pen. Practice positioning your fingers and angling the pen exactly as shown in Figure 3-5.

Combatting ink-flow problems

After you've assembled your pen, but before you begin doing calligraphy, you must see if you can get the pen to write. A unique problem for fountain pens, you will likely encounter some ink-flow issues when writing, especially when using a new cartridge or pen. If you are using a cartridge pen, it's entirely normal for the pen to refuse to write immediately. The challenge is getting the ink out of the cartridge, down into the nib, and onto the paper. Meet the challenge by trying these techniques:

✔ Hold the pen loosely with the nib pointed downward about two inches above a sheet of scratch paper. Tap the nib lightly on the paper several times. Avoid jabbing the pen into the paper — just let it slide through your fingers of its own weight. The idea is to coax the ink to flow down into the nib.

✔ Hold the flat edge of the nib flush against the paper as shown in Figure 3-6 (don't hold it an angle to the paper) and move the pen side to side in straight lines so that the direction of the side-to-side movement is in line with the flat edge of the

nib.. The side-to-side stroke will help draw the ink down into the nib. This side-to-side technique is helpful for testing all pens. It not only helps in getting the ink to flow, but allows you to gauge the flow of the ink and get the "feel" of the pen. Practice this technique and adopt it as a standard way to test a pen prior to using it.

✔ Another technique you might try to get ink flowing is to apply a tiny bit of pressure against the paper as you draw the nib toward you. If you try this, be extremely careful that you don't press down too hard and bend the nib.

✔ If none of these methods work, I have an almost no-fail technique for getting a cartridge pen started. Just unscrew the barrel and give the cartridge a little squeeze until you see a small droplet of ink form at the back of the nib. Make sure you do this while you're holding the pen over a surface that won't be harmed if you squeeze a bit too hard and the drop of ink accidentally goes splat onto whatever is underneath!

✔ If you're having problems with a fountain pen that you fill from a bottle, simply refill it. Refilling will saturate the nib with ink.

Figure 3-6:
Holding the flat edge of the nib flush against the surface of the paper and scratching.

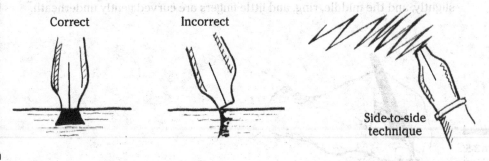

Correct Incorrect

Side-to-side technique

Once you get the pen working the first time, it should be easier to get it going the next time you use it. You definitely have to endure a "break-in" process. If you have trouble with your pen, treat it like a balky child: Be gentle and persistent and never lose your cool.

Sometimes a nib is particularly uncooperative (probably because there is an oily film on the nib). If you run into that situation, simply wipe the nib with ammonia. That should cure what ails it!

An Amazingly Talented Pen!

The calligraphy pen has a special flat nib, sometimes called a chisel-edge or broad-edge, and it's this special edge that creates the beautiful ribbonlike appearance of real calligraphy where some parts of the letters are thick and other parts are thin. As you practice each alphabet in this book, hold your pen in the special way I describe for each alphabet, and your pen does all the rest. Your pen makes all those beautiful "thicks" and "thins" automatically (see Figure 3-7 for an example). You don't even have to think about where to put the "thicks and thins." When you hold the pen correctly, the pen will put them in the right places.

before you put the old nib away may wipe the old nib with a soft paper towel to clean off the excess ink if you want to, but you really don't even have to do that. If the nib dries on your pen, it will dry. All you'll have to do to make the set to go again is to add more water; you should soak the old nib in some water to clean it again a small bowl of water. Then dry it with a soft paper towel. Note: Don't use soap of chemicals; the water not be fountains. Next, because they make it about impossible to get all of the paint thinned up doing calligraphy with pencil doodles. That might be interesting.

To change the color of the ink in your pen, you have a couple options. You can just flush out the old ink by soaking the nib in plain water and drying it before you refill it with another...

Figure 3-7:
The distinc-
tive thick-
and-thin
"ribbon"
look of real
calligraphy.

I'm sure you're eager to make some kind of mark at this point, so discover what your pen can do. Have fun and experiment by making some marks and doodles. Look at Figure 3-8 to discover the kinds of marks you can make with your pen. Now give it a try: Grab a piece of paper and try to duplicate the doodles from Figure 3-8. Then see what else you can do — try making some doodles of your own.

Figure 3-8:
Doodles
you can try
to copy.

See the thick and thin lines in Figure 3-9? Keep doodling and making marks, and discover just how you need to hold the pen to make the fattest and thinnest possible lines. Make as many as you want!

Figure 3-9:
Thick and
thin lines
you can
duplicate.

Taking care of your fountain pen

Using nonwaterproof ink in your pen makes taking care of your pen incredibly easy. In fact, there's nothing special that you'll have to do at all. When you change nibs and

before you put the old nib away, you may wipe the old nib with a soft paper towel to clean off the excess ink if you want to, but you really don't even have to do that. If the ink dries in your pen, usually all you have to do is refill the pen and you're set to go again. If for any reason, you feel that you should rinse the nib, just run it under warm water or let it soak in a small bowl of water and then dry it with a clean, soft paper towel. Don't ever use any soap or cleanser on the interior parts of the fountain pen, because they are just about impossible to rinse out of the pen. You might wind up doing calligraphy with soap-bubbles. That might be interesting.

To change the color of the ink in your pen, you have a couple options. You can flush out the old ink by soaking the nib in plain water and drying it before you fill it with another color or you can simply switch to a clean nib. If you're using a cartridge pen, you can put in the cartridge with the new color and create a very interesting effect where the color of the letters change gradually as you write with the pen. If you're filling your pen from a bottle, you'll have to either flush out the nib or use a clean nib. You wouldn't want to "pollute" the ink in the bottle with a different color.

Using a Dip Pen

After you've learned how to use a fountain pen, you're ready to graduate to the next step up in quality — the dip pen. The beauty of the dip pen lies in its basic simplicity. It does an excellent job and is easy to take care of. Plus, dip pens can last forever. (To get an idea of how dip pens compare to other calligraphy pens, see Chapter 2. To read about the techniques required to use a dip pen, see Chapter 15). Because of their reliability and precision, I use only dip pens for important calligraphy.

I recommend using the Mitchell Roundhand dip pen (you can find out more about my recommendations for dip pens and other calligraphy materials in Chapter 2). Throughout this section, when I refer to a dip pen, the Mitchell Roundhand is the dip pen I have in mind. However, just in case you're using a different brand, I point out any differences other brands may have if knowing those differences will be helpful.

Checking out the pen's parts

Dip pens have three basic parts: the handle, the nib and the reservoir (see Figure 3-10 to see the parts of a dip pen). The simple design of the dip pen makes it easy to change nibs. You can also change the reservoir each time you change the nib.

Figure 3-10:
Details of
a dip pen.

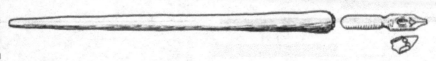

Figure 3-10:
Details of
a dip pen.

Filling — not dipping — your dip pen

The reservoir slides on underneath the nib. The reservoir is brass and can be bent and shaped easily with the fingers so the fit is snug. It is best to have a separate reservoir for each nib so you don't have to keep bending it everytime you clip it onto a different nib.

Before you try to fill the pen, check to make sure that the little reservoir fits correctly so it touches the back of the nib very close to the flat edge. Also make certain that the

reservoir is snug so it won't slip accidentally on the nib. (If you are using a Brause pen, the reservoir is on top of the nib, but everything else is basically the same.)

Filling a dip pen is easy if you know the trick: Don't dip it! Although we call it a dip pen, I don't recommend that you actually dip it in the ink. Instead, use a small round artist's paint brush or a dropper stopper (like the one that comes in the Pelikan Fount India ink bottle) to place a droplet of ink in from the side between the nib and reservoir.

Another very interesting way to fill the Mitchell pen is to put a drop of ink into the little dimple that's on top of the nib (see Figure 3-11). After you have put a drop of ink in the dimple, hold the handle near the end so it is horizonal and the ink drop is held just like it was in a spoon. Tap the handle of the pen once lightly on a hard surface. If done correctly, the drop of ink will pop down into the reservoir underneath, and you're ready to write.

The wider the nib you're using, the quicker the ink is used up. With a wide nib, you refill every two or three letters. Whenever you use a dip pen, you must refill frequently, but there is a rhythm to it.

If you're using a different kind of pen such as Brause and Speedball, simply use a small paintbrush or dropper-stopper to insert a drop of ink in from the side. Don't overfill, and, if you're using a dropper-stopper, watch out for air bubbles when filling — they have a way of impersonating ink drops!

Don't let the dip pen run dry. Fill it frequently so that your letters always look nice and dark. Don't allow the letters to begin to look pale and thin as the ink in the pen begins to run low. Keep the pen full.

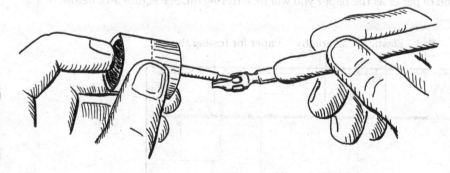

Figure 3-11:
Filling the
dip pen.

Taking care of your dip pen

You should always take the nibs apart and wipe them clean and dry with a paper towel before you put them away.

It's probably not a good idea to store a nib in the pen handle. I prefer to keep all my dip pen nibs in one of those sectioned, clear boxes that have a snap-shut lid so they are protected from dust and humidity. It makes more sense to store your nibs separately from the handle because the dip pen has so many different size nibs that you would probably want to use a different size nib the next time you use the pen anyway.

The dip pen nibs can be given a more thorough cleansing than you would give a fountain pen nib. If the nibs become encrusted with dried ink, and they will if you use them a lot, I recommend that you use toothpaste and an old toothbrush to clean them up. Toothpaste does a super job. Rinse and dry the nibs thoroughly before putting them away. The steel nibs can rust if they are not dried thoroughly.

Using nonwaterproof ink makes clean up really easy. Even if the ink has dried on the nib, you can rinse it away with plain water. Waterproof ink not only creates a problem in cleaning if it should dry on the nib, but it tends to expand when it dries. It can act like a wedge in the slit in the nib and cause the slit to splay open which would make the nib useless.

Setting Up Your Board

Now that you have your pen ready, the next thing to do is set up the drawing table or board where you are going to do your calligraphy. See Chapter 2 to review the information on the kind of work surface and its size.

The set-up of a calligraphy board is unique. First, it is a good idea to tape down one or two sheets of paper (depending on the the thickness of the paper) that are almost the same size of the board to serve as a pad underneath the paper on which you do calligraphy. This paper can be any kind of smooth, clean paper. I wouldn't use paper that has a fold in it or has anything printed on it. I use a single sheet of poster paper. Another option is a few sheets of drawing paper or layout bond paper. Across the bottom half of the board tape another sheet of heavy-weight paper (I like to use watercolor paper) that will serve as a shield or guard. Your hand rests on top of this sheet of paper while the paper that you're doing calligraphy on, slides underneath. This will protect the calligraphy paper from getting moisture and oils from your hand. Tie an elastic band (available at fabric stores) across the top of the board. This is used to hold the top part of your paper in place. As you are lettering, you move the paper up line by line. The last thing you'll need is a small piece of paper for testing your pen. This should be the same kind of paper as the paper you will be lettering on. See Figure 3-12 below.

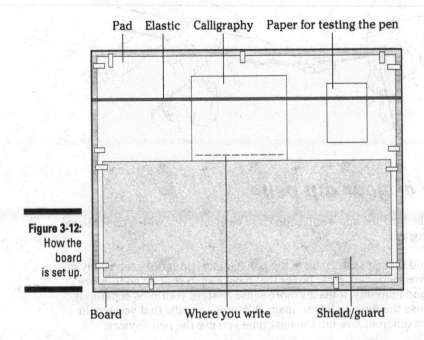

Pad Elastic Calligraphy Paper for testing the pen

Figure 3-12: How the board is set up.

Board Where you write Shield/guard

Keeping Letters Straight: Drawing Guide Lines

Drawing lettering guide lines is not only easy, but extremely important when you want your calligraphy to look the best it can be. You use guide lines to keep your letters straight and even. For many of the alphabets you will need four lines (see Figure 3-13):

✔ **Writing or base line:** The letters sit on this line.

✔ **Waist line:** Shows the height of letters, such as *a*.

✔ **Ascender line:** Indicates the height of the staff on letters such as *d*.

✔ **Descender line:** Shows the length of the descenders on letters such as *g*.

Figure 3-13:
The guide
lines.

Ascender line

Waistline

Baseline

Descender line

The correct way to use the guide lines is not to try to write inside them, but to draw the letters so they just touch the lines. You'll see more about how that works in the chapters that explain the alphabets.

Calculating the distance between lines

The spacing between the guide lines, measured in *pen widths* (the width of the nib you are using), varies from one alphabet to another. In each alphabet chapter, I tell you how many pen widths to use for spacing (Figure 3-14 shows you an example). When you're ready to draw your guide lines, you first must calculate the distance between the lines: Multiply the the size of the nib by the number of pen widths the alphabet requires. For example, if the pen nib is 2mm wide and the alphabet requires five pen widths between lines, then the distance between the lines will be 2mm multiplied by 5, which equals 10mm.

Figure 3-14:
Pen widths
added to the
guidelines.

The Manuscript company has a small ruler called The Manuscript Calligraphy Rule which can be used to measure the spaces between lines for the most commonly used pen nibs.

Using a T-square and drafting tape

This method requires a drawing board, a T-square, and drafting tape:

1. **Align the bottom of your paper to your board using a T-square (see Figure 3-15).**

2. **Tape it down.**

3. **Mark along one side of the paper the distance between the guide lines using a ruler and a pencil.**

4. **Draw horizontals using the T-square (see Figure 3-16).**

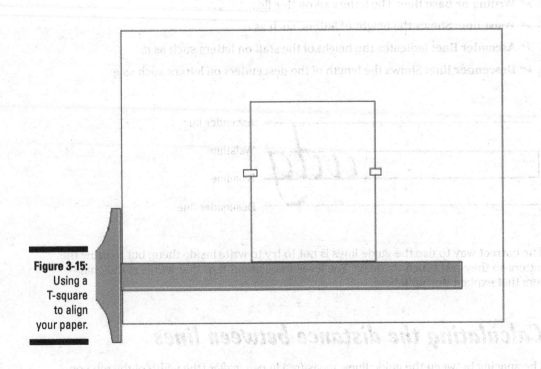

Figure 3-15:
Using a
T-square
to align
your paper.

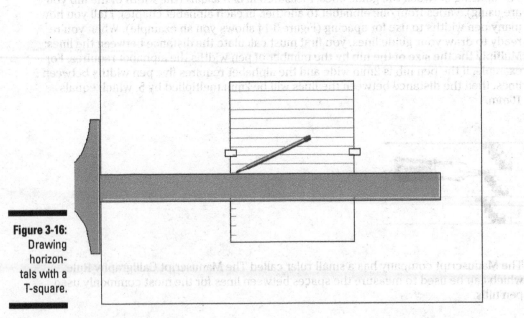

Figure 3-16:
Drawing
horizon-
tals with a
T-square.

Using a ruler and right triangle

This method requires a drawing board, a ruler that is at least as long as the piece of paper, and a right triangle:

1. Tape the ruler in a vertical position to the board, making certain that the increments along the ruler's edge are on the right side (see Figure 3-17).

2. Place the paper against the edge of the ruler and tape it down (see Figure 3-17).

3. Slide a right triangle along the edge of the ruler and draw the horizontals at the correct intervals (see Figure 3-18).

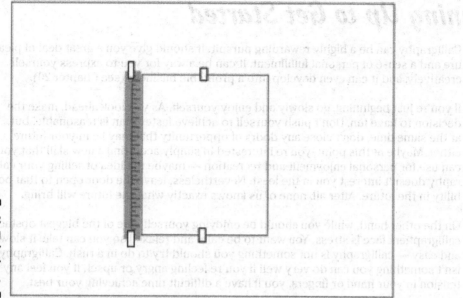

Figure 3-17:
Getting
your ruler
and paper
taped down.

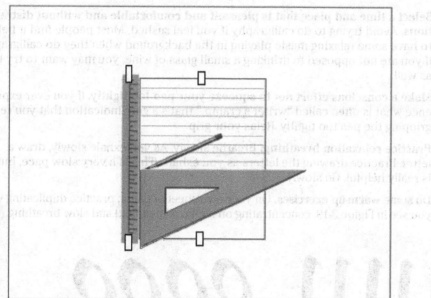

Figure 3-18:
Using a right
triangle
to draw
horizontals.

A third way to draw guide lines?

There is another way that people have used to draw guide lines. Maybe it even came to your mind as you were reading about the two methods I describe above. It's the method you may have used in school if you ever had to rule off a sheet of paper. First, you measured and marked the intervals along both sides of the paper. Then you used a straight-edge to connect the marks from one side to the other. This method is vastly inferior to the other two methods because of the time involved and the greater margin for error. I mention it only to warn you that you should not do it this way. Don't use this method.

Loosening Up to Get Started

Calligraphy can be a highly rewarding pursuit. It should give you a great deal of pleasure and a sense of personal fulfillment. It can be a way for you to express yourself creatively, and it can even develop into a profitable business (see Chapter 20).

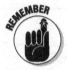

If you're just beginning, go slowly and enjoy yourself. As you look ahead, make the decision to have fun. Don't push yourself to achieve faster than is reasonable, but, at the same time, don't close any doors of opportunity that may lie in your future either. Maybe at this point, you're interested in simply acquiring a new skill that you can use for personal enjoyment and recreation — maybe the idea of selling your calligraphy doesn't interest you in the least. Nevertheless, leave the door open to that possibility in the future. After all, none of us knows exactly what the future will bring.

On the other hand, while you should be enjoying yourself, one of the biggest obstacles calligraphers face is stress. You want to be calm and relaxed so you can take it slow and easy — calligraphy is not something you should try to do in a rush. Calligraphy isn't something you can do very well if you're feeling angry or upset. If you feel any tension in your hand or fingers, you'll have a difficult time achieving your best.

Fortunately, calligraphers have discovered some tricks for relaxing:

- **Select a time and place that is pleasant and comfortable and without distractions.** Avoid trying to do calligraphy if you feel rushed. Most people find it helpful to have some relaxing music playing in the background when they do calligraphy. If you are not opposed to drinking a small glass of wine, you may want to try that as well.

- **Make a conscious effort not to squeeze your pen too tightly.** If you ever experience what is often called "writer's cramp," that's a sure indication that you're gripping the pen too tightly. Relax your grip.

- **Practice relaxation breathing.** Breathe slowly. As you exhale slowly, draw a letter. Practice drawing the letters as you exhale. This is a very slow pace, but it is really helpful. Go slowly.

- **Do some warm-up exercises.** On your own sheet of paper, practice duplicating what you see in Figure 3-19, concentrating on a relaxed pen hold and slow breathing.

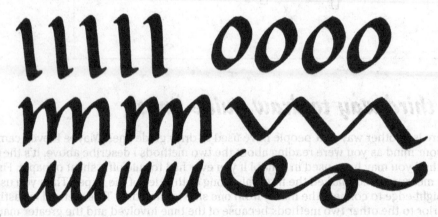

Figure 3-19:
Warm-up
exercises.

Good posture and the correct pen hold are vital. Figure 3-20 shows the correct position of the paper, the arms, and the pen. In this figure you can see that the woman has the paper straight up and down in front of her. She holds the pen in a relaxed manner and is also using a stick in her left hand to press down on the paper so it won't bounce as she letters on it. She has another long piece of paper under her hands that acts as a shield so moisture and oils from her hands will not transfer onto her work.

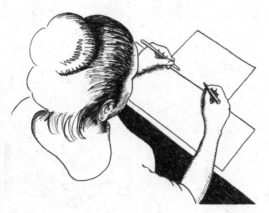

Figure 3-20:
The correct
posture and
pen hold
for doing
calligraphy.

Good posture and the correct pen hold are vital. Figure 3-2 shows the correct position of the body, the arms, and the pen. In this figure, you can see that the woman has the paper straight up and down in front of her. She holds the pen in a relaxed manner and is also using a stick in her left hand to press down on the paper, so it won't bounce as she letters on it. She has another long piece of paper under her hands that acts as a shield so moisture and oils from her hands will not transfer onto her work.

Figure 3-2:
The correct posture and pen hold for doing calligraphy.

Part II
The Amazing, Incredible Italic Alphabet

The 5th Wave By Rich Tennant

"Your calligraphy's improved nicely, except for this little flourish you put at the end."

In this part . . .

The first alphabet that most people are eager to learn is Italic. Italic is by far the most popular, the most versatile, and the most useful alphabet that you can learn. Italic is so important that an entire part of this book is devoted to the one alphabet. No other alphabet gets that honor.

To give you a chance to master all aspects of Italic, the practice in Part II is broken into a couple gentle steps. First, you practice drawing the simple letter shapes with a regular marker pen. Once you have that part mastered, you begin to use the calligraphy pen to transform those basic shapes into real calligraphy.

So you can continue to improve your skill in doing the Italic alphabet, I give you some pointers for spotting mistakes and correcting them, ideas for creating interesting variations on the Italic letters, how to add fancy embellishments and flourishes, and finally the ways to incorporate Italic into your everyday handwriting style.

Chapter 4

Taking a Few Baby Steps with Italic

In This Chapter

▶ Checking the materials you will need

▶ Looking at what Italic is

▶ Practicing the shapes of the lower case letters

▶ Practicing the whole alphabet

▶ Writing words

*I*talic is a popular, practical, and very pretty alphabet sometimes called Chancery or Chancery Cursive. It originated in Italy during the Italian Renaissance and was a style of writing that was used at all levels of society — from official documents to personal correspondence. Leonardo da Vinci wrote a version of the Italic alphabet.

I am going to take a simple, step-by-step approach in presenting this first alphabet. I encourage you to be diligent about doing the work in this chapter and the next. Please don't skip over anything in these two lessons. Once you've completed these two chapters, if you choose to jump around in the book or skip over things, you'll have a good foundation to build on.

In this chapter I show you how to draw the Italic lowercase letters correctly. In the next chapter, I show you the techniques for using the calligraphy pen to draw those shapes and introduce you to the capital letters for this alphabet. Going over the letter shapes separately from learning the techniques of using the pen makes it easy for most people to become really proficient in doing calligraphy. Once you can do one alphabet well, it is pretty easy to pick up other alphabets. Once you know how to use the pen to do Italic, that skill will carry over to the other alphabets as well.

Practicing the shapes of the letters first without using a calligraphy pen and then doing the same letters later with a pen is the way that I was taught when I started out, and I'm convinced that it's the best way to go. It helps avoid the frustration of trying to draw the letters correctly and at the same time struggling to control the pen. Breaking it down into two separate steps makes it easier.

You won't be using a calligraphy pen in this chapter. To practice the shapes of the letters in this chapter, all you'll need is a pen that has a fairly broad tip. Any pen that is between 1.0 and 2.0mm is perfect. A Sanford Uni-Ball Gel Impact Roller Ball Pen with a 1.0mm point is one of my favorites. Also the fiber-tip (Flair type) pen made by Paper Mate writes bold and is a good choice. Even if your pen is not as wide as my examples, that will not be a problem. I like to think of the examples as paths where the idea is to stay inside the edges, not something you're supposed to color in. The one thing you want to avoid is a pen that makes a line that is a whole lot heavier than the examples. Some markers with fine points will work fine, but many markers have tips that are too wide. Standard ballpoint pens are usually too narrow and won't show up very well.

Introducing Italic

I've chosen Italic as the first alphabet in this book for several reasons:

- ✔ **Italic is by far the most popular style among modern calligraphers.** It is a beautiful style which is appropriate for almost any occasion. It is an alphabet that has many variations.

- ✔ **Italic is probably the most practical and versatile style that you can know how to do.** You can use it for everything you might want to do, from a simple note or invitation to a formal certificate.

- ✔ **Italic can be written fairly rapidly.**

- ✔ **Italic is a pretty easy alphabet to learn.** It is the one alphabet in this book that most resembles our everyday handwriting. Italic has both a printed (calligraphic) form and a cursive or handwriting form.

Why is it that we call this alphabet Italic? Doesn't *italics* have to do with the slanted letters you get when you click the *italics* button on your word processor? The answer is an interesting bit of historical trivia. First, the name, Italic, comes from the word, Italy, which is the country where the alphabet originated at the time of the Renaissance. During that same era, printers, whose craft was in its infancy, began to look for a typeface that could be used to emphasize words and set them off from the plain vertical letters of text. They adopted the new, very popular Italic alphabet to do the job. So, originally, the Italic alphabet and italicized letters printed in books were one in the same thing. Over time, that changed, but the name stuck. Today, when words are italicized, it generally means that they are just a slanted form of a vertical font. However, the original *italics* were actually Italic letters. Italics doesn't mean slanted; in fact, it refers to this alphabet.

To get a better idea of what I'm talking about, check out a sampling of the Italic alphabet yourself — just take a look at Figure 4-1.

Figure 4-1:
A sentence using the Italic alphabet.

We are happy to announce the arrival of
Mikhail Ernest Adams born 11-18-05

It's All in the Family — Six Simple and Easy Letter Families

To make things simple, I think of the 26 lowercase letters as being grouped into six letter families. I grouped the letters in these families according to the similarities in their shapes and the strokes that make them. Instead of practicing the letters in alphabetical order, it makes more sense to practice them in these six groups.

Almost all of these letters are made in one stroke without lifting the pen from the paper. A few require two strokes.

Getting the right proportion with the Italic lowercase letters is of primary importance. The most common mistake that people make with this alphabet is to make the letters the wrong proportion — either too tall or too fat. These letters are supposed to fit

inside a parallelogram that leans slightly to the right and is about two-thirds as wide as it is tall. When you're drawing the letters, visualize the shape in Figure 4-2.

Figure 4-2:
Visualize this parallelogram when drawing the lowercase Italic letters.

The pull-down letters (the l shape)

The first letter family is the simplest. The letters in this family are all made with a simple, pull-down stroke as their main element. There are five letters in this family. They are *i, l, j, f,* and *t.*

Before you do the actual letters take a look at the pull-down stroke (see Figure 4-3). Notice the slant and how the stroke begins on the top of the line and then ends on the bottom line.

Figure 4-3:
The pull-down shape.

Now trace over the lines that are drawn in gray in the practice below. After each stroke that you trace, copy it in the space provided. Begin each stroke on the top line and end on the bottom line. Focus on getting the slant just right.

Do not be concerned if it seems awkward at first trying to do these letters. The awkward feeling is only because making the letters this way is new to you. Just relax and go slowly. With practice, doing these letters will become easier and easier.

Now take a look at the letters that based on the pull-down stroke. First, study the examples that are drawn in black. Then alternate tracing and copying. Trace over each of the letters that are drawn in gray and then copy in the spaces between the ones you traced.

Please take note of a couple of things:

- Pay very close attention to way the letters sometimes begin and end with little tails called serifs.
- The *i* and the *j* have dots which actually look like little dashes.
- The *f* and *t* have a horizontal crossbar.
- The *t* is a short letter and its cross-bar begins at the point where the serif begins at the top of the first stroke.

TIP

Go slowly and try to keep your pull-down strokes perfectly straight. Don't let them get curvy. Also, remember to keep their slant uniform.

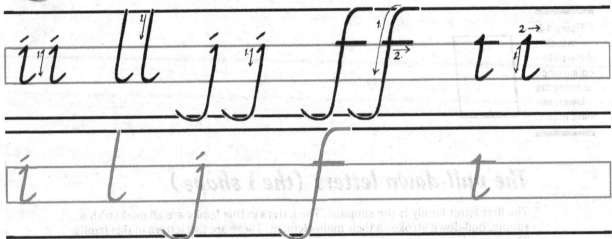

Pull-down, bounce-over letters (the **n** shape)

The second family is made up of what I call the pull-down, bounce-over letters.

The seven letters in this family are *n*, *m*, *r*, *h*, *b*, *k*, and *p*. All these letters have a stroke that begins with the pull-down stroke which continues with a bounce-over, upward swing to the right. Check out the stroke in Figure 4-4.

Figure 4-4:
The pull-down, bounce-over shape.

Before you make the actual letters, practice the pull-down, bounce-over stroke a few times. Notice how the bounce-over part of the stroke branches off from the pull-down part about halfway up. Try to make all the branching off happen at the halfway point. Trace and copy in the space below.

Now practice the letters themselves. As you practice, be careful that you make the letter *p*, in two strokes. If you make the entire letter in one stroke, the result will be that the long, staff part of the letter will turn out looking thicker and darker than the rest of the letter. That will not look good. So, make the p in two strokes.

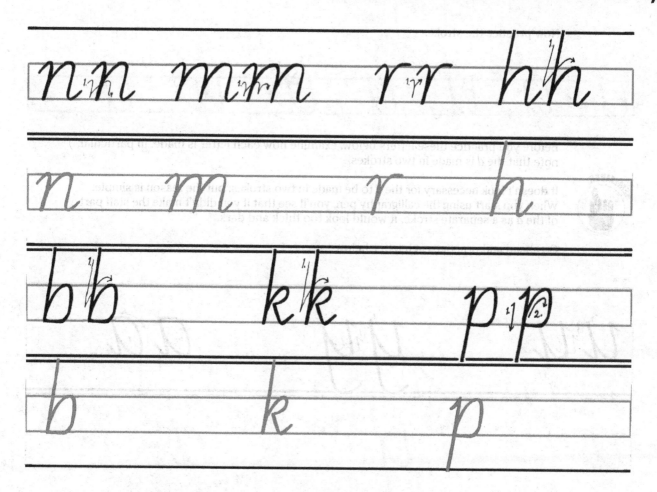

Pull-down, swing-under, pull-down letters (the u shape)

This family is very similar to the previous family. These letters begin with a vertical stroke but instead of bouncing up and over, the stroke continues in a curve upward and to the right (see Figure 4-5). The letters that have this kind of stroke are the *u, y, a, g, q,* and *d.*

Figure 4-5:
The pull-down, swing-under, pull-down shape.

Now practice the stroke.

Before you practice these letters below, examine how each letter is made. In particular, note that the *d* is made in two strokes.

It doesn't look necessary for the *d* to be made in two strokes, but the reason is simple: When you start using the calligraphy pen, you'll see that if you didn't make the staff part of the *d* as a separate stroke, it would look too thick and dark.

Go ahead and practice each letter below.

Oval letters (the o shape)

Only three letters belong in this family — *o, c,* and *e*. As you can see from Figure 4-6, the stroke you need to use to make letters oval letters is, well oval.

Figure 4-6:
The oval
shape.

You may be tempted to use a circle while practicing drawing the oval shape, but keep the emphasis on oval and trace and copy the stroke below.

Before you practice the letters in the space below, look at the examples drawn in black. Then trace over each letter drawn in gray. Copy the letter in the space provided next to each letter.

Please notice that the *e* is made in two strokes. This is not entirely necessary, but it does make it easier to draw the correct shape. For that reason, most calligraphers prefer to make the e in two strokes.

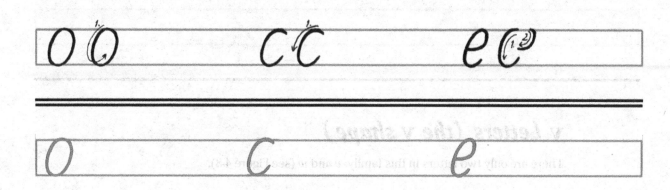

x letters (the x shape)

Only three letters belong in this family as well: *x*, *s*, and *z*. These letters have diagonals that make the shapes (see Figure 4-7).

Figure 4-7:
Drawing the
x-shape.

Practice the *x* shape first. To get the proportions right, keep in mind that it should fit inside a slanting parallelogram. If you drew the slanting parallelogram (see Figure 4-2) and then connected the corners diagonally, you would have the *x* shown in Figure 4-7.

Practice the *x*-shape family letters. Remember that these letters have straight diagonals — even the *s*. Most people are not accustomed to making the s with a straight diagonal across the middle, but that's how the Italic *s* is made. Practicing will help you get the feel for it.

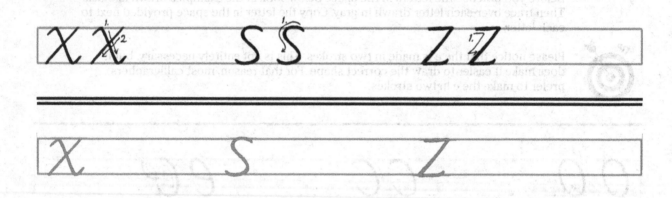

v *Letters (the v shape)*

There are only two letters in this family: *v* and *w* (see Figure 4-8).

Figure 4-8:
The *v* shape.

The trick to getting these letters right is making sure that the sides of the *v* are straight and not curved. Practice the *v* shape below.

Practice the two letters.

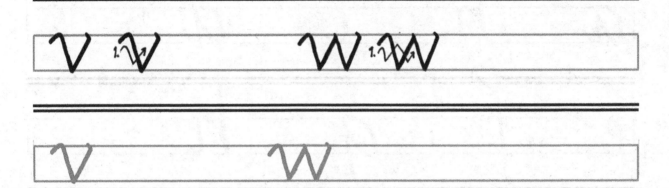

Putting Together What You Know to Make Letters and Words

In the appendix, I give you more opportunities to practice these lowercase letters, but you can give it a whirl right now by tracing the gray letters below and copying the letter into the spaces next to the letters.

a b c d

e f g h

i j k l

m n o

p q r s

t u w

v x y z

Now you need to practice how to space letters when making a word. I set up the next practice exercise so you can trace a word and then copy it right next to the one you traced. Look at how the letters are spaced inside the word. They are really close together — be sure to duplicate the spacing. Although I provide only a couple of words below, you get a chance to practice more words in the appendix.

able hello

You not only need to know how to space letters within a word, but you also need to practice how to space the words themselves. I created the next practice exercise so you can trace the words on one line and then copy them on the following line. This way, you can see how the words are spaced apart — there's just enough space to fit a letter o. Most people are not accustomed to spacing things this closely, but that's all part of doing Italic.

If you find that you are having trouble fitting everything on the line, don't despair — this is a common problem. Just work on tightening things up so the letters and words are closer together.

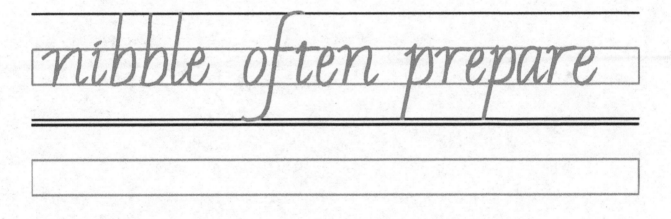

nibble often prepare

Chapter 5

Doing Italic with a Calligraphy Pen

In This Chapter

▶ Understanding how to hold the calligraphy pen

▶ Using your pen to practice the lowercase letters pen

▶ Trying your hand at doing the Italic capital letters

▶ Writing words and numbers

Guess what? You're going to be doing real calligraphy! In this chapter, I show you how to use a calligraphy fountain pen to make the Italic alphabet (if you haven't done any calligraphy before, you need to visit Chapter 4 to practice some letter shapes before you use a calligraphy pen). For this chapter you'll need a fountain pen (see supply list in chapter 3) with a 2B nib (1½ mm).

Using the calligraphy pen correctly is not difficult, but understanding the correct way to use the pen is an essential part of learning to do calligraphy really well. It requires that you follow some special techniques that are mostly the same for all alphabets. The pen technique for Italic is probably the simplest and easiest way to learn these techniques. Learn how to use the pen correctly for this alphabet, and you'll be set to take on more challenging alphabets (see Chapters 8 through 13 to try some more challenging alphabets).

Before you begin using the fountain pen in this chapter, however, you must know the shapes of the Italic letters and the strokes to make them (see Chapter 4). Calligraphy is like math: You build on what you know, and because the Italic alphabet is easy to learn as well as versatile, it makes an excellent foundation to put in place before you take the next step of learning to use the fountain pen to make letters.

Later I will explain when and how to use a dip pen. After you get a few alphabets under your belt, you'll probably want to try the dip pen (see Chapter 3), the most effective tool a calligrapher can use.

In this chapter, you can find information on proper pen angle and how to hold the calligraphy pen so you can practice the lowercase as well as uppercase letters of the Italic alphabet, using the exercises I provide throughout the chapter. Then you can put together everything you know to practice words and numbers. This chapter is your first chance at doing some real calligraphy . . . well, what are you waiting for? Get started!

What Is Pen Angle for Italic and How Do You Get It Right?

Two important elements for doing calligraphy accurately is holding your pen at the correct angle and getting the right height for your letters. I explain how to do both in the sections that follow — don't worry, you get to use your calligraphy pen to practice.

Getting your angle right

You have to hold your pen in the best position — the right pen angle — so that the thicks and thins that the pen makes appear in the correct places when you are making the letters. You can achieve the right pen angle for Italic pretty easily because you hold your pen in just one position for all the letters. The pen angle is always the same: 45 degrees, and 45 degrees is fairly natural for most people.

To do Italic, the pen is not twisted and turned this way and that. It is held in one constant position as the hand and arm move it on the paper.

You may be wondering how pen angle might differ, depending on which hand you use. Figure 5-1 shows what the correct pen angle looks like for a right-hander. The pen does not point directly back toward you, and it doesn't point out to the side. I try to imagine that the back of the pen is pointing just past my right shoulder.

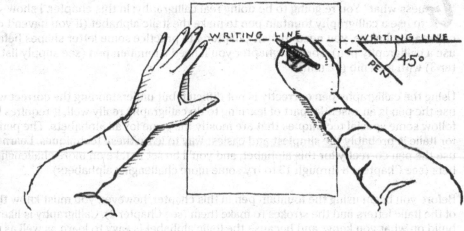

Figure 5-1:
The correct pen and hand position if you are right-handed.

If you're a lefty, you should read more about lefties in Chapter 2.

Practicing the pen angle

The correct pen angle for Italic will enable you to make a zigzag design where the thicks and thins alternate (see Figure 5-2). This pen angle is the pen angle that you should use for Italic. Study Figure 5-2.

Figure 5-2:
Zigzag design.

Now trace the zigzag below and copy it by connecting the dots in the space provided.

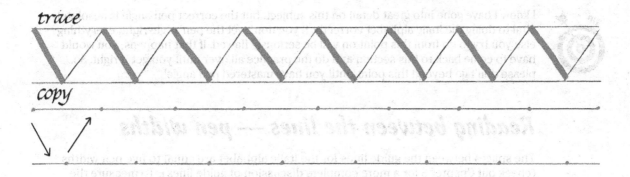

trace

copy

Perfecting the pen angle

The zigzag design gave you a feel for the Italic pen angle, but these next practice exercises will help you perfect it.

Hold your pen in the same position that enabled you to make the zigzag, and you should be able to make plus signs. The horizontal and the vertical strokes should be equal in thickness. And if you hold the pen correctly, the beginnings and endings of these strokes should be slanted at exactly 45 degrees. (See Figure 5-3.)

Figure 5-3:
The plus
sign.

Trace over the plus signs that are drawn in gray and after each one copy in the blank spaces that follow the ones you traced. Make sure you hold the pen at the right angle to get those 45-degree slants. Practice until you get the slants correct.

Trying the six basic shapes

When you feel confident that you have the pen angle under control (if you're not confident, check out the sections "Practicing the pen angle" and "Perfecting the pen angle" before you jump in here), try your hand at the basic shapes for the Italic letters. First, look at the examples that are drawn in black. Then trace over the gray shapes and copy in the blank spaces.

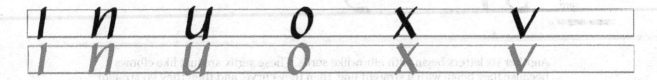

I know I have gone into great detail on this subject, but the correct pen angle is absolutely vital to doing the Italic alphabet correctly. If you don't get the pen angle right, everything else you try to do from this point on will be seriously flawed. If that happens, you would have to come back to this section and do the practice all over until you get it right. So, please don't go beyond this point until you have mastered pen angle!

Reading between the lines — pen widths

The spaces between the guide lines for the Italic alphabet are equal to five pen widths (check out Chapter 3 for a more complete discussion of guide lines). To measure the precise distance between the lines, turn the pen sideways and make five little marks, one on top of the other like a stack of little bricks (see Figure 5-4).

Figure 5-4:
The distance between the lines for this style is five pen widths.

Don't write letters *inside* the guide lines. Look carefully at the tops of the a and g in the example, and you will see that they are actually written just slightly *on top of* the lines. So, the rule is this: don't write inside the guide lines but on top of the guide lines. Ideally, your strokes should cover the lines but not really go too far over the lines. (I confess — I have a tendency to go past the lines!)

Those Tails Called "Serifs" — Don't Get Caught by the Tails!

The "tails" that you make at the beginnings and endings of some of the letters are called serifs. Notice that there are three kinds of serifs on these letters. It's really important that you use the correct serifs with each letter.

Six of the letters have serifs that are pointed (see Figure 5-5).

Figure 5-5:
Six letters begin with a sharply pointed serif.

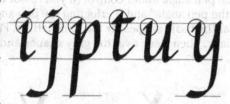

Another six letters begin with elbowlike serifs. These serifs are just like elbows because they begin with a straight line, then they curve, and then they go straight again (see Figure 5-6).

Figure 5-6:
Six other letters begin with elbow-like serifs.

mnrvwx

The serifs that are at the ends of many of the letters all have elbow curves (see Figure 5-7).

Figure 5-7:
All the serifs that are at the ends of letters are elbow curves.

adhiklmntux

Some the letters have just one serif, some have two, and some have none. Do you know how many letters have no serifs? (Answer: nine — *b*, *c*, *e*, *f*, *g*, *o*, *q*, *s*, and *z*.)

Round serifs are really inappropriate for Italic (see Figure 5-8). Round serifs will mess up the beautiful rhythm and flow of the Italic letters. Stay away from round serifs!

Figure 5-8:
Round serifs are all wrong for Italic! They might be attractive for other styles but not this one.

wrong

I don't know a memory trick for remembering which serifs go with which letters. My advice is to simply practice them until you know them.

Doing Lowercase Italic with the Pen

Look at the examples that are drawn in black. Holding your pen positioned at a constant 45-degree angle, trace the letters in gray and then copy them in the space next to the traced letter. You can also try your hand at tracing some words and then copying them in the space under the traced words. To get more practice with the lowercase letters that appear here as well as the words, look in the appendix.

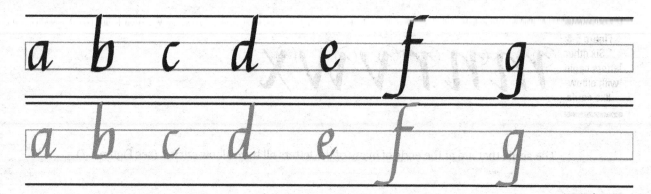

The lines that follow are for practicing using Italic letters in words. Trace the words that appear in gray and then copy them in the spaces underneath.

Italic Capital Letters

Many of the capital letters begin with a shape that I call the "ear." Also many of them have a shape which I call the "foot" (see Figure 5-9).

Figure 5-9: The "ear" and "foot" shapes.

Practice these two shapes by tracing the shapes drawn in gray and copying in the blank spaces. As you practice, compare the shapes that you make to the examples in Figure 5-9. Be especially careful as you practice these shapes to keep the straight parts straight and the thin parts thin.

One of the interesting features of the Italic alphabet is the height of the capitals. They're not as tall as the ascenders. The tops of the capitals are midway between the waist line and the ascender line (for more on guide lines see Chapter 3).

First, study the large example of each letter paying close attention to the little numbers and arrows that show you the sequence and direction of the strokes. Sometimes it helps to trace over the example with your finger. Once you think you understand how to make the letter, trace it and copy it as many times as you can in the space that is provided.

Continue to check your pen angle and don't forget that tops of the capitals are only halfway between the ascender line and the waist line.

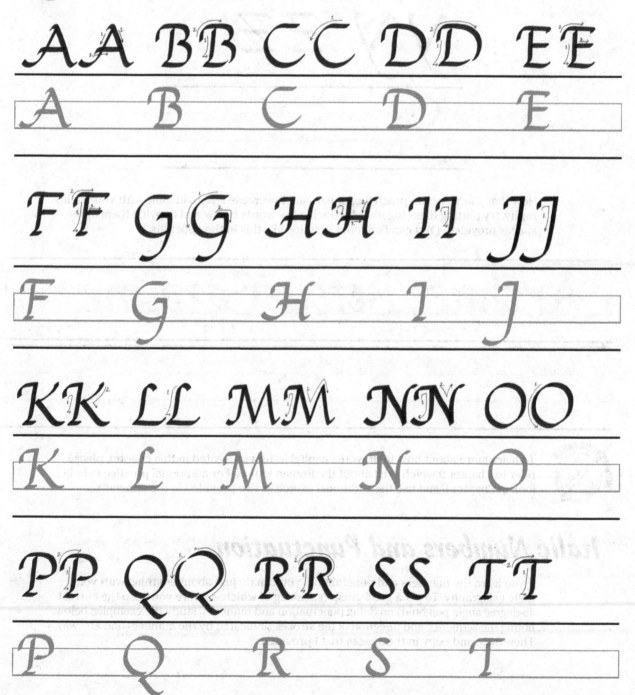

U U V V W W X X

U V W X

Y Y Z Z

Y Z

Now that you've begun practicing upper- and lowercase letters in Italic with your calligraphy, try putting them together by tracing the words below and copying them in the spaces provided. (You can find more practice like this in the appendix.)

Arthur Betty Caroline

 To learn more about how to draw the capital letters presented in this chapter, please refer to Chapter 9 which is all about the Roman letters. For additional practice in Italic, look in Chapter 6 and use the additional exercises I've provided in the appendix.

Italic Numbers and Punctuation

If you learn the numbers and punctuation, you can do just about anything with your Italic calligraphy. To get a good grasp (speaking of which, be sure you keep the correct 45-degree angle pen hold) on doing punctuation and numbers, study the examples below, noting the sequence and direction of the strokes (indicated by the numbers and arrows). Then trace and copy in the spaces that I provided.

0123456789.,:;e-("?!$¢)"

0123456789.,:;e-("?!$¢)"

Chapter 6
Perfecting the Italic Alphabet

• •

In This Chapter

▶ Checking the materials you will need and what you need to know

▶ Looking at ways to improve your calligraphy

▶ Checking the common errors that people make

▶ Learning how to join the letters for Italic handwriting

▶ Simplifying the capital letters

▶ Using calligraphy for writing letters and addressing envelopes

• •

*I*t almost goes without saying that the more you practice, the more your calligraphic skills will improve. That's pretty much a given. However, it's not really how much or how often you practice that is the key factor here; it is the effectiveness of your practice that is the key to seeing real results.

In this chapter I want to give you some tips for ways to improve your skills. I'll show you some special things to look for to help make your practice really effective and also explain how to avoid many of the most common errors. If you use the things I suggest, I am certain that you will see your skills improve rapidly.

You'll need a Manuscript calligraphy fountain pen and the medium nib for the practice exercises in this chapter.

You should already know how to do the Italic alphabet with a fountain pen before you go through this chapter. If you haven't learned how to do this alphabet yet, please go back and do the practice in Chapters 4 and 5.

Checking Yourself with the 5-S Formula

I think that one of the best ways to check your progress is to use a formula that I read about several years ago in an old handwriting book. The formula is broken down into five words, each beginning with the letter *s*. As you review your work against each part of this formula, you should be able to zero in on where you need more practice. After you discover what areas you need to work on, redo some of the practice exercises you've worked on, focusing on the tips in this section to correct your form.

Although I apply this formula specifically to Italic in this chapter, you should be able to apply the fundamental principles of examining your stroke, shapes, slant, size, and spacing to all alphabets I cover in this book. This formula gives you the opportunity to compare your work not only against samples I provide but against specific guidelines as well.

Strokes

The most important thing to look at when you're evaluating how well you are doing is the kind of stroke you are using. By stroke I mean how you move the pen as you are drawing the letters. Your stroke should be smooth and not shaky. Smooth strokes show confidence and strength while shaky strokes will look weak and uncertain, as if the person who made them does not really know what she is doing (see Figure 6-1). Strive to develop a smooth and confident stroke.

Figure 6-1:
Shaky stroke (left); better stroke (right).

weak stroke better

The stroke should also be made using the correct pen angle. An incorrect pen angle can spoil the entire appearance of your calligraphy. If the pen angle is too "flat" the letters will have down strokes that look too wide. If the pen is held at too steep an angle, the letters will have skinny down strokes and be too wide where the letters have horizontals (see Figure 6-2 for examples of incorrect pen angles). I tell you what pen angle to use for each alphabet discussed in this book.

Figure 6-2:
"Steep" pen angle (left); "flat" pen angle (right).

bad pen angle bad pen angle
good pen angle

Stroke is so important that even if you do everything else perfectly but your stroke is poorly done, your calligraphy will never look right. On the other hand if your stroke is strong and smooth and your pen angle is correct, the other things about your letters may not be what they should be, and your calligraphy can still look really good.

When you practice, think about your stroke. Strive to make the strokes smooth and confident and to keep your pen angled correctly.

Shapes

Obviously, you should strive to use letters which have the correct shapes for the particular alphabet you are doing. There are several common errors that people make

when it comes to making the correct shapes. As you practice, double-check the shapes of your letters to make sure they are correct (Figure 6-3 gives you an example of what incorrect and correct shapes look like).

Figure 6-3:
Incorrect
shapes
(left);
correct
shapes
(right).

awkward accurate

Slant

The slant of the letters should be uniform. Ideally, the slant should be from 3 to 6 degrees from the vertical. You can visualize this by imagining the position of the minute hand on a clock when it is about two minutes after the hour (see Figure 6-4).

Figure 6-4:
A visual
for the per-
fect slant.

Fortunately, Italic is very forgiving when it comes to how much slant you can get away with. I have seen Italic written with no slant at all and also with a slant of 10 to 15 degrees from the vertical. In both situations, if the slant was consistent throughout, it looked okay. The really important thing about slant is consistency. If your slant is the same for every letter, it will look good. Slant is a problem when it is not uniform. (See Figure 6-5.)

Figure 6-5:
Inconsistent
slant (left);
uniform
slant (right).

poor slant uniform

Sizes

The sizes of the letters are also an important element that you should evaluate. Consistency is again an important key here. (See Figure 6-6.)

The way to keep the sizes of the letters consistent is always to use guide lines — either penciled in on the paper or by using a guide sheet underneath (see Chapter 3 for more on guide lines). The guide lines you use should be the correct distance apart for the size pen nib you are using.

Figure 6-6:
Inconsistent
sizes (left);
uniform
sizes (right).

inconsistent consistent

Spacing

How is your spacing? When you look at the distances between letters and words, these spaces should look even. You don't want some letters to look closer together or farther apart than all the other letters. Again, uniformity is absolutely important. (See Figure 6-7.)

For the Italic alphabet, the letters inside words are usually spaced just about as closely together as you can reasonably fit them. Serifs can actually even touch the previous or next letters. The distance between words should be the width of the letter *o*.

Figure 6-7:
Inconsistent
spacing
(left); uni-
form spac-
ing (right).

po or spacing better spacing

The Simplest Way to Practice Italic — Write It!

One real advantage that the Italic alphabet has over almost all other calligraphic alphabets is it can be used for handwriting. What better way to practice the Italic alphabet than to use it for your everyday handwriting! Not only will you be practicing the alphabet, but you'll also be developing a beautiful and highly distinctive handwriting style to boot.

My son, Michael, learned to write in Italic when he was in elementary school. (You can probably guess who his teacher was.) Today Michael is an adult, and his handwriting is truly distinctive. He still receives compliments for how beautifully he writes. Your handwriting can be distinctive, too.

If you carry your fountain pen with you wherever you go, you can use it at every opportunity. You can become a true "calligraphic doodler."

In most of the chapters in this book, I have recommended that you use a 2B nib for lettering. However, for handwriting, the 2B nib is just too large. The practice exercises in this chapter require that you use the medium nib. If you decide to pursue Italic handwriting further, you will probably want to use the fine nib.

Joining Letters Cursively — How It's Done

The key to writing Italic is joining the letters together. Most of the joins are simple and intuitive. The serifs provide the means for making most of the joins.

Use a medium nib for the following practice exercises.

Simple diagonal joins

The easiest joins to make are the diagonal joins from a serif at the end of one letter to a serif at the beginning of another letter. When you make these joins, you will see that the spacing between the letters has to be wider than you would use if you were doing Italic in what Fred Eager aptly called the "calligraphic mode." You can use this kind of join anytime you have one of 12 letters (*a, c, d, h, i, k, l, m, n, u, x,* or *z*) preceding one of 13 letters (*i, j, m, n, p, r, t, u, v, w, x, y,* or *z*). Figure 6-8 shows you what I mean.

Figure 6-8:
Diagonal joins from serif to serif.

ai cu dr hi in kn li

Trace over the letters drawn in gray and then copy in the spaces between.

ai cu dr hi in kn li

Diagonal joins to a, d, e, g, o, and q

If you want to make a join from a serif to a, d, g, o, or q, you must go "up and over" (see Figure 6-9). There's a good possibility that you already make this kind of join in your present handwriting style so this should not be too difficult to understand.

Figure 6-9:
Diagonal joins from serif to "up and over."

ca ad ig ue ho iq na mo

Now use the following exercise to practice this join.

ca ad ig ue ho iq na

Horizontal joins from f, o, r, t, v, and w

These joins are not unique; you've probably seen them before, but perhaps they're a little different from the way that you presently join these letters in your normal

handwriting (see Figure 6-10). It's especially important that the joins from the *f* and the *t* be made from the crossbars on the letters.

Figure 6-10:
Horizontal
joins from
these
letters.

fi ou ru ti vi wi

Practice the horizontal join in the following exercise.

fi ou ru ti vi wi on

Joins from b, p, and s

I call these the "back and out" joins, because you have to come back out after you have completed making the stroke to the left which ends each of these letters (see Figure 6-11). Practice this join without making it into a loop.

Figure 6-11:
Joins from
b, p, and *s.*

bi pi sy ba pa sa

Practice the "back and out" joins in the exercise below.

bi pi sy ba pa sa bo

Joins to ascenders

These joins are done without making loops. Simply swing upward from the join and come straight down back over the same line without making a loop (see Figure 6-12).

In Italic handwriting, you may make the ascenders and descenders shorter than for formal Italic. Using shorter strokes will make it easier to write and help speed up your writing.

Figure 6-12:
Joins to the
ascenders.

al ck ib ah rl oh ph

Practice joining to ascenders in the exercise, but don't use loops.

al ck ib ah rl oh ph

Joins to an s

This is a unique kind of join. It is the only join where the shape of the letter actually is changed to make the join look good. The key here is that the top of the *s* is not drawn (see Figure 6-13).

Figure 6-13:
Joins to
the *s*.

as us os ts is rs ms ps

Practice joining to the *s* in the exercise below. Remember: The top of the s is not drawn.

as us os ms is rs

Joins from an e

Since the *e* is a two-stroke letter, the join is done as it is shown in Figure 6-14. This is probably a join that you have never seen before.

Figure 6-14:
A join
from an *e*.

en eu ea eo el eb et es

Practice joining from an *e* below.

en eu ea eo el eb et

No joins

It is not good to join from descenders such as g, j, q, and y. Making loops would certainly detract from the beautiful appearance of these letters. It also tends to promote sloppiness.

Avoid joining too many letters in a row. It is good to lift your pen after joining three or four letters. Lifting the pen will help you develop a steady rhythm and speed.

Simplifying the capitals

Among the many people who use Italic as their everyday handwriting style, most prefer to use very simple capital letters. Some people prefer that the capitals have no slant. I like to slant the capitals the same as the lower case letters. In any case, the capitals should remain unjoined to the lowercase letters (see Figure 6-15).

Figure 6-15:
Simplified
capital
letters.

ABCDEFGHIJKLM
NOPQRSTUVWXYZ

Refer to Chapter 5 and to the appendix for more practice writing with the capital letters.

Reviewing the Most Common Errors

In the following sections, I show you the most common errors calligraphers face when doing Italic. Each illustration shows you an error, and if you see something familiar — don't worry, I let you know how to correct it.

Droopy a shapes

In Figure 6-16, you can see four letters where the a shape has been made incorrectly. The tops of the "bowl" parts of these letters are too angled and the bottoms are too rounded. To correct this error, you need to make the tops of the a shapes flatter and the bottoms sharper. Refer to Chapter 4 to see the correct shapes. To the right of the four letters, I have included two sketches of girl's profiles to show the error and the correction in a way that you can visualize it. The sad girl is the wrong shape. The happy girl is the correct shape. She even has a book balanced on her head to show you how much poise she has!

Figure 6-16:
Droopy a
shapes.

adgq

Spikey letters

In Figure 6-17 we see letters where the narrow curves have been made too pointed. The letters look sharp and spikey. This error is not as bad as the previous error, but it can still cause problems. For example, the *n* and the *u* look too much alike. To correct this error, avoid such sharp angles when making the letters. Use narrow curves.

Figure 6-17:
Spikey
letters.

ahbpmnudgy

Fat and rounded letters

The letters in Figure 6-18 look too fat and rounded. These letters are too wide for Italic. This is a common mistake which is easy to correct. Just remember that the body of the letters should fit inside a tilted parallelogram as described in Chapter 3.

Figure 6-18:
Fat and
rounded
letters.

hbkpoe

Rounded arches

In the examples in Figure 6-19 the letters are not only too wide but arches of the *m* and *n* are too rounded. These letters which are formed using the "pull-down — bounce-over" shape, should be made so that they are narrower and the "bounce-over" parts of the letters branches off from the "pull-down" parts about half way up. In these examples, the branching off occurs too near the top of the letters. See Chapter 3 for details about the correct shapes.

Figure 6-19:
Rounded
arches.

mn

Crooked pull-down strokes

Figure 6-20 shows three letters where the slant of the pull-down strokes is not uniform. The way to correct this error is to make certain that all the pull-downs are slanted the same amount. If they are all slanted the same amount, they should be parallel.

Figure 6-20:
Crooked
pull-down
strokes.

hnm

Branching too high or too low

In Figure 6-21, the "bounce-over" parts of the shapes branch off either too high or too low. The branching should be halfway. In the example, the first letter in each pair shows branching that is too high. The second letter in each pair shows branching that is too low.

Figure 6-21:
Branching
too high or
too low.

rvhhnnmm

Gaps in letters

Figure 6-22 shows three letters that have open spaces where the letters should have closed shapes. This kind of error can occur in any letter that has a closed shape. The gap could be at the top or at the bottom. The way to correct this error is to make sure that you make every letter complete and don't leave any gaps where strokes should meet.

Figure 6-22:
Gaps in
letters.

oeb

Badly shaped e's

Figure 6-23 shows three examples of how not to make the letter *e*. The biggest problem here has to do with the way the second stroke is made (see Chapter 4 for details on how to make the letter in two strokes). The second stroke should be headed in a horizontal direction when it meets the first stroke in the middle. In the first example, the second stroke meets the first stroke in the middle, but it is slanted too much. In the second example, it is not horizontal and it joins the first stroke too low. The third example has the second stroke joining the first stroke too high.

Figure 6-23:
Badly
shaped *e*'s.

e e e

Badly shaped s's

Figure 6-24 shows three examples of how not to make the letter *s*. In the first example, the middle of the letter is not disgonal; it is curvy. This part of the letter should be drawn as a straight diagonal (see Chapter 3). The other two examples have tops and bottoms that do not appear to be equally proportioned – either the bottom or the top is too big. To make this letter correctly, the tops and bottoms should appear to be equal.

Figure 6-24:
Badly
shaped *s*'s.

s s s

Badly shaped t's

Figure 6-25 shows three examples of *t*'s that are incorrect. The first *t* is too tall and also its crossbar does not begin at the point of the serif at the top of the first stroke. The second example has a croosbar that is too low and too long. The third example has a croosbar that begins at the correct place but is too long. If you are prone to making any of these errors, concentrate on making the letter the correct height and adding the crossbar correctly.

Figure 6-25:
Badly
shaped *t*'s.

t t t

Errors with joins

There are two kinds of common errors illustrated in Figure 6-26. First, you see three joins which are supposed to be diagonals, but they are curved instead. This kind of error severely detracts from the beautiful, rhythmic flow of the Italic letters. The way to avoid this error is simply to make these joins straight diagonals.

The second group of three pairs of letters in this figure shows joins that curve downward below the writing line and create a space underneath the letter. A "back and out" join should not do this. Instead, whenever a letter ends with a stroke to the left, the join should retrace the stroke along the bottom of the letter and then swing up just like the diagonal join to connect to the next letter.

Figure 6-26:
Errors
with joins.

an nd ut bi pu so

Errors in capitals: a through k

In Figure 6-27, you see the following letters: The first *a* is too wide. The second is too narrow and also the sides are not angled equally. The first *b* is too wide. The second *b* has a top part that is too small and a bottom part which is too large. The *c* and the *d* are too narrow. The *e* and the *f* are too wide. The *g* is too narrow. The first *h* is too wide. The second one has sides which are not parallel. The first *k* is too wide. The second *k* has curved "legs" that should be straight.

Figure 6-27:
Errors
in capital
letters *a*
through *k*.

AA BBCDEFGHHKK

Errors in capitals: l through t

Figure 6-28 illustrates the following errors: The *l* is too wide. It should be only half as wide as it is tall. The first *m* has a middle "V" which is too short and does not touch the writing line. It should come down to touch the line. The second *m* is badly proportioned. The two halves should be equal. The first *n* is too wide, and the second is too narrow. The *o* is too narrow. The *o* is a wide letter. The first *p* is too wide and the second is too narrow. The *r* is too wide and the "leg" is curved. It should be straight. The first *t* is too wide, and the second is too narrow.

Figure 6-28:
Errors in
capital
letters *l*
through *t*.

L MM NNOPPRSTT

Errors in capitals: u through z

Figure 6-29 illustrates these errors: The U is too wide. The pairs of *v*'s, *x*'s, *y*'s, and *z*'s illustrate letters that are first, too wide and second, too narrow.

Figure 6-29:
Errors in
capital
letters *u*
through *z*.

UVVXXYYZZ

TIP

For an in-depth look at the proportions of the simple capital letters (which are actually Roman letters) that you use with the Italic alphabet, you may want to check out the first part of Chapter 9 which describes the proportions of the Roman letters. This will give you the exact proportions you should be using.

The Nearly Lost Art of Beautiful Correspondence

In today's world it seems as though the handwritten letter is almost a thing of the past. E-mail and word processors have become the norm. Even when a note or memo is handwritten, it is most often done hastily with a ballpoint pen or marker. When was the last time that you received a handwritten letter or note where the writer used a fountain pen? If you can remember when, you are the rare exception. Is beautiful handwritten correspondence a lost art? I certainly hope not.

Pre-typewriter formats

The handwritten letter does not have to follow the typical typewriter/word processor format. If you simply look back in history at some of the examples of handwritten letters, you will find some exquisite designs (see Figure 6-30).

Figure 6-30: Three designs you can use for letter writing.

The first example in Figure 6-30 shows the first word placed out into the left margin and the remainder of the paragraph is indented. This was a common format used before the days of typewriters.

The second example shows the writing inside a shape. The third example shows spiral writing. In spiral writing, you would begin in the center and write outward. This is challenging to write as well as to read, because the paper has to be turned.

If you try a spiral design, concentrate on making all the down strokes of the letters radiate outward from the center. Figure 6-31 gives you a template for spiral writing. Place your paper on top of this template. If you can see the template through your paper, you can use it as a guide sheet to write in a spiral.

I have two pages of practice exercises for Italic handwriting in the appendix; these exercises help you join letters correctly and space words correctly so your handwriting will look spot on. Use a medium nib for those exercises.

Figure 6-31:
Spiral
writing
template.

Chapter 7

Turning Up the "Wow! Factor" with Variations and Embellishments

In This Chapter

▶ Checking out different kinds of variations

▶ Finishing letters with flourishes

▶ Adding some flavor with designs and doodles

Years ago when I was a student in art school, one of my teachers used to talk about good art having a "Wow! factor." He explained that *Wow! factor* meant that a good work of art would cause viewers to respond with a feeling of "Wow!" when they saw the piece of art. He elaborated that an especially good work of art was the one that would elicit a whole series of "Wows!" as the viewer continued to observe it.

I believe the same thing can be said about calligraphy. Good calligraphy certainly has "Wow! factor." Good calligraphy has the power to amaze, enthrall, and inspire us. And that's a "wow!"

In this chapter I want to show you some of the ways that you can increase the "Wow! factor" in your own calligraphy. In this chapter, I make suggestions about things you can do to spice up the Italic alphabet, but many of these examples apply to other alphabets I introduce you to in this book as well.

 You at least need to know how to do the Italic alphabet before you can try any of the extras in this chapter (see Chapters 4 through 6 for more on perfecting the Italic alphabet). The nib that is used for the practice exercises in this chapter is the 2B nib. Any nib that is 1½mm in width will work.

Using Variations to Change the Look of Letters

You can use two kinds of variations. The first variation I show you, in the first couple of sections below, affects the appearance of all the letters in the alphabet: I show you how to make all the letters look thick and heavy or light and thin. The second variation involves making changes in the shapes of some of the letters but not all of them: I show you how you can make rounded shapes look angular, angular shapes look rounded, and I also give you some alternative shapes to try.

Heavy and bold letters

One of the simplest and easiest ways to change the appearance of the entire alphabet is to use guide lines that are spaced either farther or closer together than the standard spacing. For instance, if you use guide lines that are only 3 pen widths apart, you produce a version

of Italic which is dark, heavy and bold (see Figure 7-1). The contrast between thicks and thins will be heightened.

Figure 7-1:
Heavy and bold letters using guide lines that are 3 pen widths apart.

Heavy and Bold can be dramatic. A quick brown fox jumps over a lazy dog. Pack my box with five dozen liquor jugs.

Try your hand at drawing these letters. Using a 2B nib, trace the gray words and then copy them in the guide lines below the words you traced. You can find more sentences in the appendix that you can trace and copy to perfect this technique.

Heavy and Bold can be dramatic.

Light and thin letters

In contrast to making the letters look heavy and bold (see the section "Heavy and bold letters" above), if you use guide lines that are 7 to 8 pen widths apart you produce a very light and thin version of Italic where the difference between the thicks and thins will be almost imperceptible (see Figure 7-2).

Figure 7-2:
Light and thin letters using guide lines that are 7 to 8 pen widths apart.

Light and thin is delicate. A quick brown fox jumps over the lazy dog.

Try your hand at drawing these letters. Use a 2B nib for these exercises as well. You can trace and copy the sentence below.

Light and thin is delicate.

Angular shapes

You can vary the look of the alphabet by changing the basic shapes. One change is to make the rounded parts of the letters more angular (see Figure 7-3). This version has sometimes been called Batarde and is very popular. Study the alphabet example, and then try your hand at reproducing the letters on your own paper. Your letters don't have to look exactly like these. Since there are no hard and fast rules, feel free to use your imagination. Remember, though, the letters need to be consistent in size, shape, and slant. This variation is one of my personal favorites.

Angular Italic
Try this variation for a different look.

Figure 7-3:
An angular
version of
the Italic
letters.

Using a 2B nib, try doing some angular shapes by tracing and copying the phrase below.

Angular Italic variation

Rounded shapes

This is the opposite of the previous variation (see "Angular shapes" above). In this case, you make the angular parts of the letters more rounded (see Figure 7-4). Everything is the same as regular Italic except you make the angular parts of the lower case letters more rounded. Study the example that I have provided and see if you can produce a similar version on your own. Since this is not standard Italic, you don't have to follow any rules. This produces a more contemporary and more informal version of Italic.

A rounded variation.
Pack my box with five
dozen liquor jugs.

Figure 7-4:
A rounded
variation
of the Italic
letters.

If you like the rounded variation, use a 2B nib and try your hand at drawing the letters below. Trace the gray letters and then copy them in the line beneath.

A rounded variation.

Seven alternate letters

The seven letters that are shown in Figure 7-5 (*b, d, g, q, v, w,* and *y*) are not really variations; they are simply alternate ways to make the letters. I have included them here, because I think they go along with the variations. These alternate letters are widely used and accepted. In fact, some calligraphy books teach one or more of these as part of the basic Italic alphabet. You can use these letters instead of the letters that are shown in Chapters 4 and 5 or you may use them in combination with the basic letters in those other chapters. Using them in combination with the other letters can some- times create an appealing touch of variety.

Figure 7-5:
The seven
alternate
letters.

In the practice exercise below, you get a chance to practice each of the letters. Simply study each letter and its stroke sequence (shown in black) and then trace the gray letter and copy it freehand in the space provided. While you practice, keep these things in mind:

- Keep the ascender part of this *b* nice and straight so it doesn't look like the number 6. You can use this alternate letter any place where you would use the standard form of the letter.

- You can use this *d* at the end of words, but don't use it where it would follow an ascender letter. For example, you could use it at the end of *good*, but you shouldn't use it at the end of the word, *gold*.

- This *g* isn't really easy to do, but with a little practice you can add a really distinc- tive letter to your Italic repertoire.

- The tail on this *q* can be made longer if you like.

- For many people, the alternate *v* and *w* are easier to do than the standard letters. If you are having difficulty making the standard letters look good, you can use these instead.

- This version of the *y* is used almost as often as the *y* that is shown in Chapters 4 and 5.

Avoiding errors

When you depart from the standard forms and use variations, it is easy to fall into the trap of making errors in stroke, shape, size, slant, and spacing. (See Chapter 6 for a full explanation of this 5-S formula.) Make sure you use this formula as a guide, no matter what alphabet you are doing.

The most common errors when it comes to variations have to do with ignoring the smoothness of the stroke and the uniformity and rhythm of the shape, size, slant, and spacing of the Italic letters. No matter which variations you use, it's a good idea to always keep the 5-S formula in mind.

Swashes and Flourishes

One of the ways to add real pizzazz to your calligraphy is to add some swashes or flourishes. *Swashes* and *flourishes* are essentially the same thing: They're stylistic embellishments that you add to the letters. They're accents or ornaments. They don't take the place of good lettering skills. Only use such devices to show off the letters.

A word of caution: use any flourishes with restraint — don't overdo them. A few flourishes, just like a little spice, can enhance the appearance or flavor; too many flourishes, like too much spice, can lead to disaster. If you're ever uncertain about whether or not to add a flourish, it's probably better not to flourish.

Adding flourishes to letters

Figure 7-6 shows you some flourishes for most of the lowercase Italic letters. There are many more flourishes than these, but these are the most common ones.

A very popular flourish is an "S-curve" which can be added to many of the letters. The "S-curve" is a stroke or series of strokes that resembles the letter *S*. Most often, the "S-curve" is made horizontally.

Concentrate on making smooth strokes whenever you do flourishes. Nothing can detract from the appearance of a flourish more than a stroke which does not look smooth and fluid.

Look at the examples in Figure 7-6, and use the following suggestions to add flourishes to the lowercase letters.

- ✔ For letters like *a, c, d, h, i,* etc. which end in serifs or have seriflike endings, you can extend the final stroke of the letter horizontally ending in an upward curve. This flourish can be used on these letters only when they happen to be the last letter in a word.

- ✔ Looped "S-curves" can be added to ascenders on the letters *b, d, h, k,* and *l.* These loops can be made as large as you like.

- ✔ Looped "S-curves" can also be added to descenders on the letters *f, g, j, p,* and *y.*

- ✔ You can extend the final stroke on the *e, q,* and *r.*

- ✔ You can add an "S-curve" to the tops of the *c* and *s.* This flourish can be used to connect to the letter *t,* as shown in Figure 7-6

✔ You can extend the final part of the *v* and *w* upward.

✔ You can connect double *l*'s as shown in Figure 7-6.

a b & d d e f g h h i j
k l m n p q r s ſ
t t u v w x y y z st ſt ll

Figure 7-6:
Flourishes
for all the
lowercase
letters.

Flourishes are fun to use, so be sure to get some practice in before you give them a whirl. Trace the gray letters below and then copy them in the blank line underneath the traced letters.

flourished minuscules

The previous pointers for making flourishes apply to the capital letters as well. Just take a look at Figure 7-7 for some examples.

A A B B C C D D E E F F E
G G H I J K L M N O P
Q R R S T T T U V W W
X Y y Z

Figure 7-7:
Flourishes
for all the
capital
letters.

When trying to do flourishes, keep these tips in mind:

- ✔ A capital *a* can be flourished two ways — either on the left or the right side as shown in the examples above.

- ✔ The letters *b, d, e,* and *f* can be flourished in two ways: either with a stroke that curves over the top or wraps around underneath.

- ✔ Many of the capital letters can be flourished with "S-curves."

- ✔ Several of the letters can be flourished by lengthening the ending stroke. Examples are *q, r, u, v, w, x,* and *z.*

- ✔ Some letters such as *c, o, s,* and *t* have unique flourishes. Refer to the examples above to see the possibilities.

Now you can try flourishes on capitals as well. Trace the flourished letters below and copy them in the blank line that follows. The appendix gives you an extended exercise where you can practice flourishes on all of the capitals.

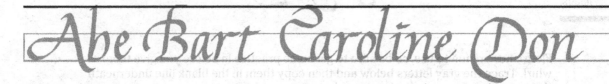

For really large flourishes, lightly sketch the lines with a pencil before you attempt to draw them with the pen. Also pick up the pen at intervals so you don't have to do the entire flourish in one, uninterrupted stroke. For large flourishes this would be quite a feat. The only place where you can successfully pick up the pen is where you're making the thin parts of a stroke. You can put the pen back down and continue the stroke from the thin part. You could never pick up the pen in the middle of making a thick stroke.

A flourished signature

A signature is an ideal place to use flourishes. The flourishes should both enhance the appearance of the letters and also help unify the letters into a cohesive, self-contained design.

Just adding flourishes randomly will definitely not do the job. The flourishes need to be added in a thoughtful and purposeful manner.

The best way to use flourishes successfully is too make lots of preliminary sketches.

Figure 7-8 shows you some examples of signatures where the flourishes do not "work" very well. The flourishes are too random and disjointed.

Figure 7-9 is a better example of a flourished signature. Notice how these flourishes enhance the overall appearance of this signature. The flourishes appear to be balanced and to lead the eye from one part of the signature to the next. They appear to flow evenly from the first letter to the last. This produces a design that has unity and visual appeal.

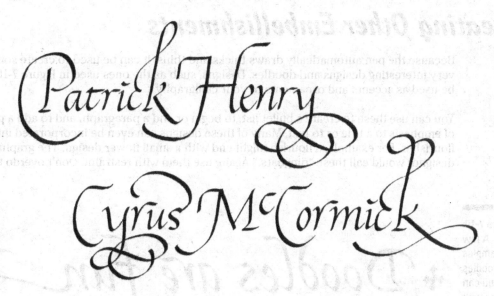

Figure 7-8:
Poor examples of flourished signatures.

Figure 7-9:
A better design of a flourished signature.

Using the empty guidelines below, try you hand at designing your own flourished signature:

1. **Experiment. Try writing your signature several different ways.**

2. **Incorporate different kinds of flourishes.**

3. **Select one that looks the best.**

4. **Refine it by making the flourishes even better.**

5. **Draw the design lightly in pencil.**

6. **Go over it in pen.**

7. **Evaluate your results.**

If you don't like your results, repeat the above steps until you come up with a final product that you're happy with.

Creating Other Embellishments

Because the pen automatically draws thicks and thins, it can be used to create some very interesting designs and doodles. Designs, such as the ones used in Figure 7-10, can be used as accents and ornaments to your calligraphy.

You can use these to create a bullet list, to begin or end a paragraph, and to add a point of emphasis to a title or to text. Many of these designs can even be incorporated into flourishes. For example, a flourish might end with a small flower design. The graphic designer would call these "dingbats." Again, use them with restraint. Don't overdo them.

Figure 7-10:
A few examples of doodles you can create with the broad-edge pen.

Now take at shot at practicing some doodles below. Just trace the ones you see in gray, and then copy them in the blank space below.

Part III
Expanding Your Repertoire

The 5th Wave By Rich Tennant

"Leave it to Hancock to steal the show with his formal Manuscript."

In this part . . .

In this part you get to practice five more popular and highly useful alphabets: Blackletter, Roman, Manuscript, Uncial, and Copperplate. I also include a chapter about creating outlined and decorated letters.

Each alphabet has its own "personality." Blackletter is often used for certificates and has an ancient and official look. It is much easier than it looks and is great for perfecting your technique with the pen. Roman is classical, solid, and strong and is appropriate for titles. The Roman letters are the model for all our capital letters. Manuscript, a second cousin to Italic, is easy to read and easy to do. Uncial is artistic and expressive. It can be serious or fun. Copperplate is the fanciest of all and is often used for such things as wedding invitations.

These alphabets not only expand your skills but also "round out" your knowledge of basic calligraphic styles and techniques. This knowledge gives you a solid foundation on which you can continue to expand your skills.

Chapter 8
The Blackletter Alphabet

The name, Blackletter, comes from this alphabet's dense, black appearance, especially when you see a whole page covered with these letters. Blackletter has also been called Gothic, because it originated in the Gothic or Medieval era (around the 12th century) when monks and scribes used this alphabet for copying church documents.

Today, Blackletter is used primarily in headings on certificates and diplomas. Many newspapers, such as the *New York Times,* use variations of this alphabet in their titles. Blackletter looks really official. You may be familiar with one version of this style called "Old English."

In this chapter, I cover the step-by-step basics of how to write the Blackletter style of calligraphy, both the upper- and lowercase letters. I not only show you the basic strokes, but I also show you how to string the letters together to make words. In this chapter as well as the Appendix, I provide ample practice at writing the letters and putting words together. Soon, you'll find yourself creating your own official-looking Harvard diploma — hang it on the wall an impress your friends (with your calligraphy prowess, of course!).

Getting to Know the Blackletter Alphabet

For most students, the surprising thing about this difficult-looking style is how remarkably easy it is to learn. It's actually an easy and fun alphabet, because the lower case letters are all formed from just seven basic strokes, and of those seven strokes, four are used in only a few of the letters. So, that leaves just three basic strokes that are used in different combinations to form the majority of the letters.

Blackletter has great visual appeal. It looks wealthy and official. However, it cannot be lettered as quickly as some other alphabets such as Italic. It is also not always especially easy to read, and that can be a problem. So, you probably wouldn't want to use Blackletter for something where legibility is vital, such as an advertisement or a sign. Figure 8-1 can give you an idea of what the lowercase Blackletter alphabet looks like.

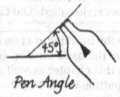

Figure 8-1:
The
lowercase
Blackletter
alphabet.

Getting the "Write" Dimensions

To get started with Blackletter, as with all calligraphy alphabets, you have to be sure you're writing with the correct pen at the correct angle and height. To be sure you've got it right, just follow these guidelines:

✔ **Calligraphy pen:** You can use either a Manuscript fountain calligraphy pen with a wide nib — 2B — or you can use another brand of pen (either fountain or dip pen) with a 1½mm nib.

✔ **Pen angle:** Use a constant 45-degree angle (see Figure 8-2).

✔ **Height:** The height of the body of these letters is 4 pen widths; the ascenders and descenders are each just 2 pen widths in height (see Figure 8-3).

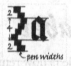

Figure 8-2:
The correct
angle for
writing
Blackletter.

Pen Angle

Figure 8-3:
The correct
height for
writing
Blackletter.

pen widths

TIP

If you are using one of the pens that was recommended for this lesson, your nib will be calibrated correctly for doing these practice exercises.

Boning up on the Basic Strokes of Blackletter

The lower case letters are made from just seven basic strokes, and actually only three of those strokes are primary basic strokes, the main ones that are used in almost all the letters. The remaining four strokes are known as secondary basic strokes and are only used in a few instances.

Drawing the three primary basic strokes

Figure 8-4 shows you what the three primary basic strokes for the lowercase Blackletter alphabet look like. One or more of these basic strokes is used in making every letter in the alphabet. For that reason, it is important to be able to do them without making any mistakes. This is doubly important since every one of the letters in the Blackletter alphabet is formed by combining basic strokes in various combinations. If you can do the basic strokes correctly, you can do all the letters correctly.

- ✔ The diamond
- ✔ The vertical
- ✔ The thin diagonal

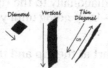

Figure 8-4: The three primary strokes.

Before writing any actual letters, use the practice exercise that follows to get a feel for making the three strokes that make up most of the lowercase letters in this alphabet. Just follow these tips:

- ✔ **The diamond:** To make the diamond shape, you start at the upper left and move the pen down diagonally to the right at a 45-degree angle.

- ✔ **The vertical:** To make the vertical, place the pen at the top of the stroke and move it straight down.

- ✔ **The thin diagonal:** You can make the thin diagonal two different ways:
 - Slide the pen upward and to the right at a 45-degree angle.
 - Slide the pen downward and to the left at a 45-degree angle.

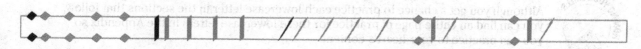

When you want to keep a stroke straight and even, it helps to take a breath and then exhale slowly as you make the stroke.

Moving on to the four secondary basic strokes

Although you'll use them less often, Figure 8-5 shows you the four secondary basic strokes. You use these basic strokes to make just a few of the letters. Even though these strokes are not used very often, it is still important to be able to do them correctly, because they are critical in the places where they are used. It still holds true — if you can do the basic strokes correctly, you can do all the letters correctly.

- ✔ The horizontal
- ✔ The thick diagonal
- ✔ The two curved strokes

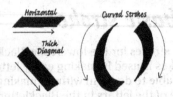

Figure 8-5:
The four
secondary
strokes.

Now get a feel for the four secondary strokes, using the practice exercise that follows. The following list describes how to make each stroke:

- **The horizontal:** To make the horizontal, begin at the left side and move the pen straight across to the right.

- **The thick diagonal:** To make the thick diagonal, you begin just like you did to make a diamond (see "Drawing the three primary basic strokes," earlier in this chapter). Start at the upper left and move the pen down diagonally to the right at a 45-degree angle, but don't stop with a small diamond — keep going until you have drawn a thick diagonal.

- **The two curved strokes:** To make the curved strokes, start at the top and then make a half circle left and right.

Combining the Basic Strokes

The challenge is to combine these seven simple, basic strokes to form all the letters in the Blackletter alphabet. This will test your accuracy with the pen, especially in keeping the correct pen angle. In fact, one big advantage of learning this alphabet is it will help you perfect your technique with the calligraphy pen. (Refer to Chapter 3 to go over the basics of using a pen.) Perfect your Blackletter skills and you will improve your ability to do all the other alphabets.

Although you get a chance to practice each lowercase letter in the sections that follow, you can find an entire page of practice for these lowercase letters in the Appendix so you can practice to your heart's content.

Instead of going through the lowercase letters in alphabetical order, I show them to you in groups or "families" according to their shapes and strokes. So, letters with similar shapes or strokes are grouped into a family. You can then practice and perfect similar strokes and end up writing an entire group of letters rather than just one.

Letters that have a main vertical stroke: l, i, j, h, t, f, k

The first group to check out is made up of letters with a main vertical stroke. The letters (from simplest to the most complex) are *l, h, i, j, t, f,* and *k.* Figure 8-6 shows you an example of the *l* and how it's drawn.

Figure 8-6:
The letter *l.*

To make the letters that have a main vertical stroke, review how the *l* is drawn (see Figure 8-6) and follow these steps:

1. **Begin at the ascender line and draw a vertical stroke downward almost to the base line.**

2. **Without lifting the pen, add a diamond directly underneath. This diamond should rest right on the writing line.**

Twenty-three out of twenty-six letters in this alphabet have vertical strokes, but the seven letters in this group are the ones where the vertical stroke really stands out as the dominant feature. Knowing how to make the l will get you started, but each letter has its distinctive characteristics, and these must not be glossed over. Look at the examples shown across the top of the trace and copy exercise below to see how to make each of these letters. Most people can look at the examples and see what to do, but if you happen to be one of those people who is more verbal than visual, you can use the following list of how-to descriptions to read about how to do these letters correctly:

✓ **Make an** *h* **in two strokes:**

- **First stroke:** Make an l (long vertical with a diamond at the bottom).

- **Second stroke:** Lift the pen and add a curved stroke to the right side.

✓ **The** *i* **is made in two strokes:**

- **First stroke:** Make a diamond just below the line shown. Then without lifting the pen add a vertical directly underneath. When you reach the bottom of the vertical, add another diamond.

- **Second stroke:** Lift the pen and put a diamond on top to make the "i-dot."

✓ **The** *j* **is made in three strokes:**

- **First stroke:** Make a diamond and follow it with a long vertical.

- **Second stroke:** Draw a horizontal at the bottom.

- **Third stroke:** Place a diamond at the top for the dot.

✓ **Make the** *t* **in two strokes:**

- **First stroke:** Make a vertical that begins above the waist line and ends with a diamond.

- **Second stroke:** Draw a horizontal that touches the waist line of the letter. Make certain that the beginning of this stroke is in line with the slant at the top of the vertical.

✓ **The** *f* **is also made in three strokes:**

- **First stroke:** Make an l (a vertical with a diamond).

- **Second stroke:** Draw a horizontal that follows along the waist line. Third stroke: Draw a short, thick diagonal at the top of the vertical. Make certain that the slant at the beginning of this stroke lines up with the slant of the vertical.

✔ **The *k* is a two stroke letter:**

- **First stroke:** Make a letter l (vertical and diamond).

- **Second stroke:** Lift the pen and make a short horizontal that fits under the waist line. At the end of the horizontal, slide the pen down diagonally to the left to make a thin diagonal. Add a short vertical and a diamond at the bottom.

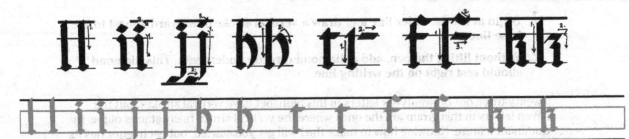

The trick to making the *k* correctly is to fit all the parts together in the right proportions. The common problem is making the second stroke (which has four parts) too big for the rest of the letter. Practice making all the parts of the second stroke the correct size

Letters that have an *o* shape: o, a, b, d, g, q, p

For this second family, you learn how to make each letter that uses an *o* shape: *o, a, b, d, g, q, p*. See Figure 8-7 for an example.

Figure 8-7:
The letter *o*.

First, follow these steps for making the *o* (see Figure 8-7):

1. **Make a vertical that begins right under the waist line and ends before you get to the base line.**

2. **Add a diamond which is almost long enough to be a thick diagonal.**

3. **Lift the pen and make a diamond at the top.** Make certain that the left corner of this diamond touches the upper right corner of the vertical.

4. **End the stroke with a vertical.** Try to place the stroke so that the white space remaining inside the letter is exactly the same width as the verticals you make with the pen. The vertical should end so that the lower left corner touches the right corner of the diamond which you made at the end of the first stroke.

All the other letters in this "letter family" have an *o* included somewhere within them. Knowing how to make the *o* is the beginning to understanding how to make these other letters but is not adequate by itself. You need to know the individual characteristics of

each letter. Look at the examples in the trace and copy exercise below to see how to make each of these letters. You may also refer to the following list of how-to descriptions if the examples are not entirely understandable to you:

✔ **Make the *a* in three strokes:**

- **First stroke:** Make a vertical. Then without lifting your pen, add a diamond to the bottom of it.

- **Second stroke:** Lift the pen and add a diamond near the top of the vertical.

- **Third stroke:** Add a short, thin diagonal to the right side of the top diamond; then, without lifting the pen, add a vertical underneath the top diamond; and finish it with a diamond at the bottom of the second vertical.

✔ **A *b* is made in two strokes:**

- **First stroke:** Make an *l* (long vertical and a diamond).

- **Second stroke:** Make a diamond on the right side of the vertical and follow it with a short vertical that touches corner-to-corner with the diamond at the bottom.

✔ **Make the lowercase *d* in two strokes:**

- **First stroke:** Begin just like the o and a with a short vertical and a diamond.

- **Second stroke:** Beginning at the ascender line, make a long thick diagonal that ends just past the waist line. Follow this with a vertical that touches the diamond at the bottom corner-to-corner.

✔ **The lowercase *g* is made in four strokes.** The first two strokes are exactly like the *a*:

- **First stroke:** Make a vertical with a diamond at the bottom.

- **Second stroke:** Lift the pen and make a diamond at the top.

- **Third stroke:** Make a thin diagonal followed by a vertical just as you did for the a except this time continue the vertical all the way down to the ascender line.

- **Fourth stroke:** Lift the pen and make a horizontal along the descender line that meets the vertical at the bottom.

✔ **The *q* is made in three strokes.** It's almost exactly like the g except the ending is slightly different:

- **First stroke:** Make a vertical and a diamond.

- **Second stroke:** Make a diamond at the top.

- **Third stroke:** Make a thin diagonal followed by a vertical that continues all the way down to the ascender line. End the stroke with a short horizontal that is drawn to the left of the vertical.

✔ **Use 3 strokes to make the *p*.** The first stroke is like the letter, *j*:

- **First stroke:** Make a diamond and a long vertical (just like you did to begin the *j*).

- **Second stroke:** Lift the pen and make a second diamond right next to and touching corner-to-corner the diamond at the top. Continue the stroke with a vertical that ends above the waist line.

- **Third stroke:** Starting just to the left of the long vertical of the first stroke and resting on the base line, make a horizontal that ends at the corner of the short vertical of the second stroke.

Most people run into problems making the *o* shape so the verticals are straight and don't lean, the white space is the correct width, and the top and the bottom where the strokes join are formed correctly. If you have trouble making this letter, don't become discouraged; just keep working, and you'll get it.

Letters that have a u or n shape: u, n, m, w, y, v

The letters *u*, *n*, *m*, *w*, *y*, and *v* are made in two or more strokes. Check out the *u* and *n* shape to get the feel for this group.

Make the *u* by following these steps (see Figure 8-8):

1. **Make a diamond, a vertical and a diamond.** Make this diamond a tiny bit longer so it's almost a short, thick diagonal.

2. **Starting at the top again, make another diamond that is a very short distance away from the first diamond.**

3. **Complete the stroke with a vertical and a diamond that touches the other diamond corner-to-corner at the bottom.**

Figure 8-8: The letter *u*.

Make the *n* by following these steps (see Figure 8-9):

1. **Make a diamond, a vertical and a diamond.**

2. **Starting at the top again, make another diamond that touches the first diamond corner-to-corner.** Make this diamond a tiny bit longer so it's almost a short, thick diagonal.

3. **Complete the stroke with a vertical and a diamond that does not touch the other diamond at the bottom.**

Figure 8-9: The letter *n*.

All the other letters in this "letter family" have either a *u* or an *n* included somewhere within them. If you can make the u and the n, you should be able to do the others in this group. Look at the examples in the trace and copy exercise below to see the strokes you use to make each of these letters. I provide a list of how-to descriptions if the examples are not entirely understandable to you:

✔ **The *m* is made in three strokes.** It is like the n where you simply repeat the second stroke:

- **First stroke:** Make a diamond, a vertical and a diamond.

- **Second stroke:** Starting at the top again, make another diamond that touches the first diamond corner-to-corner. Make this diamond a tiny bit longer so it's almost a short, thick diagonal. Complete the stroke with a vertical and a diamond that does not touch the other diamond at the bottom.

- **Third stroke:** To the right of the second stroke, add another stroke exactly like the second stroke.

✔ **The *w* is made in three strokes.** The first two strokes are exactly like the *u:*

- **First stroke:** Make a diamond, a vertical and a diamond. Make the final diamond a tiny bit longer so it's almost a short, thick diagonal.

- **Second stroke:** Starting at the top again, make another diamond that is a tiny space to the right of the first diamond. Complete the stroke with a vertical and a diamond that touches corner-to-corner the other diamond at the bottom.

- **Third stroke:** Make a curved stroke that begins at the waist line and ends at the corner of the last diamond.

✔ **The *y* is made in two strokes.** The first stroke is like the first stroke of a *u,* and the second stroke is like the first stroke of a *j:*

- **First stroke:** Make a diamond, a vertical and a diamond. Make the final diamond a tiny bit longer so it's almost a short, thick diagonal.

- **Second stroke:** Make a diamond to the right of the first diamond and continue with a long vertical. Make certain that the vertical touches the corner of the bottom diamond as it passes by.

✔ **The *v* is made in two strokes.** The first stroke is like the first stroke of a *u,* and the second stroke is like the last stroke in a *w:*

- **First stroke:** Make the diamond — vertical — diamond stroke.

- **Second stroke:** Make a curved stroke that begins at the waist line and ends at the corner of the last diamond at the bottom.

Put your pen to paper and practice this group in the space provided.

Open-sided letters: c, e, r and the remaining three letters: s, x, and z

There are six letters remaining. Three are the letters that have open sides. The other three do not fit in a group. See Figure 8-10 for an example of each letter.

Figure 8-10:
Open-sided
letters and
s, *x*, and *z*.

Because these letters don't fit into a group, you can look at Figure 8-10 as well as the practice exercise that follows to see how they're made. Now practice all of these letters, keeping in mind the tips that follow:

✔ **The *c* is made in two strokes:**

 • **First stroke:** Make a vertical. Then without lifting your pen, add a diamond to the bottom of it and a thin diagonal to the right.

 • **Second stroke:** Lift the pen and add a diamond near the top of the vertical. This diamond is just a tiny bit longer than a regular diamond.

✔ **Use two strokes to make the *e*.** This letter is a *c* with an additional thin diagonal:

 • **First stroke:** Make a vertical. Then without lifting your pen, add a diamond to the bottom of it and a thin diagonal to the right.

 • **Second stroke:** Lift the pen and add a diamond near the top of the vertical just exactly as you did for the c. End the stroke with a thin diagonal to the left that meets with the vertical.

✔ **The *r* is made in two strokes.**

 • **First stroke:** Make the diamond — vertical — diamond stroke.

 • **Second stroke:** Lift pen and join a short horizontal onto the top diamond.

✔ **The *s* is made in four strokes.**

 • **First stroke:** Make a curved stroke that begins at the waist line and ends halfway to the base line. Add a thin diagonal to the end of this stroke.

 • **Second stroke:** Begin at the thin diagonal and make a curve going the opposite direction. End at the baseline.

 • **Third stroke:** Add a diamond at the bottom.

 • **Fourth stroke:** Add a short horizontal to the top.

✔ **The *x* is made in three strokes.**

 • **First stroke:** Make a curved stroke that starts at the waist line and ends at the base line.

 • **Second stroke:** Make a second curved stroke that goes the opposite direction of the first and overlaps the first stroke in the middle.

 • **Third stroke:** Add a diamond to the top of the second stroke.

✔ **The *z* is made in two strokes.**

- **First stroke:** Begin with a thin diagonal and continue with a horizontal that follows the waist line. Keep your pen on the paper and slide it downward and to the left, making a thin diagonal. Make another horizontal that follows the base line and end with another thin diagonal.

- **Second stroke:** Draw a horizontal through the middle.

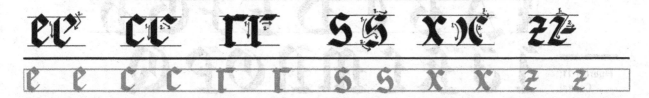

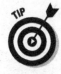

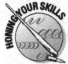

Sometimes it's easier to place the strokes correctly if you begin and end with a small, thin diagonal that will give you a starting and stopping place. For example, if you end the diamond at the bottom of the first stroke with a small, thin diagonal, it will give you a stopping place for your second stroke.

Practice all the lowercase letters. Trace the letters printed in gray and copy in the blank spaces provided. You can find an entire page of practice for these lowercase letters in the Appendix so you can practice to your heart's content.

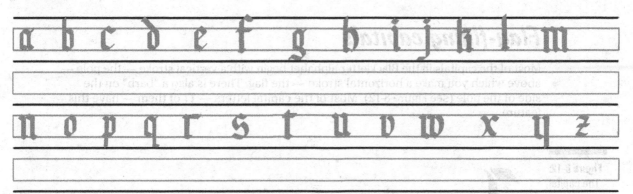

Moving On to Capital Letters

In the days of yore when the medieval scribes were using this alphabet, there were no Blackletter capital letters. To make the capitals, an artist would add large, ornate letters called versals (they only made capitals at the beginning of verses, thus they were called versals). Versals were sketched, outlined in ink, and then ornately decorated with paint and gold leaf. They're quite beautiful. For more information on versals and how to create them, see Chapter 12.

Because there were no actual Blackletter capitals originally, some calligraphy teachers only teach the lowercase letters. However, if you're like most people, you probably want to have a set of capitals, just in case. It's handy to be able to do them when someone asks you to do a certificate.

Figure 8-11 shows you one of many modern adaptations. I've also thrown in the numbers, which also were not part of this alphabet back in the 12th century — another handy element to use if you need to do a certificate or invitation that requires numbers. These capitals are 5-6 pen widths in height. In the sections that follow, I show you how to do each capital by placing them into three groups according to their similarities.

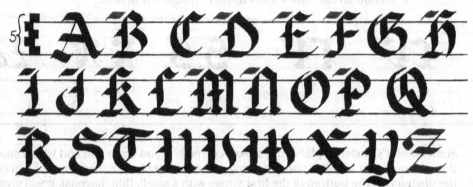

Figure 8-11: Capital letters for the Blackletter alphabet.

I give you a chance to practice each capital letter in the sections that follow, where you can trace the gray letters and copy them in the blanks provided. But you can find more practice exercises for these capitals in the appendix.

Flag-flying capitals

Most of the capitals in the Blackletter alphabet begin with a vertical stroke — the pole — above which you make a horizontal stroke — the flag. There is also a "barb" on the side of the pole (see Figure 8-12). Most of the capital letters — 17 of them — have this feature.

Figure 8-12: The capital *i*, complete with a flag flying on a pole.

Flag ↗
Pole →

You make the basic element of these 17 capital letters — the flag flying from the pole — by:

1. **Drawing a long vertical stroke downward from a point halfway between the ascender line and the waist line to the writing line. This is the "pole."**

2. **Adding a horizontal line at the bottom which is the "foot."**

3. **Adding another horizontal stroke near the top of the vertical, not letting it touch the vertical. This is the "flag."**

4. **Adding a short, curved stroke to the side of the vertical. This is the "barb."**

It is important to make certain these letters don't have any slant. If you have difficulty keeping the letters from slanting, you can lightly pencil in the vertical strokes before you make the letters with a pen.

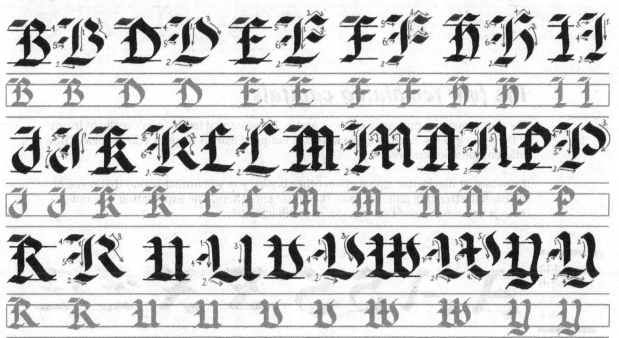

The circular letters

Five letters are in this group — *c, g, o, q,* and *t.* All these capitals have curved strokes. Just check out the first stroke on the capital *c* in Figure 8-13 to see what I mean — all of the circular capital letters share this curved stroke.

Figure 8-13: The curved stroke as shown as a capital *c.*

The curved-stroke capitals are pretty straightforward as you can see in the practice exercise below. However, here are some tips when creating these capital letters:

- ✔ Try to visualize where you want the curved stroke to go before you make it.
- ✔ Make the stroke all in one motion and at an even speed. Smooth and steady is the way to do it.
- ✔ Don't be discouraged if at first the curved stroke seems too difficult. With practice, you'll eventually get it right.

Now's your chance to try the circular capital letters. Trace the gray letters and copy them in the space provided.

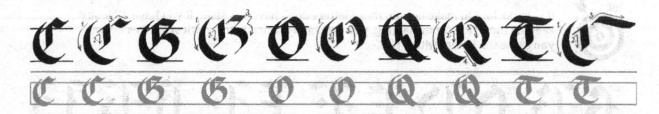

The four remaining capitals

The four remaining capitals are *a*, *s*, *x*, and *z*. These capital letters don't really fit in any of the other groups. Each of these letters is unique. Figure 8-14 gives you an idea of how different these letters are.

If you look at Blackletter alphabets in other books, you will probably find that some of the capital letters are different from the ones I show here. The explanation is simple — there is not one standard set of capitals for Blackletter.

Figure 8-14:
The capitals
a, s, x,
and *z.*

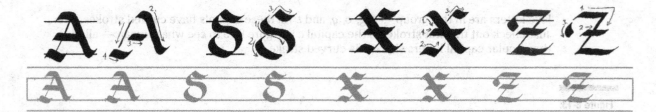

Look at the models. Then alternately trace and copy.

Nudging Forward to Numerals

Although there were originally no Arabic numerals with this alphabet (people were still using Roman numerals when Blackletter was developed), it is helpful to have a set of numbers that you can use when you need them. The set of numbers in Figure 8-15 is my own creation. I believe these numbers go with this alphabet extremely well.

Figure 8-15:
Numerals.

1234567890

Here are some tips for making these numbers:

- ✔ Make the numbers the same height as the capital letters.
- ✔ Keep the strokes angular. Avoid too many round shapes.
- ✔ Follow the sequence and direction of the strokes shown in the examples.

Practice tracing and copying in the space below.

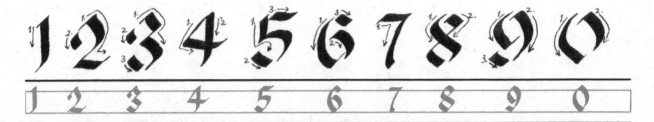

Stringing Together Black Letters

If you feel comfortable making all the letters of the Blackletter alphabet (if not, see the sections earlier in this chapter), you can begin to practice putting these letters together in words. See Figure 8-16 for an example.

Figure 8-16:
Words
done in
Blackletter.

Academy Bureau Club Dept.

When stringing the letters together to make words, keep the following in mind:

- ✔ Keep the letters close enough together so that the white spaces between them are not much wider than the black strokes that make the letters.
- ✔ Make the space between words equal to the width of the letter *o*.
- ✔ Keep both the letters and the words dense and compact.

In the exercise below, trace over the gray letters. Then see if you can copy them within the lines that are drawn directly underneath. The trick is to keep the letters closely spaced. This exercise is just the beginning, though. The appendix has an extended exercise that gives you a chance to practice stringing together all the lowercase and capital letters of the Blackletter alphabet.

Academy Bureau Certificate Department

Here are some tips for making these numbers:

- Make the numbers the same height as the capital letters.
- Keep the strokes angular. Avoid too many round shapes.
- Follow the sequence and direction of the strokes shown in the examples.

Practice tracing and copying in the space below.

Stringing Together Black Letters

If you feel comfortable making all the letters of the Blackletter alphabet (if not, see the sections earlier in this chapter), you can begin to practice putting these letters together in words. See Figure 8-16 for an example.

Figure 8-16:
Words done in Blackletter

When stringing the letters together to make words, keep the following in mind:

- Keep the letters close enough together so that the white spaces between them are not much wider than the black strokes that make the letters.
- Make the space between words equal to the width of the letter r.
- Keep both the letters and the words dense and compact.

In the exercise below, trace over the gray letters. Then see if you can copy them within the lines that are drawn directly underneath. The trick is to keep the letters closely spaced. This exercise is just the beginning, though. The appendix has an extended version that gives you a chance to practice stringing together all the lowercase and capital letters of the Blackletter alphabet.

Chapter 9
Classical Roman Letters

In This Chapter

▶ Looking at the Roman alphabet

▶ Practicing the proportions and shapes of the letters

▶ Stringing letters together

▶ Using the pen to draw the Roman alphabet

▶ Avoiding some of the most common errors

▶ Making your letters sizzle with serifs

In this chapter, I cover the step-by-step basics of how to do the Roman alphabet. This alphabet is called Roman, because the ancient Romans actually developed it — it's our oldest alphabet.

Today the Roman alphabet, in various forms, can be seen virtually everywhere we see something printed or written. Nearly all the Western alphabets, typefaces, and fonts that we use today are derived from these letters. The words that you are reading right now are written in a typeface called *Times New Roman.*

Mastering the Roman alphabet involves studying both the formation of the letters and the pen angle. Because the two are equally important and can also be equally challenging, in this chapter, I show you how to do these two things separately.

Understanding the Roman Alphabet

The Roman letters look really simple to do, but their simplicity can be deceptive. The fact is, these letters can really challenge your abilities as a calligrapher more than any other alphabet in this book. Because of the simplicity of the letters, any flaw or mistake you make will stand out like a sore thumb. There are no flourishes or embellishments in this alphabet that will hide your goofs.

The Roman alphabet (see Figure 9-1) is an extremely useful style for the calligrapher for two reasons. First, it is easy to read, and, second, it represents classical elegance in its purest form. It combines well with other styles and is especially effective for titles. One other important value in learning to do the Roman alphabet is this: It will give you a deeper understanding of the proportions of the capital letters — regardless of the style you are using.

You might be wondering why I haven't included any lowercase letters with this alphabet. Why only capitals? The answer is simple, the alphabet that I present here is faithful to the historical model, and there weren't any lowercase letters in formal Roman. Lowercase letters were added centuries later as an outgrowth of an informal writing style called New Roman Cursive. Also I don't show any numbers with this alphabet, because only Roman numerals

were used in Roman times. If you want to use numbers, see the Manuscript numbers in Chapter 10. If you are interested in learning more about the fascinating history of these alphabets, the web site at en.wikipedia.org/wiki/Latin_alphabet gives a good overview.

ABCDEFGHI JKLMNOPQR STUVWXYZ

Figure 9-1:
The Roman alphabet.

From the calligrapher's point of view, the Roman letters can't be beat if you're looking for an alphabet to use in titles and headings. Also, you can use the Roman letters as the capital letters with the Italic lowercase letters. Combining the two alphabets creates a perfect marriage of the strength and dignity of the Roman letters with the elegant gracefulness of the Italic letters.

Perfecting your technique for the Roman alphabet involves two steps: perfecting how to make the letter shapes and perfecting the pen angle. So, for the section, "Getting to Know the Five Groups of Letters," as you practice the shapes of the letters, you need to use a pencil or a marker type pen with a fine tip. In the section, "Trying the Letters with a Pen," where you practice making the letters with — you guessed it! — a calligraphy pen, use either a Manuscript fountain pen with a wide nib — 2B, or a dip pen with a 1½mm nib.

Getting to Know the Five Groups of Letters

I have divided the letter shapes of the Roman alphabet into five basic groups based on the proportion of the width to the height of the letters. In the sections that follow, I introduce you to letters that are as wide as they are tall; letters that are ¾ as wide as they are tall; letters that are ½ as wide as they are tall; a couple of letters that are very narrow; and a couple that are extra wide.

Letters as wide as they are tall

Five letters are as wide as they are tall. They will fit inside squares so that their edges touch all four sides of the squares (see Figure 9-2). All five of these letters are circular: *o, c, g, d,* and *q.*

Figure 9-2:
Letters *o, c, g, d,* and *q.*

OCGDQ

You can practice these letters in the exercise that follows — just trace the gray letters and then make them freehand in the boxes provided. Here's how to make these letters:

1. **Begin all the letters at roughly the 11 o'clock position and end the strokes at 5 o'clock.** The hash marks on the letters guide you from the start to stop position.

2. **Follow the rest of the stroke sequence as indicated.**

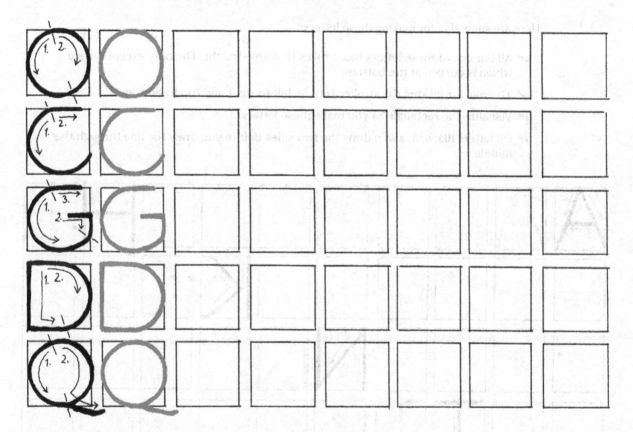

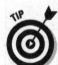 Keep these tips in mind while making these letters:

✔ **Avoid using your fingers to move the pen as you make the circular letters. It is best to move your whole hand and arm.**

✔ **Practice making the strokes with a smooth, uniform speed — not too fast and not too slow.** You should be able to count to four or five at a normal rate as you make each one of the circular strokes. If you can't reach five, you're going too fast. If you can count to seven or higher, you're going too slowly.

Letters ¾ as wide as they are tall

The largest group has letters that are three-fourths as wide as they are tall (see Figure 9-3); so, the ratio of the width to the height of these ten letters is three to four. Ten letters fall into this category: *a, h, k, n, t, u, v, x, y,* and *z.*

Figure 9-3:
Letters *a, h, k, n, t, u, v, x, y,* and *z.*

AHKNTUVXYZ

Here are some tips for making these letters:

- ✔ All but one of these letters has strokes that are straight. The only exception is *u* which is curved at the bottom.
- ✔ The rule for making the strokes is to go left to right and top to bottom.
- ✔ Visualize the rectangle as you make these letters.
- ✔ On letters like *a, h,* and *n* draw the two sides before you draw the line through the middle.

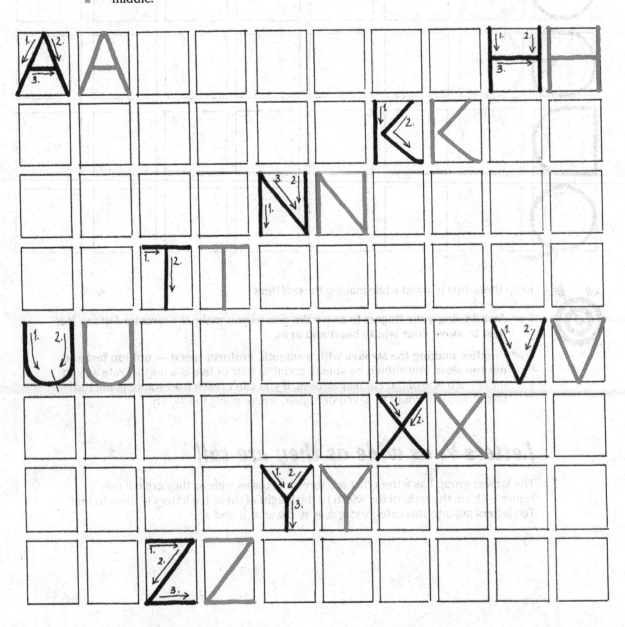

Letters ½ as wide as they are tall

The letters that are ½ as wide as they are tall can be found in Figure 9-4.

Figure 9-4:
The letters
b, r, e, f, s, l,
and *p.*

BREFSLP

Here are some tips for making these letters:

✔ Only the *l* is made in one stroke. All the other letters in this group are made with two or three strokes.

✔ Visualize a half-wide rectangle as you make these letters.

✔ The horizontal stroke in the middle of the *f* is lower than the same stroke on the *e*.

✔ The round shape on the top part of the *p* extends farther down than the corresponding shape on the *r*, and the round shape on the *r* is longer than the same shape at the top of the *b*.

✔ You can remember them by using the memory aid "brief sleep."

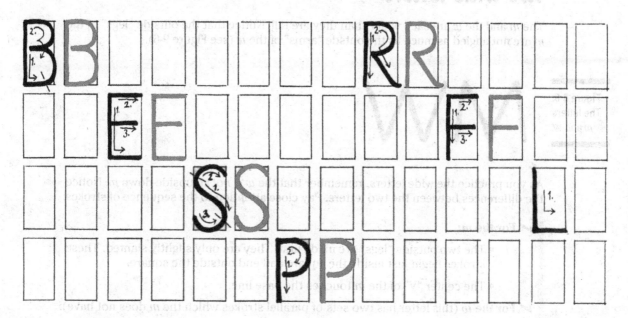

Two narrow letters

The *i* and the *j* are very narrow letters (see Figure 9-5). They're only as wide as the pen that is drawing them. Notice that the *j* is simply an *i* with a "tail" added.

Figure 9-5:
The *i* and
the *j* are the
narrowest
letters.

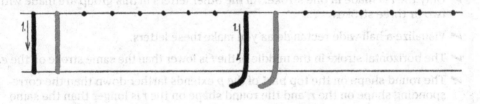

Follow these tips for making these letters:

- ✔ Begin the strokes at the top.
- ✔ Pull down slowly and evenly.
- ✔ Keep the letters vertical — no slant.

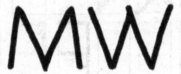

Two wide letters

The *m* and the *w* are each wider than they are tall. Notice that the outside "legs" of the *m* are not angled as much as the outsde "arms" of the *w* (see Figure 9-6).

Figure 9-6:
The letters
m and *w*.

As you practice the wide letters, remember that the *w is not* an upside-down *m*. Notice the differences between the two letters. Pay close attention to the sequence of strokes:

- ✔ **For the *m*:**
 - The two outside "legs" are made first. They are only slightly slanted. These strokes begin just inside the square and end outside the square.
 - The center "V" of the *m* touches the base line.
- ✔ **For the *w*** (this letter has two sets of parallel strokes which the *m* does not have):
 - The first and second strokes are parallel, and the third and fourth strokes are parallel.
 - Notice how the second and third strokes overlap at the top and how the two points at the bottom lie well inside the square.

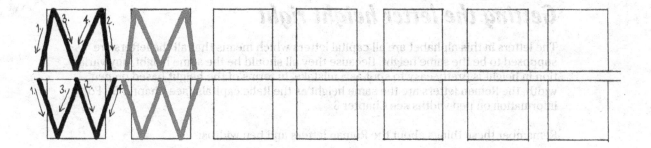

Putting the Letters Together

Now it's time to put the letters together. As you use these letters to make words, notice the spacing between letters and words. Try to make the spacing look as even as you can. I'll explain more about spacing later in this chapter. For now, try to keep the spaces between letters and words as consistent as you can.

Figure 9-7:
Putting
letters
together.

ART BIOLOGY

Give it a try! Trace the words in gray and then make them freehand in the space provided. You can find many more words to practice that span the entire alphabet in the appendix.

While stringing letters together, keep these tips in mind:

✔ Take your time; don't rush.

✔ If it helps you, you can lightly pencil in the shapes of the letters first.

Trying the Letters with a Pen

If you have the letter shapes down (if not, see "Getting to Know the Five Letter Groups" earlier), you should be ready to try the letters with the pen. In the sections that follow, I provide the guidance you need to perfect using the pen with the Roman alphabet.

Getting the letter height right

The letters in this alphabet are all capital letters which means that all the letters are supposed to be the same height. Because they all should be the same height, any variation in height is pretty easy to spot as a mistake. In terms of the height based on pen width, the Roman letters are the same height as the Italic capitals (see Chapter 5). For information on pen widths see Chapter 3.

Remember these things about the Roman letters and pen widths:

✔ The height equals eight pen widths (see Figure 9-8).

✔ The space between lines of letters equals three to four pen widths (see Figure 9-8). I don't know why three or four pen widths between lines, but it does look really good that way.

Figure 9-8:
Pen widths
for letter
height.

Smoothing out your stroke

As you use your calligraphy pen to make these letters, it is important to discipline your hand to keep the strokes completely smooth and even. Unfortunately, the Roman alphabet is very "unforgiving" when you make a goof — especially the goofs where the stroke looks shakey.

It is difficult to do this alphabet "cold." I always suggest doing warm-up exercises before attempting to do any serious work where you are going to use this alphabet.

Sometimes it helps to sketch these letters very lightly with a pencil as a guide and then go over the penciled letters with your pen. That way you can make the correct letter shapes and spacing with the pencil, so, when you go over the penciled letters with the pen, you can concentrate on making smooth strokes.

Zeroing in on the right pen angles

Unlike the previous alphabets where the pen angle was constant for all the letters, this alphabet has two pen angles (for more on pen angle, see Chapter 3):

✔ **The basic pen angle for most of the letters is 20 degrees** (see Figure 9-9), which is much flatter than the pen angle used for alphabets like Italic (see Chapter 6) and Blackletter (see Chapter 8).

✔ **The second pen angle is 45 degrees** (see Figure 9-11) and is used for diagonals in some of the letters. This second pen angle is the same as the angle for Italic (see Chapter 6) and Blackletter (see Chapter 8).

Figure 9-9:
The
20-degree
pen angle.

Figure 9-9:
The
20-degree
pen angle.

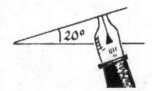

The letters that use the 20-degree angle are: *b, c, d, e, f, g, h, i, j, l, o, p, q, t,* and *u.* The following parts of the letters which otherwise are made with the 45-degree pen angle, are made using a 20-degree pen angle (see Figure 9-10):

- ✔ The cross-bar on the *a*
- ✔ The vertical on the *k*
- ✔ The right side of the *m*
- ✔ The vertical and the rounded part of the *r*
- ✔ The leg of the *y*
- ✔ The right-to-left diagonal of the *z*

Figure 9-10:
Select parts
of *a, k, m,
r, y,* and
z use the
20-degree
angle as
indicated.

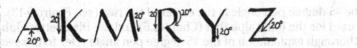

The letters that are made entirely with a 45-degree pen angle (see Figure 9-11) are *n, s, v, w,* and *x.* For the most part, these are letters that are made up of diagonals.

Figure 9-11:
The
45-degree
pen angle.

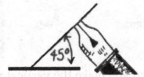

Practicing pen angle

When it comes to the 20-degree pen angle, if you make a plus sign (see Figure 9-12), you can notice:

- ✔ That the verticals are a whole lot thicker than the horizontals
- ✔ How the beginnings and endings of the strokes are angled

Figure 9-12:
The plus sign using the 20-degree angle.

You might discover that holding your pen at a 20-degree angle is not the easiest thing to do. Here's an exercise that will help.

Practicing the angle before you begin the letters is best. Practice the 20-degree angle by tracing and copying the plus signs below. Notice how much wider the vertical stroke is than the horizontal. As you practice, try to get a mental picture of how you are holding the pen to achieve the correct pen angle. For a right-handed person the barrel of the pen is probably pointing back to a point inside your shoulder. If you are left-handed, you will have to experiment to see how you should hold the pen to make the 20-degree plus sign. See Chapter 2 for information on the different ways a left-handed writer can hold the pen.

For most people, the 45-degree pen angle is the easier of the two (see Figure 9-13). This is the angle that is used for the Italic alphabet (Chapter 5) and the Blackletter alphabet (Chapter 8). For a thorough explanation of the 45-degree pen angle refer to the section on pen angle in Chapter 5.

Figure 9-13:
The 45-degree plus sign.

Follow these tips on making and/or practicing the plus sign:

- ✔ Don't twist or turn the pen.
- ✔ Hold the pen in the same position in your hand when you make the vertical and horizontal.
- ✔ The beginnings and endings of the vertical and horizontal strokes should be perfectly angled at 45-degrees. See Figure 9-13.

Creating letters with a 20-degree pen angle

Figure 9-14 shows you the letters which require a 20-degree pen angle: *b, c, d, e, f, g, h, i, j, l, o, p, q, t,* and *u.* Essentially these are the letters which do not have any diagonals in them.

Figure 9-14:
The letters
using a 20-
degree pen
angle: *b, c,
d, e, f, g, h, i,
j, l, o, p, q, t,*
and *u.*

BCDEFGHIJLOPQTU

Tips for making the letters with a 20-degree pen angle:

✔ The vertical strokes are noticeably wider than the horizontal strokes.

✔ Keep the letters the correct width according to which group they belong to.

✔ Don't become discouraged if your first efforts are unsatisfactory. Practice is the key to improvement.

BCDEFGHIJLOPQTU

Making letters with the 45-degree pen angle

For the letters *n, s, v, w,* and *x,* you make them entirely with the pen held at a constant 45-degree angle. For the letters *a, k, m r, y,* and *z,* you make some parts (basically their diagonals) with a 45-degree pen angle and other parts with a 20-degree pen angle. Figure 9-15 shows you all these letters.

Figure 9-15:
Letters
made with
the 45-
degree pen
angle: *n, s,
v, w,* and *x*
as well as
parts of *a, k,
m r, y,* and *z.*

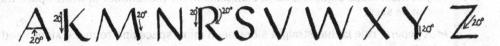

Study the examples in the practice exercise below:

✔ The strokes that are to be done with 20-degree angle are indicated.

✔ All the other parts of these letters require you to use a 45-degree pen angle.

✔ Notice that *z* seems to contradict the pattern — the horizontals require a 45-degree angle and the diagonal does not. This is necessary to give the strokes the correct weight.

AKMNRSVWXYZ

Stringing the alphabet together

Pay close attention to the spacing between the letters and between words (see Figure 9-16). Spacing of the Roman letters is done completely "by eye." Of course, you want the spacing to look nice and even. The problem is complicated by the fact that measuring and putting an equal distance between letters won't do the trick. As strange as it may sound, if you use equal distances between the letters, they will actually look like they're spaced unevenly. Since spacing is done "by eye," there are no rules or gauges that you can use to space the letters. Remember, even spacing will not work. The letters must appear to be evenly spaced. To do this, the letters are actually spaced unevenly.

Figure 9-16:
Examples of
equal (left)
and unequal
(right)
spacing.

SPACING SPACING

Equal distances between the letters will make the letters appear unevenly spaced. To achieve spacing where the letters appear evenly spaced, you must have unequal distances between the letters.

The goal is to space the letters so that all the white spaces in between them appears to be equal in area (see Figure 9-17). Bear in mind these guidelines on spacing:

✔ Because some letters have rounded sides and other letters have vertical sides, you must make adjustments to compensate for the amount of white space that can be seen.

✔ A general rule is that straight sides need more space and rounded sides need less space.

✔ Check your spacing by turning your work upside-down to see how equal the white spaces look.

✔ Check your spacing by holding your work up to a mirror.

Figure 9-17:
Examples of
words.

ACE BARK CYAN

 You can practice the whole alphabet by stringing together the letters to create words. You can get a feel for it in the exercise below, but I give you a fuller practice exercise in the appendix.

ACE BARK CYAN

Common Errors

It would be impossible to list all the errors that people could make with this alphabet, but I describe to you several of the ones that seem to appear the most often (see Figure 9-18) as well as how to avoid them:

- ✔ The horizontal on the *a* is not placed correctly. It should be just below center.

- ✔ The *b* is too wide. Remember, this is a half-wide letter.

- ✔ The *c* "hooks over." The top of this letter should be straight.

- ✔ The *h* is too wide. It is a ¾ wide letter.

- ✔ The strokes are overlapping in the center. The diagonal strokes on the right side of this letter should not extend so far as to overlap the vertical stroke on the left.

- ✔ The *e* is too wide. This is a half-wide letter.

- ✔ The *d* is too narrow. This letter is supposed to be as wide as it is tall. Perhaps you are not accustomed to seeing this letter so wide. That's because many commonly used typefaces have a narrow *d*, and you're used to seeing it that way. If that is the case, I recommend that you do a little research and look at examples from antiquity of the Roman letters. I believe that helps develop appreciation for the proportions of these letters.

- ✔ The *f* is too wide. Again, this is a half-wide letter.

- ✔ The "legs" of the *m* are angled out too much. The outside "legs" of the *m* should be closer to vertical. The *m* is not an upside-down *w*.

- ✔ The center part of the *m* does not come down to the baseline. This is another common error that people have grown accustomed to seeing. The center "V" is supposed to touch the writing line.

- ✔ The top of the *p* is the wrong size. It should be a whole lot larger than this.

- ✔ The "leg" of the *r* is in the wrong position. The "leg" begins close to the vertical and is not curved at the top like this one is.

- ✔ The *s* is too curved. This letter looks more like an Uncial *s*.

- ✔ The sides of the *w* are not angled enough. The *w* should have two sets of parallel strokes — the first and third strokes and the second and fourth strokes. The *w* is not an upside-down *m*.

- ✔ The center of the *w* is too short. The center part should extend so it is even with the top of the letter.

ABCHKEDF MMPRSWW

Figure 9-18:
Fifteen very
common
errors.

Adding On Some Serifs

Classical Roman letters have serifs. You need to be careful adding these serifs to make certain they are not too big and they are positioned correctly. It is very easy to make them either too long and to place them a little off-center.

Look at Figure 9-19 and notice that the *c, g, o, q, s,* and *z* have no serifs. The serifs are located where straight strokes meet the top and bottom guide lines.

ABCDEFGHI JKLMNOPQR STUVWXYZ

Figure 9-19:
The
alphabet
with serifs
added.

Getting to know the three kinds of serifs

When it comes to making serifs, you have some choices. In the following list, I show you three ways you can add serifs listed in order from the easiest to do to the most difficult; choose the method that you like the best:

✓ **Slab serif:** An easy, simple serif is the *slab serif,* which is added after the letter has been made. A slab serif is simply a small, straight line that is added to the letters. The pen angle for these serifs is 20 degrees. Look at the example on the left in Figure 9-20.

✓ **Joined slab serifs:** It's possible to make the slab serifs joined to the letters as you draw them (as opposed to making the slab *after* you complete the letter like you do with a simple slab serif — see above bullet). Look at the example in the center in Figure 9-20. This kind of serif is very popular (it's the one I prefer), and it really dresses up the letters. You have to practice to get it just right, but it is not especially difficult to master, and it's definitely worth the effort.

The trick is to remember that all the joined slab serifs should be made with a 20-degree pen angle. That means if you have a serif at the top of or bottom of a line

that is made with a 45-degree pen angle, you have to do a little turning of the pen as you go from serif to 45-degree angle.

- ✔ **Pedestal serif:** Another, more difficult, but extremely impressive serif is the little *pedestal serif.* You draw these serifs just like the previous joined serifs except a tiny curved stroke is added after the letter is done. This does require practice and accurate control of the pen. You have to make certain that this tiny curved stroke looks like part of the letter, and that's not particularly easy.

When I do these serifs I always sketch the letter lightly with pencil first. You have to be careful to keep the serif in proportion to the rest of the letter — not too big and centered correctly. Look at the example on the right in Figure 9-20 which shows this distinctive serif.

Figure 9-20: Three kinds of serifs.

I I I

Making the serifs

The goal is to add serifs that are going to enhance the appearance of the letters. Keep the following guide lines in mind as you add serifs:

- ✔ Keep the serifs repectably small and straight. Avoid making serifs that are too big or wavy.
- ✔ To add slab serifs to the letters after they are drawn, simply add short horizontal strokes to the letters.
- ✔ To draw a joined slab serif to the top of a letter, begin with a short horizontal stroke which is the serif. Then, without lifting your pen, add a small curved stroke slightly downward and to the left so that the pen is centered underneath the serif. Continue with the downstroke of the letter.
- ✔ To draw a joined slab serif at the bottom of a letter, end the downstroke with a small curved stroke slightly downward and to the left. From this point, finish with a short horizontal stroke which is the serif. If done correctly, the serif will be centered directly under the downstroke.
- ✔ If you want to do the pedestal serif, first make the joined slab serif and then add small curved strokes to cover up the "gap" areas.
- ✔ If you're making a joined serif at the top of or bottom of a stroke that is made with a 45-degree pen angle, you'll have to do a little turning of the pen as you go from serif to 45-degree angle.

Practice these three kinds of serifs in the space below.

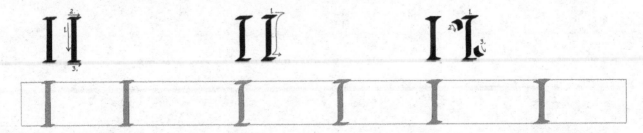

Chapter 9: Classical Roman Letters 127

that is made with a 30-degree pen angle, you have to do a little turning of the pen as you go up from 30 to 45 degree angle.

• **Pedestal serif:** Another, more difficult, but extremely impressive serif is the little pedestal serif. You draw these serifs just like the previous joined serifs except a tiny curved stroke is added after the letter is done. This does require practice and accurate control of the pen. You have to make certain that this tiny curved stroke looks like part of the letter and that's not particularly easy.

When I do these serifs I always sketch the letter lightly with pencil first. You have to be careful to keep the serif in proportion to the rest of the letter — not too big and centered correctly. Look at the example on the right in Figure 9-20 which shows this distinctive serif.

III

Figure 9-20.
Three kinds
of serifs.

Making the serifs

The goal is to add serifs that are going to enhance the appearance of the letters. Keep the following guide lines in mind as you add serifs:

• Keep the serifs reasonably small and straight. Avoid making serifs that are too big or wavy.

• To add slab serifs to the letters after they are drawn, sketch and short horizontal strokes to the letters.

• To draw a joined slab serif to the top of a letter, begin with a short horizontal stroke which is the serif. Then, without lifting your pen, add a small curved stroke slightly downward and to the left so that the pen is centered underneath the serif. Continue with the downstroke of the letter.

• To draw a joined slab serif at the bottom of a letter, end the downstroke with a small curved stroke slightly downward and to the left. From this point, finish with a short horizontal stroke which is the serif. If done correctly, the serif will be centered directly under the downstroke.

• If you want to do the pedestal serif, first make the joined slab serif and then add small curved strokes to cover up the "gap" areas.

• If you're making a joined serif at the top of or bottom of a stroke that is made with a 30-degree pen angle, you'll have to do a little turning of the pen as you go from 30 to 45 degree angle.

Practice drawing three kinds of serifs in the space below.

Chapter 10

Formal Manuscript, Foundational Hand, or Bookhand

. .

In This Chapter

▶ Looking at the height, pen angle, basic shapes, and proportions

▶ Getting to know the lower case letters

▶ Learning the capital letters

▶ Using two sets of numbers \

▶ Putting letters together

▶ Varying the style

. .

The alphabet in this chapter is known by several different names — Manuscript, Foundational Hand, and Bookhand, among several names. It's actually a version of the Roman alphabet with many practical applications. It is not as formal looking as Roman and much easier to do. You can use this alphabet for just about any purpose.

This alphabet, as the names Manuscript and Bookhand indicate, was originally used for lettering manuscripts and books. The letters eventually evolved into many of the typeface designs we see in books today.

The name, Foundational Hand, comes from the fact that this alphabet has been a preferred, beginning alphabet with many calligraphy teachers. Although it is a popular, beginning alphabet, you should not underrate its value. You will certainly find many uses for this very versatile and beautiful style.

In this chapter, I cover the Manuscript letters, both upper- and lowercase and the numbers. Since this alphabet is based on shapes rather than strokes, I don't give you a stroke-by-stroke description of how to do these letters. That is unnecessary. Seeing and practicing the letters in groups according to the similarities of their shapes is the best way to get you going with this alphabet. In this chapter as well as the appendix, I provide ample practice at writing the letters and putting words together.

Getting to Know the Manuscript Alphabet Basics

More than likely, you'll discover that this is one of the easier styles to learn. The letters are very uniform in structure (see Figure 10-1) and the strokes are all very natural. It is an alphabet that requires no special manipulation of the pen.

abcdefghijklm
nopqrstuvwx
yz1234567890
ABCDEFGH
IJKLMNOPQ
RSTUVWXY
Z1234567890

Figure 10-1:
All the letters and characters in the manuscript alphabet.

In the sections that follow, I equip you with the info you need to begin putting pen to paper to do the letters of the Manuscript alphabet. The practice is easy to follow and should be fun. In hardly any time at all, you should see real success.

For this chapter you need either a Manuscript (brand name of the pen, not the alphabet) fountain pen with a 2B nib or a dip pen with a 1½mm nib. You should also understand what pen angle means and what the guide lines are. If you are not sure about these, look in Chapter 3.

Pen widths

You can find out more about pen widths in Chapter 3, but for this alphabet, Figure 10-2 shows you the pen widths to use for the lowercase and capital letters.

Figure 10-2:
Pen widths
for lower-
case and
capital
letters.

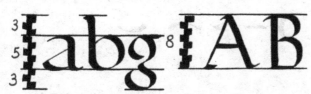

Pen angle

One reason this alphabet is easy to learn, is you use only the 30-degree pen angle for almost all the strokes and letters (see Figure 10-3). (There's only one exception, the lowercase *z,* and that's pretty easy to remember.) A pen angle of 30 degrees is not as angled as the 45 degree angle used for Italic and Blackletter (see Chapters 6 and 8) and not so flat as the 20-degree angle used for most of the Roman letters (see Chapter 8).

Figure 10-3:
The
30-degree
pen angle.

Trace over the zigzag design below. If you are holding the pen at the correct 30 degree angle, you'll be able to duplicate the alternating thick and thin lines just as they're shown below. Before you get started, review these points to be sure you make and maintain the correct angle:

- ✔ For a right-hander, the barrel of the pen points back to the edge of the right-shoulder.

- ✔ Left-handers need to figure out how the pen is held to make the zigzag design exactly as shown. That's the pen position that you need to maintain.

- ✔ Because of the pen angle, the verticals are going to be just a little wider than the horizontal parts of the letters.

- ✔ The thinnest parts of the letter *o* will not be at the exact top and bottom but close to the 11 o'clock and 5 o'clock positions.

Basic shapes and proportions

The body of these letters is five pen-widths in height. The ascenders and descenders are each just three pen-widths above and below (see the section, "Pen widths," above for more information). The body (the part of the letter that is between the waist line and the base line) is circular. These letters are based on the circle — there's no slant at all to these letters. To draw these letters, you'll use ten different basic strokes in different combinations (see Figure 10-4).

Figure 10-4:
Basic
strokes.

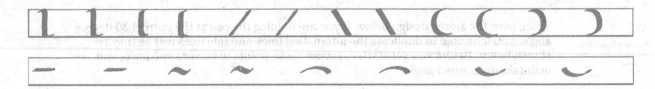

You can practice the basic strokes for this alphabet in the space below. Trace over the strokes drawn in gray, copy in the blank spaces that follow the strokes that you trace, and remember the following:

- ✔ **Pull the pen toward you; don't push it away.** All the strokes are what are called "pull strokes" which means that you are basically pulling the pen toward you instead of pushing it away from yourself. Because of the "pull strokes," this is an alphabet that can be done with a fountain pen as well as a dip pen.

- ✔ **Concentrate on keeping the sizes of the letters uniform, the strokes smooth.**

- ✔ **Keep the letters completely vertical.** If you learned Italic previously (see Chapters 4 through 6), you may have a tendency to slant the letters.

- ✔ **Avoid ovals; keep everything circular.** This is a true "ball and stick" alphabet. Again, if you already know the Italic alphabet, you may have a tendency not to make the letters wide enough.

- ✔ **Maintain a constant pen angle.** Don't twist or turn the pen as you're making the letters.

The Lowercase Letters

As with other alphabets presented in this book, rather than going through the letters in alphabetical order, I introduce the letters according to their similarities.

Although you get a chance to practice all of the letters in this chapter, you can find even more practice for the lowercase letters of this alphabet in the appendix.

The round letters

The letters *b, c, d, e, o, p,* and *q* have a circle as a major part of their shape (see Figure 10-5). Circles may not be the easiest shapes to draw, but I start with these because the round shape is the shape that all the letters are based upon. Get this right and you should be able to do all the letters with ease.

Figure 10-5:
The round letters *b, c, d, e, o, p,* and *q*.

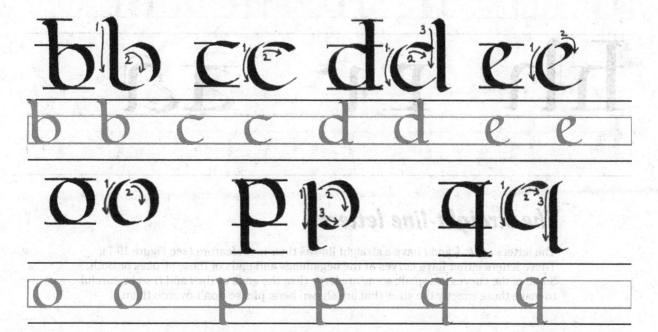

Follow these tips for making these letters:

- Always do the left side of the circle first.
- If you are left-handed, you may find that doing the right side of a circle first is easier for you. If it's easier, do it that way.
- Keep the strokes smooth and steady.

Letters that have the n or u shape

The letters *u, n, m, h, r,* and *a* are similar to each other, because they all have the *u* or *n* shape in them (see Figure 10-6). These letters combine partial circles with straight strokes.

Figure 10-6:
Letters with the *n* or *u* shape; *u, n, m, h, r,* and *a.*

As you practice these letters, keep the following tips in mind:

- Watch the white spaces inside these letters. They should be symmetrical horizontally.

- Be careful with the serifs. Make small curves to begin and end these letters. Don't make these serifs sloppy or too big.

- Make sure that the letters have no slant to them.

- The top and right side of the *a* is exactly like the top and right side of the *n*.

The straight-line letters

The letters *i*, *j*, *k*, *l*, and *t* have a straight line as their main feature (see Figure 10-7). These letters either have curves at the beginnings and ends of these strokes or both. Some of the curves are small; some are large (like the ends of the *l* and *t*) so be careful to make these exactly the sizes that are shown here; please don't overdo them.

Figure 10-7:
The straight-line letters: *i*, *j*, *k*, *l*, and *t*.

Here are some tips for making these letters:

- Keep these long, vertical strokes straight and smooth. This is one place where a stroke that is not straight will stand out.

- Keep the curved serifs at the beginnings and endings of the letters neat and small. Don't be sloppy or haphazard with these.

- Make the base of the *l* and the *t* circular.

- Don't make the *k* too narrow.

Learning the letters that have a v shape

The three letters *v*, *w*, and *y* are very similar (see Figure 10-8). Notice how the points where the letters sit on the base line have overlapping strokes. This overlap is important to the style of the letter.

Figure 10-8:
The *v*, *w*, and *y*.

Keep these tips in mind as you're practicing these letters:

- Make certain that the diagonal strokes (except for the serifs) are straight and not curved.
- Keep the two sides of the *w* equal in width.
- Keep the long stroke on the *y* straight except at the top and bottom.

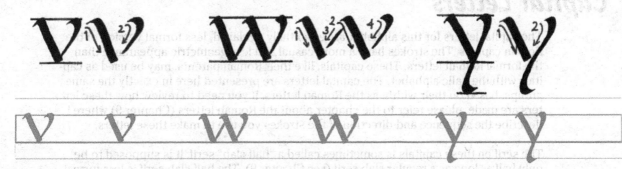

All the other letters

I've lumped the five remaining letters together into one group. Each of these letters has similarities to other letters, but they really don't fit with any of the other groups. These letters are *f*, *g*, *s*, *x*, and *z* (see Figure 10-9).

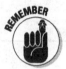

Figure 10-9:
Letters *f, g, s, x,* and *z.*

ƒgsxz

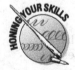
REMEMBER

When it comes to doing the *z,* turn your pen angle to 45-degrees as you make the two horizontals at the top and bottom (otherwise they'll come out looking too thin). The diagonal through the middle is made with the pen held at the regular 30 degree angle for this alphabet (see Chapter 5 for more info on the 45-degree pen angle).

Tips for making these letters:

- The *g* is a letter that may take a bit of practice. Make sure that the second stroke which resembles a *3* wraps around underneath the first stroke. Also, make the fourth stroke (the "ear") horizontal, not angled upward.

- Don't forget that the pen angle for the horizontals of the *z* is 45 degrees.

Capital Letters

The capital letters for this alphabet are essentially a relaxed, less formal version of the Roman capitals. The strokes have a more casual and less geometric appearance than the formal Roman letters. These capitals, like their Roman parents, may be used as capitals with the Italic alphabet. The capital letters are presented here in exactly the same groups, based on their width, as the Roman letters. If you need to review how these letters are made, please refer to the chapter about the Roman letters (Chapter 9) where I describe the sequence and direction of the strokes you use to make these letters.

The serif on these capitals is sometimes called a "half-slab" serif. It is supposed to be only half as long as a regular slab serif (see Chapter 9). The half-slab serif is less formal looking than the regular slab serif on the Roman letters. It is similar in appearance to the serifs on the lowercase letters.

HONING YOUR SKILLS

Be sure to flip to the appendix for even more practice on creating capital letters in addition to what you find for practice in the sections that follow.

Letters as wide as they are tall

The capitals *c*, *d*, *g*, *o*, and *q* are circular in shape and are as wide as they are tall (see Figure 10-10). They are 8 pen widths tall which is exactly the same height as the ascenders in this alphabet.

Figure 10-10:
Letters *c*, *d*, *g*, *o*, and *q*.

CDGOQ

Follow these tips as you practice these letters:

✔ Strive to make the circles as perfect as you can make them. No ovals permitted here.

✔ Keep the strokes smooth and steady.

✔ If you are having difficulty with these letters, you may lightly pencil them in before drawing them with a pen.

Letters whose width is three-fourths the height

Ten letters are in this group (see Figure 10-11). They are *a*, *h*, *k*, *n*, *t*, *u*, *v*, *x*, *y*, and *z*. These are the letters of average width. For most people, these letters are some of the easiest ones to do correctly.

Figure 10-11:
Letters *a, h, k, n, t, u, v, x, y,* and *z.*

AHKNTUVXYZ

As you practice these letters, please remember:

- Keep the width three-fourths of their height. Don't make these letters too narrow or too wide.

- Pay careful attention to the little serifs at the beginnings and endings of the strokes. The serifs really do exemplify that it's the little things that count.

- Hold the pen at a constant 30-degree angle.

Letters half as wide as they are tall

The capital letters that are only half as wide as they are tall are *b, r, e, f, s, l,* and *p* (see Figure 10-12). In some cases, this proportion may not look exactly right to you, but that's probably because the letters that we see every day do not follow all the rules.

Figure 10-12:
Letters *b, r, e, f, s, l,* and *p.*

BREFSLP

Follow these tips

- "Brief sleep" is a memory aid for recalling the half-wide letters.

- Study the small serifs on the *e* and *f* and make these carefully.

- Keep the small "foot" serif at the bottoms of the *r, f,* and *p* short and horizontal.

BBRREEFFSSLLPP

The narrow capitals

The capital *i* and *j* are narrow letters, hardly wider than a single stroke of the pen. The *j* is really just an *i* with a short "tail" added onto the bottom (see Figure 10-13). In fact, the *j* was originally designed so people could distinguish between the consonant and vowel uses of the letter *i*.

Figure 10-13:
Letters *i*
and *j*.

Tips for making the *i* and the *j*:

- Make the vertical strokes straight and vertical.
- Draw the serifs small.
- The "tail" on the *j* is short and not curved.

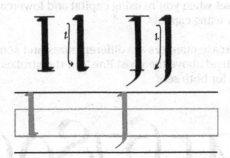

The wide capitals

Two of the capital letters are extra wide. They are the *m* and the *w* (see Figure 10-14). The two widest capitals are *m* and *w*.

Figure 10-14:
Letters *m*
and *w*.

Follow these tips when making the *m* and the *w*:

✔ The two letters are not upside-down versions of each other. The sides of the *m* are slanted inward only slightly. The *w* has two sets of parallel strokes and the outside strokes are slanted quite a lot.

✔ Keep the letters balanced so that one side is not noticeably larger than the other.

✔ Be careful to make the serifs small. Don't make the serifs so large that the sides of these letters are curved.

✔ Make certain to include the overlapping strokes as shown in the examples.

Numbers

In this section, I show you two sets of numbers that go with this alphabet (Figure 10-15). Use the first set when you're using capital and lowercase letters. Use the other set when you're only using capitals.

Notice that the lowercase numbers are different sizes and some reach below the base line, while others extend above the waist line. But the strokes and their sequence are essentially the same for both sets.

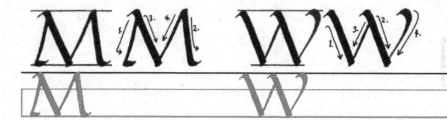

Figure 10-15:
Two sets of
numbers.

Tips for making the numbers:

✔ The numbers that are to be used when you only have capital letters are the same height as the capitals.

✔ The lowercase numbers have different sizes. The *1*, *2*, and *0* are drawn between the writing and waist lines. The *3*, *4*, *5*, *7*, and *9* extend down below the writing line but do not touch the descender line. The *6* and *8* extend up above the waist line but do not touch the ascender line.

Putting It All Together

When putting all the letters together to create words, the letters should be spaced so they appear to have an equal distance between them (see Figure 10-16).

Figure 10-16:
Examples of
spacing.

You cannot achieve this by simply spacing the letters in equal increments. In order to make the spaces between letters inside words *appear* equal, you will actually have to space the letters at unequal distances. The amount of space depends entirely upon the shapes of the letters. Take these tips to heart on spacing:

✔ Two round shapes that are next to each other (like *o* and *c*) need to be spaced more closely together.

✔ Two vertical shapes next to each other (such as *a* and *m*) need to spaced farther apart.

✔ Words should have enough space between them to fit an *o*.

✔ One way to test the spacing is to squint at the words so they blur into a line that looks gray. Another way is to turn the paper upside-down. If the spacing has been done correctly, everything will look even.

The following exercises provide a sampling of trace and copy practice for this alphabet. You can find more practice for this alphabet in the appendix.

America Belgium Canada

Variations

You can use this alphabet in a number of wonderful variations. One very attractive variation that is one of my favorites, involves simply drawing the letters narrower than usual (see Figure 10-17). There is no rule about how narrow to make the letters. You can determine how narrow you want to make the letters simply by sight. This variation has many practical applications and allows you to squeeze more letters into a space than the standard form of the alphabet.

Figure 10-17: A narrow version is a very useful alphabet.

This is a narrow version.

As you practice, follow these tips:

✔ Although you determine the width by sight, the width needs to be consistent throughout.

✔ Keep the serifs small and neat. Don't be sloppy with these.

✔ You can use regular width capital letters.

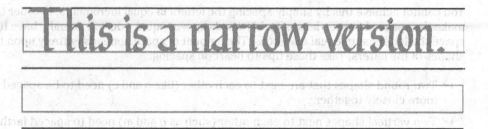

This is a narrow version.

Another nice variation is to decrease the height of the body of the letter (the distance between the waist line and base line to four pen widths). This will produce a heavier, thicker letter (see Figure 10-18).

Figure 10-18:
A heavy, bolder version.

This is a bold version.

Keep these points in mind when you do the bold variation:

- Because you have less height in which to draw the letters, you need to be careful that the shapes are drawn clearly and not squashed together so much that they look bad.

- Again, make certain that you don't make the serifs too large.

- The ascenders are still three pen widths above the waist line.

This is a bold version.

This is a bold version.

Figure 10-13.
A heavy,
bolder
version.

Keep these pointers in mind when you do the bold variation.

- Because you have less height in which to draw the letters, you need to be careful that the shapes are drawn cleanly, and not squashed together so much that they look bad.

- Again, make certain that you don't make the serifs too large.

- The ascenders are still three pen widths above the waistline.

This is a bold version.

Chapter 11

Formal Uncial and Funky Variations

- -

In This Chapter
▶ Getting a grasp on the Uncial alphabet basics
▶ Sealing the deal with serifs
▶ Lettering the formal version
▶ Putting it all together
▶ Trying some less formal — but fun — versions

- -

The Uncial alphabet is a really fun alphabet. It's also one of the easiest and most popular calligraphy alphabets today. Over the years of teaching, many of my students have told me that this is their favorite alphabet. It's a great looking alphabet that has a rich history. This alphabet, more than any other presented in this book, really shows off the variety of beautiful strokes that you can produce with the broad-edge pen.

Most people believe the name, Uncial (pronounced un-shell), comes from the Latin word, *uncia,* which means "inch." Apparently the original letters were about an inch in height.

This style of calligraphy has many variations. So in this chapter, I first show you the basics of a formal version of Uncial. This version is similar to the style of writing used by the early Christians in the first through fourth centuries. Second, I'll explain how to do an informal version called celtic (pronounced *kell*-tick) — a style of lettering that was used by the Irish scribes.

The letters in this alphabet are extremely "forgiving" when it comes to covering up many of your goofs. You can make mistakes in the letter shapes and the letter sizes with this alphabet that you wouldn't dare make with other alphabets. Even if your letter shapes and sizes are not entirely accurate, the letters can still look pretty good. All you have to be careful about is keeping the strokes smooth and steady (shakey strokes are the bain of this alphabet).

Have What You Need?

For this chapter you will need either a Manuscript fountain pen with a 2B nib or a dip pen with a 1½mm nib. You should also understand what pen angle means and what the guide lines are. If you need information about pens or pen angle, look in Chapter 3.

Understanding Uncial

I show you the formal Uncial alphabet in Figure 11-1, an alphabet that you can use for almost any purpose. This is an all-capital alphabet so there are no lowercase letters. The letters are fat — all the letters (except the *i* and *j*) are as wide as, or wider than, they are tall.

ABCDEFGHI JKLMNOPQR STUVWXYZ

Figure 11-1: The Uncial alphabet — a formal version.

The body of these letters is 5 pen widths in height, and the ascender and descender parts of these letters are very short — hardly extending at all beyond the waist line and the writing line (see Figure 11-2). For that reason, we don't bother to draw the ascender or descender guide lines for this alphabet. We use only top and bottom guide lines. Basically, this is an all-capital alphabet. Lowercase letters were never part of this alphabet.

Figure 11-2: Pen widths and the two guide lines for doing the Uncial alphabet.

This is another alphabet where you use only one pen angle throughout. The pen angle is 20 degrees (see Figure 11-3), which means that right-handers will be holding the pen so the barrel almost points directly back at them. The pen is just about perpendicular to the writing line.

If you are left-handed, you have several options. (To read about how left-handers hold the pen and which pen they should use, please see Chapter 2.) You will need to figure out how to hold the pen to obtain the 20-degree pen angle when you draw the letters. This is the same pen-angle that is described in Chapter 9 about the Roman alphabet. Doing the zigzag design below helps determine the correct way to hold the pen.

Figure 11-3: The 20-degree pen angle.

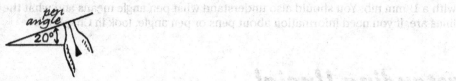

pen angle 20°

Practicing the angle helps you get a handle on doing the Uncial alphabet. Trace over the gray zigzag design below. If you're holding the pen at the correct 20-degree angle, you will be able to duplicate the alternating thick and thin lines exactly as they're shown.

The Uncial Serifs

Uncial has two very interesting serifs that resemble the flared end of a horn (see Figure 11-4). You use them at the ends of two kinds of strokes — the vertical and the curved strokes. For example, you can find the first serif used with the vertical stroke on the letter *i* and the second serif used with the curved stroke at the top of the *c*.

Figure 11-4:
A close-up view of the two serifs used with several of the Uncial letters.

You can draw these serifs different ways. Choose the method that works best for you and gives you the best results. Basically, you have the option of either adding the serifs after you have made the letters or you can do the serifs as parts of the strokes as you make the letters. You can draw the serif on the vertical three ways and draw the serif on the curved stroke two ways.

When you place the serif on the vertical, you have the following options (see Figure 11-5):

- ✔ **Draw the serif first and then add the vertical as a a separate stroke.**
- ✔ **Draw the vertical first and then lift your pen and add the serif.** If you use this method, it is helpful to draw a thin diagonal at the beginning of the vertical stroke. This will help you see exactly where to place the serif.
- ✔ **Draw everything in one continuous stroke.**

Figure 11-5:
Options for drawing a serif on a vertical stroke.

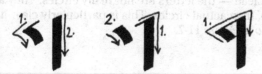

When you place the serif on the curved stroke, you have the following options (see Figure 11-6):

- **Add the serif after the stroke is complete.** If you use this method, it is helpful to end the curved stroke with a thin diagonal which will help you see where the serif needs to go.

- **Draw the serif without lifting your pen at the end of the curved stroke.**

Figure 11-6: Options for drawing a serif on a curved stroke.

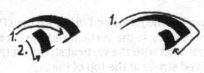

Practice tracing and copying the serif strokes. Trace over the strokes that are drawn in gray and then see if you can duplicate these shapes in the spaces that are in-between the ones you trace. Discover which method of drawing the serifs works best for you.

Getting a Handle on the Formal Uncial Alphabet

Although there are numerous variations on this alphabet, this formal version is a good starting point for any of the variations that you would like to try. We can divide the letters of this alphabet into four groups according to their shapes and the similarity of the strokes you use to draw them. The four groups are: the circular letters, the letters that have a strong vertical, the letters with diagonals, and three special letters.

Strive to keep the letters nice and wide, the strokes smooth, and the slant consistent, and you'll do very well.

The circular letters

There are five letters that are circular in shape: *c, d, e, g,* and *o* (see Figure 11-7). I call this shape circular, but don't be mislead — the letters are not really circles. They are shaped more like curved diamonds, than actual circles. This is particularly clear if you look at the shapes of the *d* and the *o* in Figure 11-7.

Figure 11-7:
The circular letters *c, d, e, g,* and *o.*

cdego

For most people, these letters are simply a whole lot of fun to make. As you practice the circular letters, follow these tips:

✔ Focus on keeping all your strokes smooth, deliberate, and steady.

✔ Keep these letters really wide.

✔ Don't get "fussy" with the serif strokes on top of the *c, e,* and *g.* Leave them alone once you've made them. Don't go back over them and try to fix any errors.

✔ Have fun making these letters.

Letters that have strong vertical strokes

Twelve of the letters have vertical strokes that stand out as dominant features: *b, f, h, I, j, k, l, n, p, q, r,* and *u* (see Figure 11-8).

Figure 11-8:
Letters *b, f, h, I, j, k, l, n, p, q, r,* and *u.*

bfhijklnpqru

The examples of how to do these letters are pretty self-exaplanatory; however, it helps to keep the following points in mind:

✔ All the letters in this group except *q,* begin with a vertical stroke. All except *n* and *q* have a horn-shaped serif at the top of that stroke.

✔ Make sure that the vertical strokes do not slant.

✔ Make the serifs small. Make sure they are flat on top and curved on the side. Avoid serifs that look like triangular pennants!

✔ Draw really short ascenders and descenders. For example, the ascender on the *h,* does not extend very far past the top guide line.

Letters with diagonals

There are six letters that have diagonals: *a, v, w, x, y,* and *z* (see Figure 11-9). These should look familiar. Although many of the Uncial letters are decidedly different in appearance from letters in other alphabets, these letters with diagonals resemble more closely the letters in other alphabets.

Figure 11-9:
Letters with
diagonals:
a, v, w, x, y,
and *z.*

AVWXYZ

As you practice these six letters, keep these suggestions in mind:

- The diagonal that forms the right side of the *a* is made first. This is a departure from the left-to-right rule.
- The *w* has two long diagonals that are parallel.
- The right side of the *v* is exactly like the right side of the *w* and the top of the *y*.

Learning the three special letters

Three of the letters don't fit into any of the other groups *m*, *s*, and *t* (see Figure 11-10). That doesn't mean that these letters are any more difficult; they're just a little different from the others.

Figure 11-10:
Letters *m*, *s*, and *t*.

Here are a few tips to keep in mind as you practice these three letters:

✔ Keep the two halves of the *m* equal in size.

✔ Keep the bottom and top of the *s* balanced so that one does not look significantly smaller than the other.

✔ Keep the *c*-shape of the *t* centered under the horizontal on top.

Putting the Letters Together

The spacing of letters when you put them together to make words and sentences requires no special skill with this alphabet. With most other alphabets, spacing can be a problem. Not with Uncial. The only rule you need to follow is simply space the letters so they look right to you. It's that simple (see Figure 11-11).

Figure 11-11:
Words using Uncial.

You have lots more opportunities to practice all these things in the Appendix in the back of this book. But for now, use the following exercise to practice the letters from this chapter.

A QUICK BROWN FOX

JUMPS OVER THE LAZY

DOG. PACK MY BOX

WITH FIVE DOZEN LAC-

QUER JUGS.

Varying the Uncial Alphabet

The Uncial letters are extremely elastic. You can create some very interesting variations of this alphabet by simply stretching and compressing the letters. Indeed, it is virtually impossible for you to make them too wide or too narrow. In addition to variations in width, you can add flourishes and curly-cues to these letters. The Celtic scribes are especially famous for their designs.

Have fun being creative with this alphabet. Let your imagination have free rein. Experiment and see what interesting things you can do with these letters. Think of it as simply doodling with the pen.

How much experimentation is allowable and what should you avoid? The answer is not easy, because there is so much latitude with this style. However, there has to be a limit. I believe that the limit lies at the point where the letters begin to look sloppy and

hastily or haphazardly done. So, what are the guidelines that need to be followed? Really, I suggest that you follow one rule — use your imagination and be creative, but never be sloppy.

Narrow variation

One of the really interesting things you can do with this alphabet is experiment with different letter widths. A narrow width leads to a very nice variation.

Figure 11-12 is an example to give you an idea of what is possible. It isn't necessary for you to try to duplicate the letters I used. Don't copy my letters; create your own!

Figure 11-12:
A narrow variation.

THIS IS A NARROW VERSION OF UNCIAL

There are no rules about how a narrow variation should or should not be done, but here are a few helpful hints to keep in mind:

✔ Because the letters are more compact than normal, you may have to simplify the letters and eliminate some of the loops and serifs.

✔ Keep the ascenders and descenders short.

Wide variation

Perhaps you're wonering if it's possible to make the letters wide. Wide variations are not only possible, but are more adaptable to this alphabet than the narrow variation. (See Figure 11-13.) Again, I provide an illustration to give you an idea of what might be possible. I hope you feel inspired to see what you can create.

Figure 11-13:
A wide variation.

ALPHABET

Again, experiment with the letters. Create your own variations. How do they look? As you experiment with wide variations, keep these ideas in mind:

✔ Wider letters tend to look less bold. Be careful that you don't lose the contrast between the "thicks" and "thins."

✔ Just as a narrow variation makes it more difficult to maintain serifs and loops, a wide variation opens the door to add more loops and fancy stuff. This alphabet can really put on a show when the letters are wide!

Curly-cue variation

The Celtic people are famous in the world of calligraphy for their use of the Uncial alphabet. They developed an entire system of design based on this alphabet. Intricate designs, sometimes called "Celtic knots," are just one of the things they created. Today, you can see some of their handiwork in *The Book of Kells*. Figure 11-14 shows some examples of Celtic type design.

Figure 11-14: A curly-cue variation.

FLOURISHES & CURLY-CURLY-CUES.

If you want to try your hand at doing these kinds of designs follow these suggestions:

- ✔ Lightly sketch your letters and designs with a pencil before you use the pen.
- ✔ Keep your strokes fluid and smooth. This is one place where sloppy strokes will stand out.
- ✔ Get some books with Celtic designs and copy those.

The craziest variation

Figure 11-15 shows you some examples that can inspire you to try out this variation. In these examples, I have tried to be as crazy as I possibly can be and still maintain the character of the letters. I have borrowed these designs from Celtic manuscripts.

Figure 11-15: Celtic designs illustrate how expressive the designs can become.

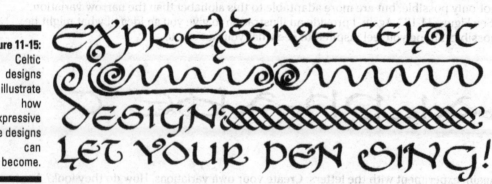

EXPRESSIVE CELTIC DESIGN LET YOUR PEN SING!

Letter fitting — a neat trick

One of the handiest things that you can do with this alphabet is fit letters together in unconventional ways (see Figure 11-16). Letters can touch and overlap. Letters can peek out from underneath other letters. Letters can be different sizes.

Figure 11-16:
Fitting
Uncial
letters
together in
interesting
and very
unconven-
tional ways.

Celtic Letter Fitting—
Put the Letters Together
In Interesting Ways.

Letter fitting can be a whole lot of fun. Experiment and try different ways of fitting letters together. As you experiment, keep these ideas in mind:

✔ Try different ways to overlap and fit letters together. You'll discover that some ways look good and other ways don't look good at all. Through trial and error, see what works for you.

✔ The key to fitting the letters together is making the letters different sizes.

✔ Always pay attention to legibility. If the letter fitting makes the words too difficult to read, simplify your design.

Fitting Letter Together — fit the letters together in interesting ways

Figure 11-16 Fitting Uncial letters together in interesting and very uncommon ways.

Letter fitting can be a whole lot of fun. Experiment and try different ways of fitting letters together. As you experiment, keep these ideas in mind.

- Try different ways to overlap and fit letters together. You'll discover that some ways look good and other ways don't look good at all. Through trial and error, see what works for you.

- The key to fitting the letters together is making the letters different sizes.

- Always pay attention to legibility. If the letter fitting makes the words too difficult to read, simplify your design.

Chapter 12

Elegantly Outlined and Decorated Letters

. .

. .

One way you can really enhance the appearance of your calligraphy and add great visual interest is to use a decorated initial. For example, if you were doing Lincoln's Gettysburg Address in calligraphy, you could begin with a large, decorated first letter. Since the Gettysburg Address begins with the words, "Fourscore and seven years ago . . ." the first letter would be a capital *f*.

Calligraphers have used large, decorated capitals in combination with "regular" calligraphy for centuries. Even though it is not new, these capitals are still very much in style today. The only difference being, today you can be a whole lot more imaginative in creating the designs for these letters than the early scribes were. People who do cross-stitch often make designs like these with initials.

Some artistic ability is definitely helpful in doing these kinds of letters, because the letters are drawn rather than written. The more artistic ability you have, the more things you will be able to do with these letters. However, in this chapter, I show you some shortcuts for drawing the letters. So, even if you have no artistic ability, you'll be able to add these letters to your repertoire.

The one thing that makes a decorated letter so spectacular is color. Once the outline of the letter has been drawn, the inside of the letter can be painted or *gilded* (covered with gold leaf), and the background can be embellished with a design and painted as well. In this chapter, I describe some easy ways that you can do those things too.

Taking the Right Approach

Using a decorated capital letter is a really easy and impressive way to "dress up" a design. It is especially effective if you are doing any kind of quotation in calligraphy. The decorated letter says to the viewer that the calligraphy is a true work of art that was created by hand; it wasn't printed on a computer.

If you're just getting started and you've never done anything like this before, use one of the templates that are available on my web site at www.studioarts.net/alphabets. After you get the hang of it, you can branch off from there.

If you're working on your own designs for decorated capitals, try to keep the designs appropriate for the subject. For example, if you are doing a poem for a child, you wouldn't want to use a letter that looked stuffy and formal; you would want to use a letter that looks informal and youthful. On the other hand, if you're working on a formal certificate, you wouldn't want to use a letter that was out of character for that kind of document.

Above all, have fun with these letters. Expand your repertoire. Expand your skills.

Getting the Right Materials

You need entirely different materials for this chapter than you did in other chapters in this book.

For the basics, you need:

- A **pencil**
- A **dip pen** with a narrow nib — 1mm or smaller
- **Ink** for the dip pen

If you want to add color, you need:

- **Acrylic paint, watercolor, or colored pencils**
- A **small round brush**

If you want to add gold leaf, you need:

- A pack of **metal leaf squares.** *Note:* I highly recommend that in the beginning, you not try to use real gold leaf. The metal leaf looks like gold and is far easier to handle. After you master the techniques of applying metal leaf, you may decide to "graduate" to using gold leaf.
- Some **gold leaf adhesive.**
- A **small jar of acrylic gesso.**
- A **larger round** or **flat watercolor brush** — like the kind of brush used for applying watercolor washes.

This is one chapter for which I won't be giving any practice exercises. Instead, you need to draw the outlines of letters or trace them from the templates that I provide. For tracing the letters, you can use tracing paper or translucent layout bond paper. For applying gold leaf and paint, a heavier weight paper is needed. The Pentalic paper that I recommend in Chapter 2 is suitable. Watercolor paper can also be used.

Drawing the Letter

You will be creating what are commonly referred to as illuminated capitals. There are three basic steps to creating these letters. First, you sketch the letter with a pencil. Second, you add color and/or gold leaf. Third, you trace over the outlines with ink.

For the sections that follow, I focus on using just one letter, the letter *y*, but you can use any letter of the alphabet.

Step 1: Sketching the letter

The first thing to do is draw the design in pencil (see Figure 12-1). You have a couple options available to you when it comes to doing this sketch. If you have the artistic ability, then by all means, use your imagination and draw the letter freehand. You can interpret a design that you have seen and liked, or you may create your own design from scratch.

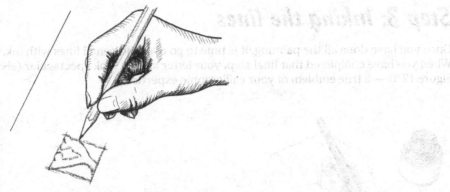

Figure 12-1:
A pencil
sketch of
the letter *y*.

An alternate method is to work from a template. All you have to do is trace or transfer the design from one of the templates available on my web site at www.studioarts.net/alphabets. If your paper is thin enough to see through, you can simply lay your paper on top of the template and trace.

If your paper is too heavy for tracing, then what you'll have to do is transfer the design:

1. **First, trace the entire design using a small piece of paper that is thin enough for tracing.**

2. **Next, turn the paper over, and on the reverse side, move the side of the pencil lead back and forth to produce shading.** Make the shading as dark as you can. Also make certain that you cover the entire surface behind the design.

3. **Finally, flip the paper right-side-up again, position it where you want the letter, and trace over the design with firm pressure.** If you have done this correctly, you'll wind up with a pale, ghost-like version of the design transferred onto the paper. You can go back over this with pencil to "firm up" the lines.

Step 2: Decorating the letters and background

After you have sketched the letter in pencil (see "Step 1: Sketching the letter," earlier) and you are happy with the way it looks, you can begin adding color to the design. Use acrylic paint or watercolor to fill in the letter with the color you want. Most often, a lighter and brighter color such as yellow against a darker background is an effective color for the letter (I get into backgrounds in the next paragraph). However, dark colors may also be used for the color of the letter.

Normally, a background that is a solid color is not as attractive as a background with a repeating design. You will find that it is fairly easy to add a design. There are a number of design motifs that are popular. A few simple ones are the horizontal lines, criss-crossed diagonal lines, floral designs, vines, and spirals (see Figure 12-2).

Figure 12-2:
Different background designs.

Step 3: Inking the lines

Once you have done all the painting, it is time to go over the pencil lines with ink. When you have completed that final step, your letter should look spectacular (see Figure 12-3) — a true emblem of your calligraphic expertise!

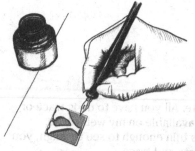

Figure 12-3:
The final, decorated letter.

Finding Alphabets You Can Use

Traditionally, the alphabets that were used for illuminated letters were the Uncial letters (see Chapter 11). The Uncial alphabet is still the one you see used most often today. It is also the alphabet from which I took the *y* I used in the earlier section, "Drawing the Letter." The Roman capitals and the Italic capitals can also look very good when used as illuminated letters. Figure 12-4 shows you an example of a template letter from the Roman capitals.

Figure 12-4:
The outlined Roman capital A fill in letter.

But, by all means, don't stop there. I have seen illuminated letters made with pictures of animals, tools, acrobats posed in different configurations, and even an alphabet where the letters were made with drawings of insects! Indeed, the only limitation to your design is your imagination. Figure 12-5 gives you an idea of something whimsical I whipped up, inspired by some alphabets from the 1700s that's appropriate to use on something for children.

Figure 12-5: A whimsical design.

You can find templates for the whimsical design, the Roman capitals, and the Uncial alphabet on my Web site at www.studioarts.net/alphabets.

Gilding: Applying Gold Leaf

The technique I describe in this section is an easy way to get the look of gold leaf. Real gold leaf is much more delicate to handle than metal leaf. For one thing, it's so thin that you don't dare touch it with your fingers. You would have to use a brush to pick it up and position it. But it's a technique that you can learn fairly easily. You can find numerous sources of information in books and on the Internet on the techniques and tools for applying real gold leaf.

When you apply gold leaf, it will make it look like it's actually made out of gold. It will not look anything like paint. It will have the luster and color of actual gold. Figure 12-6 shows a portion of a piece of calligraphy where the first letter — in this case, the letter *a* — was covered with gold leaf. On top of the gold is a design of a vine drawn in ink. Inside the letter is the same vine design. This part was tinted with watercolor.

If you've never handled gold leaf before, I recommend that you begin with metal leaf that is not pure gold. It looks like gold but it's not as fragile and difficult to handle. It's also not anywhere nearly as expensive as real gold.

Applying metal leaf is actually pretty easy:

1. **Prepare a clean work space that is free of drafts and static electricity.** Unfortunately, you won't be able to work with gold leaf sitting next to a window or a fan — the air will blow the thin leaf all over the place! Also, anything like a wool sweater that is electrically charged can attract or repel the gold leaf.

2. **Build up the area where you want to apply the leaf.** Do this by painting the area that you want to gild with three or four coats of acrylic gesso, letting each coat of gesso dry before applying the next coat. Apply the gesso as smoothly and as evenly as you can. Figure 12-7 shows this step on the left.

3. **Give the surface of the gesso a final smoothing.** Traditionally, calligraphers used agate burnishers, but the back of a spoon will do an acceptable job if you don't have a burnisher. Simply rub the surface of the gesso until it is smooth and slick.

Figure 12-6:
An actual
size
example
showing
what a
gilded letter
looks like.

And God said, after our like over the fish the air, and over the cattl over every creeping thing So God created man in h God created he him, male

4. **Apply gold leaf adhesive on top of the gesso where you want the leaf to adhere.** You do this with a small brush.

 Keep in mind that the leaf will adhere where the adhesive is and will not adhere where there is no adhesive. Be careful not to paint beyond the lines and also be careful not to leave any small unpainted areas where you want the leaf to adhere.

5. **Let the adhesive dry.** That's right — you *do not* apply the leaf to the wet adhesive. That would create a mess. (I know from personal experience!) Instead, after the adhesive has dried completely, it should remain tacky for some time, and that's when you apply the leaf.

6. **Gently pick up a sheet of metal leaf at two of the corners and slowly lay it over the area that has been prepared with gesso and adhesive.** Another way to pick up the leaf is to lay a piece of wax paper that is slightly larger than the square of leaf over the square and rub with your hand. When you lift the wax paper, the gold leaf should adhere to it. You can then lay the wax paper on top of the letter and rub again to get the leaf to adhere to the adhesive. You'll have just "one shot" in which to do this. So be careful and methodical. One sheet should cover a letter.

7. **When the leaf is in place, gently blow directly down on top of the leaf so it adheres where you want it.** The center picture in Figure 12-7 shows the gold leaf in place.

8. **Gently rub over the leaf with a soft watercolor brush.** I use what is referred to as a wash brush. Continue rubbing with the brush until you have removed all the excess leaf and all that remains is the leaf attached where you want it.

If for some reason, there is a spot where the gold leaf did not attach, you can apply adhesive to that spot, let it dry, and put a small piece of the leaf on that spot. The small pieces of leaf that are not used are usually perfect for filling in any gaps. The picture on the right in Figure 12-7 shows the finished letter.

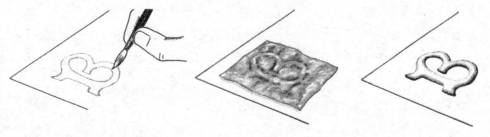

Figure 12-7:
Three steps
in the gild-
ing process.

Before you lay down the leaf, breathe onto the adhesive just exactly the same way you would if you wanted to clean the lenses on a pair of glasses. This will moisten the adhesive and increase the tackiness.

Chapter 13

A Fancy Document Script

. .

In This Chapter

▶ Looking at the Copperplate alphabet

▶ Getting a handle on how to create the lowercase letters

▶ Creating the capital letters

▶ Putting the punch on punctuation and numerals

▶ Stringing letters together to form words

. .

Copperplate? What in the world do plates made of copper have to do with a style of calligraphy?

Copperplate, also known as engraver's or engrosser's script and also as English Roundhand, originated in the sixteenth century and continued as the dominant style of lettering through the nineteenth century. It was used for engraving and for formal documents, and is a style where the pen duplicates the appearance of the script that was engraved into copper plates used for printing — hence, the name, Copperplate.

It's a very ornate style and requires an altogether different kind of pen and technique from the other styles covered in this workbook. You probably recognize Copperplate as the style used on many diplomas as well as on the U.S. Declaration of Independence and Constitution.

Copperplate is a fun alphabet to learn and practice. Not only is it fun, but, if you master this alphabet, you'll also become part of a fairly elite group. There are fewer calligraphers who practice this style than the other styles. One result of perfecting this alphabet could be that you'll gain a degree of notoriety.

In this chapter, I introduce the special, oblique pen. Then I show you how to make the strokes thick or thin and how to do ten basic strokes which you put together to make all the lowercase letters. After that, I show the capitals, numbers, and punctuation marks. I conclude this chapter with practice writing words.

Cozying Up to Copperplate

Because this alphabet is so different from the alphabets covered in the other chapters, you really don't need any prior experience before you begin this alphabet. If you have studied other alphabets, the experience in tracing and copying and the attention to detail will be valuable as you learn Copperplate. To give you an idea of what the alphabet looks like, just take a look at Figure 13-1.

$$Aa\,Bb\,Cc\,Dd\,Ee\,Ff\,Gg\,Hh\,Ii\,Jj\,Kk$$

$$Ll\,Mm\,Nn\,Oo\,Pp\,Qq\,Rr\,Ss\,Tt$$

$$Uu\,Vv\,Ww\,Xx\,Yy\,Zz$$

Figure 13-1:
The
Copperplate
alphabet.

Copperplate uses pen *pressure*, not pen *angle*, to create the thicks and thins. Copperplate also uses a special pen — the oblique pen (see Chapter 3 for more information on this type of pen). So, in the sections that follow, I explain the ins and outs, the thicks and thins, and other special requirements of the Copperplate style.

Using the special oblique pen

The special oblique pen has the point mounted at an angle on the side (see Figure 13-2). The purpose behind this odd-looking arrangement is to make it easy for you to control the slant and to make the long strokes that are characteristic of this style.

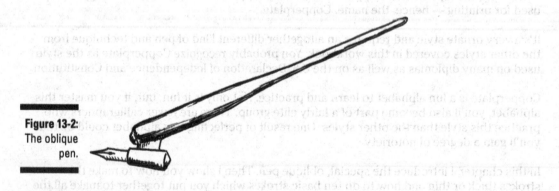

Figure 13-2:
The oblique
pen.

The ink has to be specially prepared for Copperplate. I use Higgins Eternal to which I have stirred in about a dozen drops of gum Arabic. The gum Arabic thickens the ink and also increases its surface tension. That way when you press down on the pen, the ink will cling to the opening in the point and produce the wide, heavy strokes. Without the gum Arabic, the ink would be watery and tend to break apart into droplets when the pen point spreads open.

Angles and slants

Copperplate letters have a slant of between 30 and 40 degrees from the vertical. A 36-degree slant is used most often, and that's the angle I'll use in this chapter (see Figure 13-3).

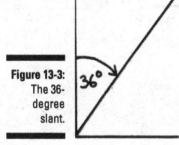

Figure 13-3: The 36-degree slant.

Because of the 36-degree slant, it's really helpful to have slant lines to follow in addition to the regular guide lines. You can draw the slant lines at the correct angle by simply drawing a diagonal on a rectangle that is 3 units wide and 4 units tall (see Figure 13-4).

Figure 13-4: Determining this slant by drawing the diagonal of a 3-by-4 rectangle.

Holding your pen

Hold your pen in a comfortable writing position and turn this page under your hand so your pen lines up perfectly with the pen in Figure 13-5. I have found that the most comfortable position for me is where the slant lines are nearly vertical. Find the position that is most comfortable for your hand.

You should maintain this position as you are lettering. The pen is not turned "this way and that" while you are writing.

Writing line

36°

slant line

oblique pen

Figure 13-5:
The position
of the pen.

Guide lines

The guide lines for Copperplate are entirely different from the guide lines for other styles (see Figure 13-6). The distances between the lines are not determined by pen width. You can make the spaces between these lines any size you like, just make sure they are all equal. You need five spaces:

- ✔ Capitals go all the way up to the top line and down to the bottom if they have a lower loop.

- ✔ The tall, looped ascenders: *b, f, h, k,* and *l* are just below the top line.

- ✔ Short ascenders: *d, p,* and *t* start just below the second line. Looped descenders: *g, j, q, y,* and *z* stop just above the lowest line.

- ✔ The short descenders: *f* and *p* stop at the line below the writing line.

- ✔ The slant lines are drawn as dotted lines. Ascenders and descenders should be drawn parallel to the slant lines.

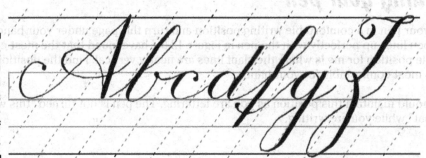

Figure 13-6:
The guide
lines and
the heights
of the differ-
ent kinds of
letters.

Controlling the pressure through thicks and thins

The pen that you'll use for Copperplate has a sharp point, and the thicks and the thins of the letters of this alphabet are created entirely by varying the amount of pressure on the pen. When you apply very light pressure, the pen will make a fine hairline. When you apply heavier pressure, the point will spread open. This should enable you to make a wider line and should be done only on the down strokes. Upstrokes are always fine hairlines that are made with only the lightest pressure.

Figure 13-7:
The thick and thin parts of the letters are created by varying the pressure on the pen point.

Practice the technique of light upstroke and heavy downstroke until you can duplicate the strokes below. Begin by tracing over the example without ink. Observe what the pen point does. Try to make the down strokes even in width. Try to make the upstrokes fine and smooth.

Learning the Ten Basic Strokes

The lower case letters are made from ten basic strokes. I show you the ten basic strokes in Figure 13-8. You can put these strokes together in different combinations to make all 26 lowercase letters.

Figure 13-8:
The ten basic strokes.

1 2 3 4 5 6 7 8 9 10

All the letters in this alphabet are drawn from top to bottom and left to right.

Here's how you do each stroke — after you read how to do each stroke, use the practice exercise that follows to trace and then copy each stroke:

- **Stroke 1 is a thin hairline.** Use a very light touch while moving the pen upward.

- **Stroke 2 is a thick line.** Use even pressure as you move the pen downward. Try to keep the width of the line as uniform as you can.

- **Stroke 3 is the horseshoe shape.** Begin at the base line with a stroke upward which is a thin hairline and end with a thick stroke downward.

- **Stroke 4 is the opposite of stroke 3.** It begins with a thick stroke downward which curves upward turning into a thin hairline.

- **Stroke 5 is a combination of 3 and 4.** It begins like stroke 3, but then it ends like stroke 4.

- **Stroke 6 is the oval.** Begin at the top and apply pressure as you draw the left side of the oval. As you reach the bottom, the stroke curves upward and changes into a thin hairline.

- **Stroke 7 is the *s* shape, which is made with a downward stroke.** Notice how the thickness of the stroke changes from thin to thick and then back to thin again.

- **Stroke 8 is the upward loop.** It begins with a stroke like stroke 1, loops over the top and turns into stroke 2.

- **Stroke 9 begins like stroke 2 except it is much longer.** At the bottom of the stroke, you curve the line to the left and continue moving the pen upward making a thin hairline.

- **Stroke 10 is a dot and a whisker.** Begin with a dot which is made by simply pressing down on the pen without making a stroke. Once you have made the dot, release the pressure on the pen and make a thin hairline which curves slightly toward the right.

Did you notice that the top and bottom of stroke 2 are square?

If you had trouble making the downstroke square, follow these steps:

1. **Lead into the downstroke with a line like the one shown in Figure 13-9.**

2. **Apply pressure to the pen, causing the point to open up toward the left.**

3. **Pull down on the stroke with even pressure.**

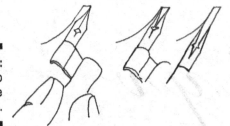

Figure 13-9:
Using line to
lead into the
stroke.

To square the bottom, roll the pen slightly to the left and lift (see Figure 13-10).

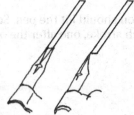

Figure 13-10:
Squaring
the bottom.

This technique requires a little practice to perfect. Try squaring this stroke in the exercise that follows.

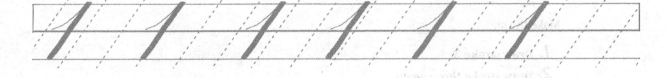

Lowercase Letters

I have divided the letters into groups according to their similarities. This is helpful in learning the letters and also maintaining uniformity.

You make the lowercase letters by combining the basic strokes. The strokes are all made from left to right.

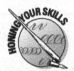

Instead of practicing all the letters of the same group together in one exercise, you need to practice these letters a bit differently because you are combining the basic strokes. So you practice each letter individually in the sections that follow. However, if you want to practice the lowercase letters even more, check out the Appendix.

Letters with the n shape

The letters with the *n* shape include: *n, m, h, p ,y,* and *v* (see Figure 13-11).

Figure 13-11:
Letters *n, m, h, p ,y,* and *v.*

nmhpyv

The lists that follow, tell you how to make each letter and give you a chance to practice each one as well.

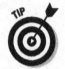

I've set up the instructions so that in between each step, you should lift the pen. So if I give you two strokes within one step, that means to do each stroke, one after the other, without lifting the pen.

Make the *n:*

1. **Draw stroke 3.**
2. **Draw stroke 5 next to the previous stroke.**

n n n n n n

Make the *m:*

1. **Draw stroke 3.**
2. **Draw stroke three again.**
3. **Draw stroke 5.**

n n m m m m

Make the *h*:

1. Draw stroke 1. Without lifting your pen, continue the line with stroke 8.
2. Draw stroke 5.

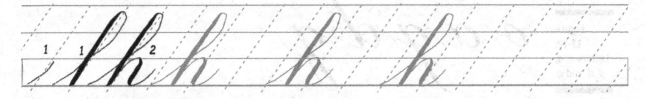

Make the *p*:

1. Draw stroke 1 followed by stroke 2.
2. Draw stroke 5.

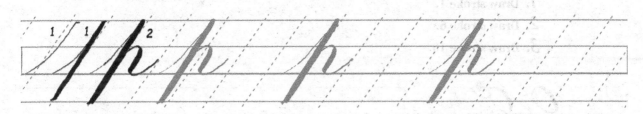

Make the *y*:

1. Draw stroke 5.
2. Draw stroke 9.
3. Draw stroke 1.

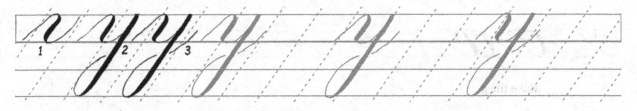

Make the *v*:

1. Draw stroke 5.
2. Draw stroke 10.

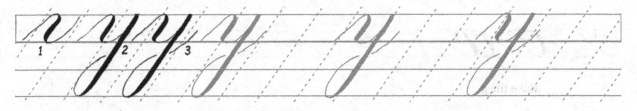

Letters with the o shape

The letters with an o shape include: o ,a ,g ,d, and q (see Figure 13-12).

Figure 13-12: Letters o, a, g ,d, and q.

o a g d q

Just follow the steps I outline below to draw each letter in this group.

Make the o:

1. Draw stroke 1.

2. Draw stroke 6.

3. Draw stroke 10.

Make the a:

1. Draw stroke 1.

2. Draw stroke 6.

3. Draw stroke 4.

Make the g:

1. Draw stroke 1.

2. Draw stroke 6.

3. Draw stroke 9.

4. Draw stroke 1.

Make the *d:*

1. Draw stroke 1.
2. Draw stroke 6.
3. Draw stroke 2.
4. Draw stroke 4.

Make the *q:*

1. Draw stroke 1.
2. Draw stroke 6.
3. Draw stroke 2 which turns into stroke 4 at the bottom.
4. Draw stroke 10.

Letters with the c shape

You only draw two letters with a *c* shape, and I give you one guess what one of those letters happens to be . . . that's right — the letter *c* — the other letter is *e* (see Figure 13-13).

Figure 13-13:
Letters *c*
and *e*.

Follow the steps for drawing each letter as you trace and copy the letter in the exercises below.

Make the *c:*

1. Draw stroke 1.
2. Draw the left half of stroke 6. Leave the right side open.
3. Draw a dot at the top.

Make the *e:*

1. Draw stroke 1.

2. Draw a small version of the first part of stroke 8. As you make the loop, draw the left half of stroke 6.

Letters with the l shape

Only a couple of letters belong in the group of *l*-shaped letters — you guessed it: *l* and *b* (see Figure 13-14).

Figure 13-14:
Letters *l*
and *b.*

Combine the basic strokes to make these letters by following the steps outlined below. Then trace and copy each letter in the exercises below.

Make the *l:*

1. Draw stroke 1.
2. Draw stroke 8. Draw stroke 4.

Make the *b:*

1. Draw stroke 1.
2. Draw stroke 8. Draw stroke 4.
3. Draw stroke 10.

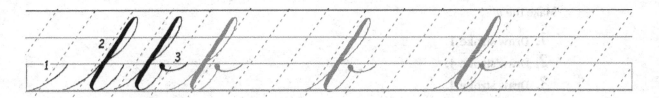

Letters with the **i** shape

In this section you can discover how to create all the letters with the *i* shape: *i, j, u, w,* and *t* (see Figure 13-15).

Figure 13-15:
Letters *i, j, u, w,* and *t.*

i j u w t

Simply follow each step below for each letter as you trace and copy the letters in the exercises below.

Make the *i:*

1. **Draw stroke 1. Draw stroke 4.**

2. **Put a dot over it.**

Make the *j:*

1. **Draw stroke 1.**

2. **Draw stroke 9.**

3. **Draw stroke 1.**

4. **Put a dot over it.**

Make the *u:*

1. Draw stroke 1.
2. Draw stroke 4.
3. Draw stroke 4.

Make the *w:*

1. Draw stroke 1.
2. Draw stroke 4.
3. Draw stroke 4.
4. Draw stroke 10.

Make the *t:*

1. Draw stroke 1.
2. Draw stroke 2.
3. Draw stroke 4.
4. Draw a crossbar.

The remaining letters

The letters *f, k, r, s, x,* and *z* don't belong to any one group, except the "leftovers" group (see Figure 13-16). So in this section, you can find out how to create each of these "leftover" letters.

Figure 13-16:
Letters *f, k,
r, s, x,* and *z.*

Just follow the steps below while you trace and copy each letter in the practice exercises.

Make the *f*:

1. Draw stroke 1.
2. Draw stroke 8.
3. Draw stroke 10.

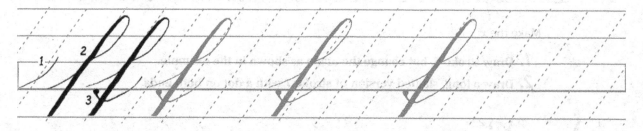

Make the *k*:

1. Draw stroke 1.
2. Draw stroke 8.
3. Draw stroke 7. Draw a small clockwise loop. Draw stroke 4.
4. Draw a dot at the top of stroke 7.

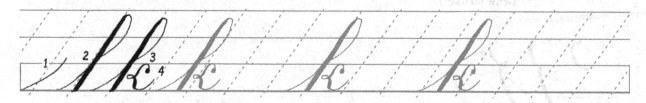

You can make the *r* two ways.

The first way by:

1. Draw stroke 3.
2. Draw stroke 1.
3. Draw stroke 10.

The second way by:

1. Draw stroke 1.
2. Draw a short stroke 10.
3. Draw stroke 4.

Make the *s:*

1. Draw stroke 1.
2. Draw stroke 7.
3. Draw stroke 10.

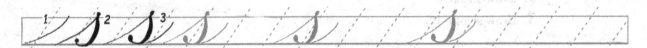

Make the *x:*

1. Draw stroke 5, but change the angle as shown in the example.
2. Draw a long, slanted version of stroke 7 with a dot on both ends.

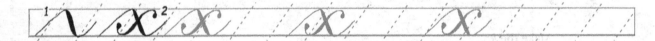

Make the *z:*

1. Draw stroke 3 which you end by making a curve to the left. Continue with a small clockwise loop.
2. Draw stroke 9 curved slightly.
3. Draw stroke 1.

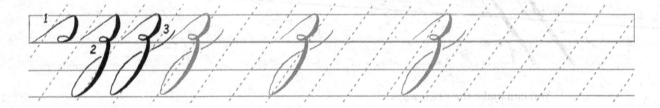

Capital Letters

The capital letters in this alphabet are really tall. Their tops touch the top ascender line. The capital letters that have lower loops (*g, j,* and *y*) extend all the way down to the bottom descender line. The capital letters do not use the ten basic strokes. As you practice these letters, concentrate on keeping the strokes smooth and even.

Letters with the i shape

The five letters in this group *(i, f, g, j,* and *t)* all have a long, thick stroke through the middle (see Figure 13-17).

Check out the numbered steps to find out how you can create each of these capital letters. The practice exercises that follow each letter's description give you a chance to trace and copy each letter so you can perfect each stroke.

Figure 13-17:
Letters *i, f,*
g, j, and *t.*

Make the *i*:

1. Draw a thin, curving hairline.

2. Draw a heavy stroke downward which ends with a curve to the left and a dot.

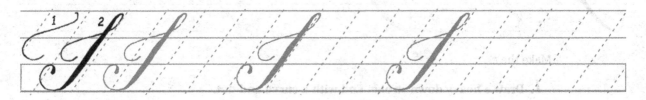

Make the *f*:

1. Draw a heavy down stroke. End with a curve and dot.

2. Draw a wavy line on top.

3. Draw a small looping stroke through the middle.

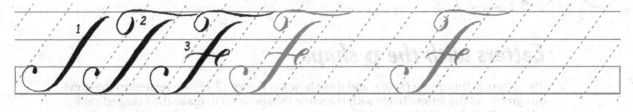

Make the *g*:

1. Draw a spiraling stroke counter-clockwise.

2. Draw a heavy downward stroke all the way to the bottom descender line. End with a curve to the left and a dot.

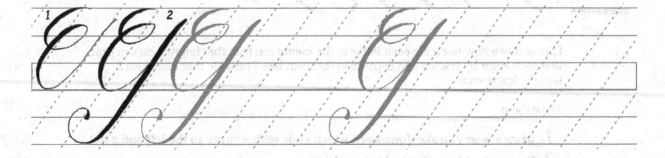

Make the *j*:

1. Draw a thin, curving hairline.
2. Draw a heavy stroke downward to the bottom descender line. Finish with a hairline loop.
3. Draw basic stroke 1.

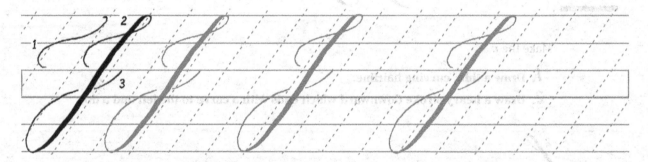

Make the *t*:

1. Draw a heavy down stroke. End with a curve and dot.
2. Draw a wavy line on top.

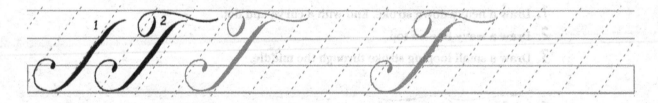

Letters with the p shape

The letters in this group (*p*, *b*, *r*, and *d* as shown in Figure 13-18) are related to the previous group. All the letters begin with the same *i* shape used to make the *i*-shaped capitals (see "Letters with the *i* shape," above).

Figure 13-18:
Letters *p*, *b*, *r*, and *d*.

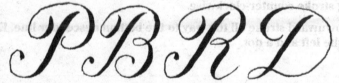

I break down how to create each letter in the numbered lists that follow. You can practice each letter by tracing and copying in the exercises I provide that follow each letter's description.

Make the *p*:

1. Draw a heavy stroke downward which ends with a curve to the left and a dot.
2. Draw a double curve stroke over the top.

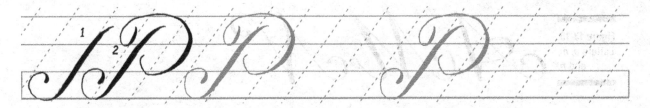

Make the *b:*

1. Draw a heavy stroke downward which ends with a curve to the left and a dot.

2. Draw a triple loop shape that begins on the left side and ends on the right side as shown.

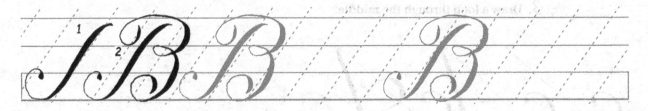

Make the *r:*

1. Draw a heavy stroke downward which ends with a curve to the left and a dot.

2. Draw a double loop shape that ends with basic stroke 4.

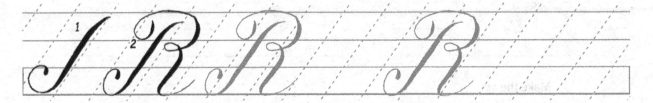

Make the *d:*

1. Draw a heavy stroke downward which ends with a small curve to the left.

2. Draw a hairline stroke back around the right side of the letter that ends with a loop.

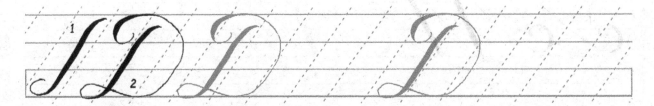

Letters with the a shape

The letters in this group include *a, m,* and *n.* All these letters have upward pointing, sharp angles. (See Figure 13-19.)

Figure 13-19:
Letters *a*, *m*,
and *n*.

\mathcal{AMN}

Practice each letter by following the steps and using the exercises I provide below.

Make the *a*:

1. Draw a dot, a narrow curve, a straight line that goes up sharply to the point.
2. Draw a heavy, straight line to form the other leg of the letter.
3. Draw a loop through the middle.

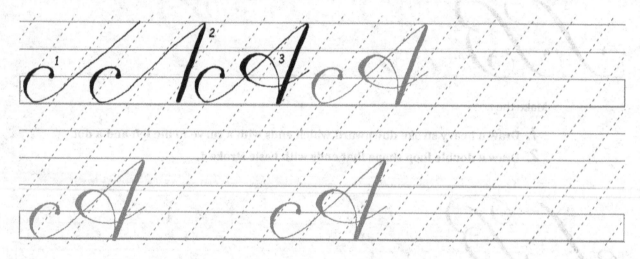

Make the *m*:

1. Draw a dot, a narrow curve, and a straight line that goes up sharply to a point.
2. Draw a heavy, straight line downward, a hairline upward and a heavy line downward that ends with basic stroke 4.

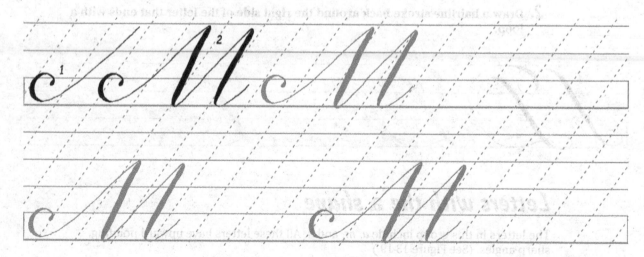

Make the *n:*

1. Draw a dot, a narrow curve, and a straight line that goes up sharply to a point.

2. Draw a heavy, straight line downward and a hairline upward that ends with small clockwise curve at the top.

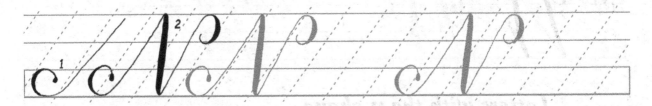

Letters with the v shape

The capital *v* and *w* have downward pointing sharp angles as shown in Figure 13-20.

Figure 13-20:
Letters *v*
and *w*.

Try your hand at lettering the *v* and *w* by following the steps below. Apply each step to the trace-and-copy exercise that follows each letter.

Make the *v:*

1. Draw basic stroke 5.
2. Draw a slightly curving, heavy stroke down to the writing line.
3. Draw a hairline going up that curves and ends with a dot.

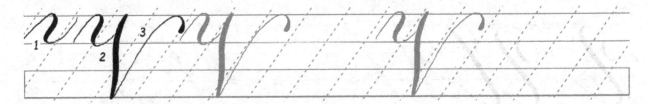

Make the *w:*

1. Draw basic stroke 5.
2. Draw a slightly curving, heavy stroke down to the writing line.

3. Draw a hairline upward. Draw a second curving, heavy stroke down to the writing line.

4. Draw a hairline upward that ends with a curve and a dot.

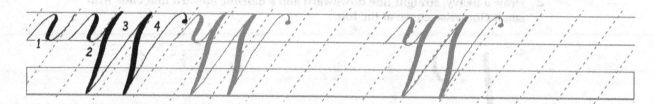

Letters with the u *shape*

The two letters in this group, *u* and *y*, look exactly alike above the writing line. The only difference is the *y* has a descender loop. (See Figure 13-21.)

Figure 13-21:
Letters
u and *y*.

You, too, can create these letters — it just takes some practice. I give you simple steps you can use while practicing each letter in the exercises below.

Make the *u:*

1. Draw a clockwise loop which becomes a heavy down stroke. At the bottom, curve the stroke to the right and continue upward.

2. Draw a heavy downward stroke which turns into basic stroke 4 at the writing line.

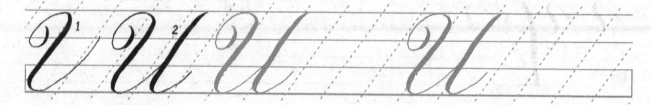

Make the *y* by following all the steps for the U except the final downstroke becomes a long loop:

1. Draw a clockwise loop which becomes a heavy down stroke. At the bottom, curve the stroke to the right and continue upward.

2. Draw a long, heavy downward stroke which turns basic stroke 9. Draw basic stroke 1.

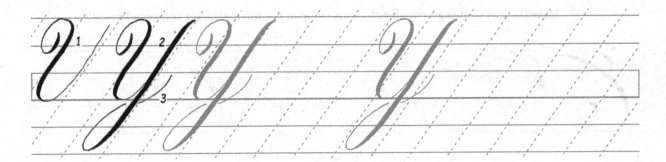

Letters with the o shape

Three letters — *o, q, c* — have counter-clockwise ovals. (See Figure 13-22.)

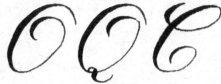

Figure 13-22:
Letters *o, q,*
and c.

Make the most of the numbered lists below — follow the steps as you practice each letter in the exercises below.

Make the *o* by drawing a counter-clockwise spiral.

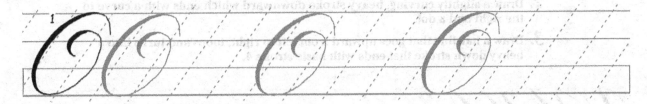

Make the *q*:

1. Draw a counter-clockwise spiral.

2. Draw a little S-shaped line at the bottom.

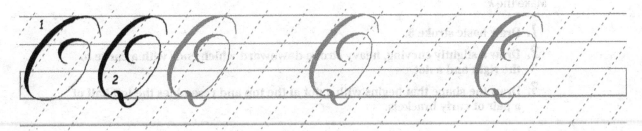

Make the c by drawing a counter-clockwise loop at the top and larger curve underneath.

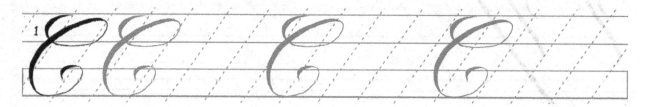

Letters h and k

Two letters are in this group — h and k. (See Figure 13-23.)

Figure 13-23:
Letters h
and k.

Get a handle on creating these letters by tracing and copying the letters in the exercises below. Just follow the steps I provide for each letter while you practice.

Make the h:

1. Draw basic stroke 5.

2. Draw a slightly curving, heavy stroke downward which ends with a curve to the right and a dot.

3. Draw a hairline that goes upward from left to right, loops and turns into a heavy down stroke that ends with basic stroke 4.

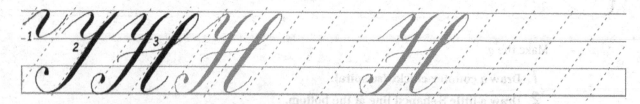

Make the k:

1. Draw basic stroke 5.

2. Draw a slightly curving, heavy stroke downward which ends with a curve to the right and a dot.

3. Draw the shape that begins with a dot at the top and resembles the left half of a pair of curly brackets.

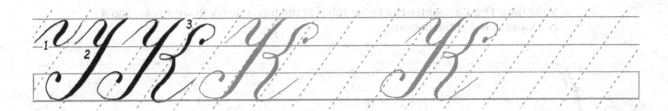

The remaining letters

This group includes 5 letters (*e*, *l*, *s*, *x*, and *z*). They are shown in Figure 13-24.

Figure 13-24:
Letters *e*, *l*,
s, *x*, and z.

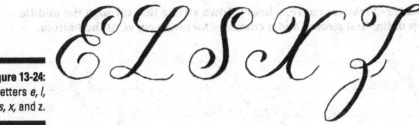

Follow the steps I provide below while practicing each letter. Just trace and copy the letters in the exercises.

Make the *e* by drawing three counter-clockwise curves.

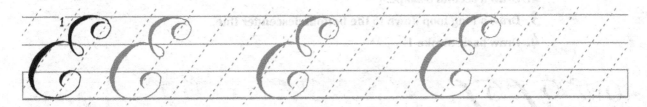

Make the *l*:

1. Begin like you are going to make a *c*, but make the loop smaller and follow it with a broad downstroke that loops to the left in a clockwise fashion and then sweeps to the right with light pressure.

2. Draw a small counter-clockwise curve. Draw a heavy down stroke that loops to left in a clockwise fashion and then sweeps to the right as a hairline.

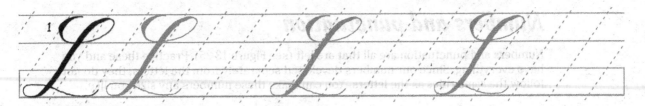

Make the *s.* Draw a counter-clockwise spiral at the top, a heavy down stroke, and a clockwise spiral at the bottom.

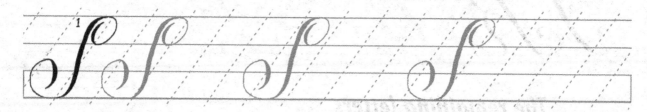

Make the *x:*

1. **Draw a clockwise spiral, a heavy down stroke, and another clockwise spiral.**

2. **Draw a counter-clockwise curve, a heavy down stroke that through the middle goes on top of the first stroke, and a counter-clockwise curve at the bottom.**

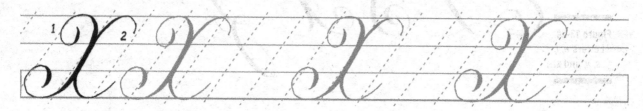

Make the *z:*

1. **Draw a small, horizontal S-shape.**

2. **Draw a second S-shape.**

3. **Draw a long loop down to the bottom descender line.**

4. **Draw basic stroke 1.**

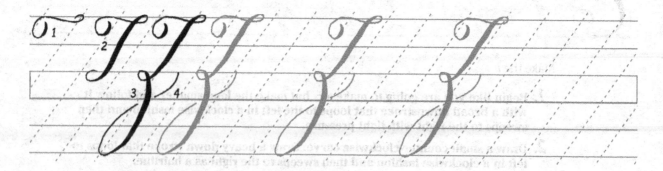

Numbers and punctuation

Numbers and punctuation are all that are left (see Figure 13-25). Practice these and you have everything. Since our numbers developed separately from the letters, they do not follow the same rules as the letters. You can make these numbers any size you like.

Figure 13-25:
The
numerals
and
punctuation.

1 2 3 4 5 6 7 8 9 0
& ?., ! : ; " "

Now you can add numerals and punctuation to your practice. I explain how to create each numeral in the steps below. The punctuation should be completely self-explanatory.

Make the *1:*

1. Draw a light upstroke hairline.

2. When you reach the top, make a downward stroke while gradually increasing the pressure so that the bottom is wider than the top.

Make the *2:* Draw a curly cue, a clockwise curve over the top, and end with a little squiggle at the bottom.

Make the *3:* Draw a curly cue and two clockwise half-circles that are linked by a small loop. End with a hairline that curves around.

Make the *4:*

1. Draw a long down stroke that begins with a slight curve at the top.

2. Draw a seond, smaller downstroke to the left of the first one. Make a loop, and a wavy line to the right.

Make the 5:

1. Draw a down stroke which is followed by a clockwise half circle that ends in a curly cue.

2. Draw a slightly curved line across the top.

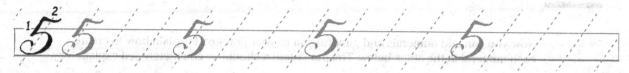

Make the 6:

1. Draw a large curved, down stroke for the left side.

2. Draw a smaller down stroke curved the opposite direction for the right side.

Make the 7:

1. Draw a wavy line on top similar to basic stroke 5.

2. Draw a downward stroke while gradually increasing the pressure so that the bottom is wider than the top.

Make the 8:

1. Make an S-shape and at the bottom, curve the stroke back up to the middle.

2. Draw basic stroke 1.

Make the 9:

1. Draw a small, curved, down stroke for the left side.

2. Draw a larger down stroke curved the opposite direction for the right side.

Make the *0:*

1. Draw a curved, down stroke for the left side.
2. Draw a down stroke curved the opposite direction for the right side.

Make the *&:*

1. Draw a slightly curved, down stroke.
2. Draw a backwards S-shape that crosses over the first stroke and ends with a small curve.

Make the *?:*

1. Draw a clockwise spiral that ends with a small counter-clockwise "hook" at the bottom.
2. Draw a dot.

All the other punctuation marks are pretty self-explanatory — you can handle them!

Putting It All Together

When you begin working on writing words, spacing is important. As you practice lettering words in Copperplate strive to keep the down strokes as evenly spaced as possible. It usually helps if you pencil in the letters lightly before you do them with the pen.

Pay close attention to the contrast between your thick and thin strokes. This contrast needs to be strong. Just look at Figure 13-26 for an example.

Figure 13-26:
Examples
of words
drawn in
Copperplate.

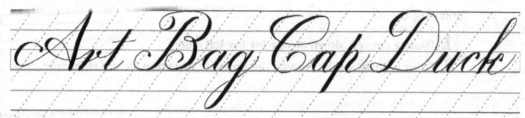

Figure 13-26:
Examples
of words
drawn in
Copperplate.

Now that you have an idea of spacing, give it a try in the exercise below. You can find more opportunities in the appendix to practice drawing words using the Copperplate alphabet.

Part IV
Popular Projects

The 5th Wave By Rich Tennant

"I make a little money on the side with my calligraphy,
mostly doing the usual things — eviction notices,
cease and desist orders, felony warrants..."

In this part . . .

Part IV is all about some of the fantastic things you can do with calligraphy. In this part, you see how to take a famous quotation or favorite saying and turn it into an impressive work of art, make an eye-catching sign or poster, create a certificate or award (whether serious or just for fun), design monograms, add borders to your calligraphy, add a touch of elegance to envelopes, mount your work on plaques, and, if you happen to do other kinds of art, combine calligraphy with other art media such as painting.

To maximize your calligraphy skills, make sure you try at least some of these projects. There's enough variety in this part so there's bound to be something here that appeals to everyone.

Now you can show off those calligraphy skills you've been practicing and really impress the people you know. The things you can make in this part make excellent gifts as well as saleable items. What's more, they're all just plain fun to do.

Chapter 14

Designing and Lettering a Quotation

. .

In This Chapter

▶ Getting what you need to succeed

▶ Getting a glimpse of good arrangement

▶ Examining different ways to design a quotation

▶ Doing a preliminary sketch

▶ Using harmony and contrast in your designs

▶ Making your designs interesting

▶ Looking at sources for quotations

. .

*O*ne of the first things you might want to try with calligraphy is lettering a favorite saying or quotation. If this is something that you'd like to try, you have just landed upon the most popular thing that calligraphers do — lettering quotations.

Lettering a quotation or saying in an artistic and compelling style is the special province of the calligrapher. You can see many examples of quotations done in calligraphy in greeting cards, plaques, posters, and inspirational artwork.

Throughout this chapter, when I use the term *design*, I'm not talking about adding designs to artwork. Basically, when I mention *design*, it means the same as *layout*. Layout has to do with the way the calligraphy is arranged or laid out on the paper and is at least as important as the lettering itself. It has to do with the overall scheme of where you position things on the paper. If you work on creating a strong layout, you can create a more appealing overall appearance than if the design is weak. By giving thought to the design, you can transform an unimpressive piece of calligraphy into a compelling work of art.

In this chapter, I give you some ideas that you can use for doing quotations in calligraphy. Specifically, I provide you with a selection of ready-made designs, plus I give you pointers on design elements such as arrangement, harmony and contrast, ways to avoid dullness. And I give you some great ideas for making your quotation unique and eye-catching.

Gathering What You Need

In order to use all of the ideas in this chapter, here's what you need:

✔ You should already be able to letter two or more alphabets. If you know just one alphabet, you can still use most of the ideas from this chapter.

✔ You should have a fountain pen or a dip pen. See Chapter 2 where I discuss pens.

✔ You need appropriate paper. You can start with the Stratmore paper I mention in Chapter 2.

✔ You should also know how to draw guide lines on the paper or, if the paper is thin enough to see through, how to use a sheet with guide lines underneath the paper. See Chapter 3 for information about drawing guide lines.

Arranging the Lines

If you have a short quotation or saying, the first thing is to decide how you want to arrange the words in lines. The goal is to arrange the words of the quotation in a way that is appropriate to the meaning.

Take a look at the two examples in Figure 14-1:

✔ The quote on the top is too fragmented, and the meaning has been distorted.

✔ The quote on the bottom needs more line breaks — it's not easy to read.

Love suffereth
long and is kind;
Love envieth
not; love vaunteth
not itself.

Figure 14-1:
Poor examples of arrangement.

Love suffereth long and is kind; love envieth not;
love vaunteth not itself.

Now take a look at the same quote arranged appropriately (see Figure 14-2).

Love suffereth long
and is kind;
love envieth not;
love vaunteth not itself.

Figure 14-2:
An example of a nice arrangement.

Deciding on Design

After you have arranged the words, the next step is to decide how to set up the design. In the sections that follow, I cover three kinds of flush designs and one design that is symmetrical. I tell you not only what they are but also how you can do them.

Flush left

To understand what a flush left design entails, look at the lines of text in this paragraph. They're all lined up on the left side so they begin at exactly the same distance from the left-hand edge of the paper. You could draw a straight line down through the first letter of every line. On the right side, the lines of text do not line up evenly. The term used to describe the design of this paragraph is "flush left." Flush left is the simplest and easiest design (see Figure 14-3).

Figure 14-3: Flush left design.

To create a flush left design, you don't have to do anything special; you basically write the way you normally do. But here are some things to keep in mind:

- You may want to draw a vertical line for your left margin.

- Since a flush left design looks so commonplace, you might want to "dress things up" by adding other design elements such as flourishes or variations in letter style or size to give your design more visual interest. Figure 14-4 shows you an example of a dressed-up design. In this example, a variation of Italic has been used with Roman. The first word has been off-set slightly to the left and flourishes have been added.

Figure 14-4: A flush left design that has been "dressed up."

Certainly
The Art of Writing
is the most miraculous
of all things CARLYLE
man has devised.

Flush right

Flush right (see Figure 14-5) means that all the lines of text line up on the right side. This design takes some planning but is not really difficult.

Figure 14-5:
Flush right
design.

To create a flush right design:

1. **You need to do a preliminary version.** The preliminary will provide you with spacing guides. To do the preliminary, letter the entire text flush left on a sheet of sketch paper. To speed things up you can use a marker if you have one that has the same size nib as the pen you are going to use for the final version.

2. **Lightly pencil in guide lines and also a vertical line for the right margin on the paper where you'll do your final version.**

3. **Cut out one line at a time from your preliminary and tape it in position to the left of the right margin pencil line and above the space to be lettered on the final version.**

4. **Letter the line on your final version using the strip above the line to gauge the spacing.**

5. **Repeat the second step for each successive line of text.**

You can see an example of a preliminary version in Figure 14-6.

Place another piece of paper underneath your writing hand. This protects the paper from the natural oils from your hand as you're lettering. I like to use a small piece of heavy-weight watercolor paper under my hand as I work.

Figure 14-6:
Using strips
from a
preliminary
version
as guides
for the final
version.

An Example *Line cut from "prelim" layout* right margin line (erased later)

This is an example of how to do a flush right design.

This is an example of how to do a flush right design. Line of final design

(The line on the "prelim" serves as a guide for lettering the final)

Symmetrical

Symmetrical (see Figure 14-7) means that each line of text is centered horizontally on the page. This design also requires planning, but is also fairly easy.

Figure 14-7:
Symmetrical
design.

You can create a symmetrical design by

- Using the same method of cutting strips for flush right (see "Flush right" above) except instead of positioning the preliminary copy on the right margin, line it up with a center line that you draw on the final version (see Figure 14-8).

- The center of a strip can be found easily and accurately by simply folding the strip in half (see Figure 14-8).

Symmetrical Design
Symmetrical Design

Figure 14-8:
Using a pre-
liminary ver-
sion to line
up the final
version.

Flush left and right

Flush left and right (see Figure 14-9) requires that all the lines begin at the same distance from the left edge and end at the same distance from the right edge. This is the most challenging of the four designs.

Figure 14-9:
Flush left
and right
design.

A flush left and right layout requires that you make a two-step preliminary before you letter the entire thing in ink:

1. **Letter the text in pencil flush left on a piece of sketch paper.** Do this lightly, because you're going to go over it with ink. Take care to make the right margin as close to even as you can.

2. **Draw a vertical line (also lightly) down the right side of the preliminary which coincides with the end of your longest line of text.**

3. **Estimate how much additional space to add between each word.** Estimate the additional increment between words that makes the line the right length.

4. **Reletter the whole thing in ink.** Expand the spaces between words so that every line ends exactly at the right margin line.

5. **Cut the lines into strips, positioning the strips above the line to be lettered.**

6. **Letter the text on the final version.**

Sketching

The best way to begin planning how you are going to design a quotation is sketching. Make several "thumbnail" sketches of different possibilities. Experiment with different ideas. Since it's only a sketch, you have nothing to lose by trying all kinds of ideas. See how many different designs you can come up with. Explore all the possibilities. It is always a good idea to have a clear idea of what you want to do before you touch pen to paper.

I normally do anywhere from four to a dozen sketches before I take another step. In fact, I don't like to move onto the next step until I am really happy with a design that I have sketched out. Once I have a sketch of a design that I like, I usually do one more sketch where I try to refine the idea.

Exploiting Harmony and Contrast

A really good design makes use of both harmony and contrast. Harmony is what unifies the design, and contrast gives it interest. You can use this principle in your designs.

Harmony or unity is the most important element. You achieve unity through a consistent style and size of the letters you use. The layout ties it all together.

Contrasts are created by using more than one alphabet, having different sizes and weights (boldness) letters, adding embellishments and flourishes, and using different colors. If you have too many contrasts, the harmony will be destroyed. Contrasts are necessary to create interest, but they should be used judiciously.

Without some contrasts, you run the risk of having a design which looks dull and boring. Most designs need some contrasts. Here are some general suggestions to follow:

✔ You can use two alphabets in a design but be careful if you use more than two. When you use two alphabets, the rule is that the older one should come before the later one. For example, use Roman before Italic (see Figure 14-10).

✔ You can make one letter or one word stand out by making it larger and/or bolder than the others.

✔ If you add flourishes, use restraint. Usually, too few is better than too many.

✔ You can add color.

✔ You can add designs or drawn images (see Figure 14-11).

Making the margins too narrow is the most common mistake that students make. Narrow margins make the calligraphy look cramped. Keep your margins nice and wide.

Figure 14-10:
A flush left and right design using two alphabets.

Figure 14-11:
A symmetrical design using three alphabets and a drawn image.

Positioning a Large Word

Another, less traditional way to design a quote is to make one word larger than the others.

You can place the word that is larger than the others in several different ways. The obvious placement is centered at the top — just like a title, but you can also place the word in other places. It can be at the bottom, in the middle, or along the side. Also, it does not have to be in a straight, horizontal line; it can be slanted or even curved (see Figure 14-12)!

Figure 14-12:
Some of the
many possi-
bilities for
positioning
a large
word in
your design.

Incorporating Designs and Drawn Images

If you can draw and paint, you should definitely consider combining calligraphy with those other art forms. On the simplest level, you can use painting to enhance and illustrate the calligraphy. When art is used in this way, you could say that it's subordinate to the calligraphy.

On a more sophisticated level, you might combine calligraphy with other other art forms so that they work together on a more equal footing. This marriage of painting and calligraphy in this way has been recognized for centuries in Asian art but has not really established itself in Western art.

Finding Quotations You Can Use

When you use quotations, you have to be careful that you don't break any copyright laws. Use quotations where there is no copyright or the copyright has expired. Please respect the copyright laws — they are the only protection that artists have against theft and plagiarism.

Become a collector of quotations. Keep a file of material that you can use as a resource for your calligraphy. An excellent place to find quotations is online. You can find an unlimited wealth of material on the Internet. One source that I especially like is www. cybernation.com/quotationcenter. I like their Ultimate Success Quotation Library software, because it comes with over 54,000 famous quotations and allows you to add more quotations to the library as well as edit them. It is the only software like it that I know of. It's a jim-dandy filing system for the quotation collector.

Chapter 15

Creating a Poster or Sign

• •

In This Chapter

▶ Assessing your skills and materials

▶ Looking at pull-stroke letters

▶ Avoiding three common errors

▶ Creating effective poster designs

▶ Doing large-scale letters

▶ Getting started with brush letters

• •

*O*ne of the most practical things you can do with calligraphy is make a poster or sign. You may be called upon to use your calligraphic skills by a club, organization, civic group, or school that needs to announce an upcoming event. If you agree to do the job, it would be your responsibility to create an effective design that would get the word out to the public. In most cases, the poster or sign would be displayed on a bulletin board or displayed in the area where the advertising needs to be done.

Tools and Skills to Polish a Poster

To create a poster or sign as I describe in this chapter, here's what you need:

✔ **You should be able to do at least two alphabets.** In Part II, I show you how to do several alphabets that you can use for a poster or sign project.

✔ **You need poster-size paper.** Refer to chapter two for recommendations for paper. Poster board is not recommended.

✔ **You need to know how to draw guide lines.** You can find that information in Chapter 3.

✔ **You need to know how to use a dip pen.** You can find out more about using dip pens in Chapter 3. For many posters, you want to make large bold letters, and for that you have the option of using special pens with nibs that are ¼ to 1½ inches wide. These are usually referred to simply as *poster pens*. Two well-known brands are the Automatic pens and Coit pens. Sometimes wide markers can be used if you don't want to invest in poster pens and if the finest pen work is not required. Also, you can draw the outlines of the letters and fill them in. See the section, "How to do large-scale letters," later in this chapter, for methods on filling in outlined letters.

Both Automatic and Coit pens have handles permanently attached to the nibs. You can use nonwaterproof inks as well as water-based tempera poster paints with these pens. It is inadvisable to use waterproof inks or acrylic paint, because both of these can dry in the pen and clog it. You would fill these pens just as you would a standard dip pen — from the side using a small paint brush or dropper stopper (see Chapter 3).

When you use large pens, the way you do some of the letters I explain in this book may have to be modified. The larger dip pens sometimes splatter ink if you try to push the nib away from you. If this is the case with a pen you're trying to use, you have to avoid push strokes and make all your strokes pull strokes. This is especially true of the Italic lower case letters (see "Using Pull-Stroke Italic" below for more information).

Using Pull-Stroke Italic

In Chapter 4 I explain that you make the Italic lowercase letters in one continuous stroke. The letter *o* is a good example. That method works just fine for the fountain pen and smaller nibs of the dip pen, but some larger nibs in dip pens and especially poster pens tend to dig into the paper and spatter ink if you attempt to push the pen. Whenever you run into that situation you have to make certain that you use only *pull strokes*. Pull strokes are made by pulling the pen in a diection toward you rather than pushing it. For example, when I describe the Italic *o* (Chapters 4 and 5), I show that it is made in one continuous stroke. In this instance, you pull the pen to make the left side of the letter and push the pen to swing back up and make the right side.

This is not difficult because most of the alphabets use all pull strokes anyway. It is Italic that will cause you the most problems. The solution is simple — use the opportunity in the sections that follow to practice Italic using pull strokes.

Figure 15-1 shows the lowercase Italic letters done in all pull strokes (the arrows show the directions that the pen moves). For example, instead of making the lower case *o* in one continuous stroke, you can make the same shape letter in two pull strokes. If you've done any of the alphabet chapters aside from Italic (see Part II), this shouldn't be a really new concept because the two pull-stroke method is exactly how the *o* is made in all the other alphabets explained in this book.

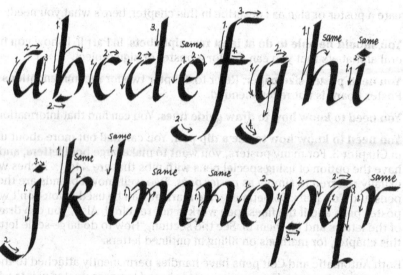

Figure 15-1:
The pull-stroke Italic lowercase letters.

Avoiding Common Errors in Design

Good design, especially the effective use of harmony and contrast, is part of making a good poster. Read Chapter 14 for more on the ins and outs of good design. On the other hand, whenever I teach poster design to a calligraphy class, I reveal common errors after discussing good design. Doing so really illuminates the benefits of good design. So in this section, I show you some of the best and worst designs, but let me warn you first about the Bad Poster Artist.

You can find in every community a person spreading bad art who goes by the name Bad Poster Artist. You know who I'm talking about. Bad Poster Artist attempts to harm the good name of artists like you and me. Beware: I think he has put at least one of his bad posters on every bulletin board in your community. He has spread his bad posters all over the place — the coffee shop, the grocery store, the gym, and he's probably even infiltrated the schools. You've seen his posters. His posters are always on a full sheet of poster board, and they look like Figure 15-2. Help me to defend our communities against the Bad Poster Artist by promoting the use of well-designed posters everywhere!

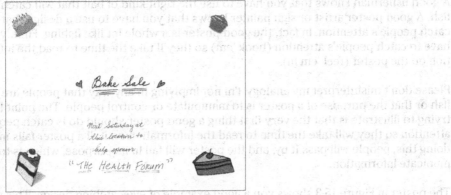

Figure 15-2:
The work of the notorious Bad Poster Artist.

Figure 15-2 shows you three common errors typically found in bad poster design:

✔ **The overall design (if you dare even call this a design) is unattractive and unexciting.** This poster is not going to catch anyone's attention. The lack of strong design shows that not much thought or imagination went into making it. It looks like it was done very hastily. Pasting on a few cut-outs of cakes and pies from a magazine will not save this design!

✔ **There are problems with the way the words are written.**

 • None of the words are large enough and bold enough to be read easily at a distance.

 • Underlining certainly doesn't help.

 • There is a mishmash of cursive handwriting, lowercase printing, and capital letters, which is ineffective at best.

 • The letters are not used correctly, attractively, or effectively.

✔ **The white space is used very poorly.** There is far too much *white space* (space without text or other decorative design elements) that gives this poster an empty look. The words appear lost in all that white space.

Making a Good Poster

If the problems with a bad poster are unattractive design, poor lettering, and poor use of white space (see the section above, "Avoiding Common Errors in Design"), then a good poster must include

- An attractive design that catches the eye
- Good lettering that's easy to read
- Effective use of the white space

I explain each of these aspects of a good poster in the sections that follow.

It's just like fishing — hook 'em and reel 'em in!

A good fisherman knows that you have to use the right kind of bait that will catch the fish. A good poster artist or sign painter knows that you have to use a design that will catch people's attention. In fact, the good poster is a whole lot like fishing. First, you have to catch people's attention (hook 'em) so they'll take the time to read the information on the poster (reel 'em in).

Please don't misinterpret my analogy. I'm not implying in any way that people are like fish or that the purpose of a poster is to manipulate or control people. The point I'm trying to illustrate is that the very first thing a good poster should do is catch people's attention so they will take the time to read the information on it. If a poster fails in doing this, people will pass it by, and the poster will fail in its purpose, which is to communicate information.

The poster in Figure 15-3 shows you a good example of eye-catching design. This poster had a small amount of information to communicate. It uses large, bold letters to attract attention and smaller letters of different styles to organize the details. There are two lettering styles — Bookhand and Italic (see Chapters 10 and 6, respectively). These two styles go together very harmoniously. The drawing ties in well with the letters. Everything in this poster was black and white except for an eye-popping accent — the drop of paint was brilliant red.

Figure 15-3:
Eye-
catching
design.

When you set out to design a poster, you need to bait that hook. Follow these tips to make sure your bait reels everybody in:

- ✔ **Consider how to attract attention from a distance.** Usually this is done by making one or more of the words stand out large and bold enough to be clearly legible at a distance of about fifty feet. Bright colors and eye-catching images can also be used to attract attention.

- ✔ **Do lots of planning and sketching before you actually begin to work on the poster itself.** Use sketches to develop your design. When you have finished sketching, you should have a pretty clear idea already worked out of how the poster is going to look before you begin the actual lettering of the poster.

- ✔ **Use variety.** Organize the information in an easy-to-read form. The primary way that you can do this is to use letters of different sizes and styles. By using two or three styles of lettering and different size letters, you can organize the information in an easy-to-read way (see the next section, "Using effective lettering," for more information).

- ✔ **Think about how you're utilizing the white space.** An effective design should look neither cramped nor empty. (See the section, "Making the most of white space," later in this chapter for more on working with white space.)

Using effective lettering

Effective lettering makes a good poster. Effective lettering means using the letters to create the desired effect. There are several ways to do this. Figure 15-4 is a poster that I used to advertise some summer art classes. This poster is a good example of using large and bold letters to catch the eye and also using different styles and sizes to organize the information in an easy-to-read format. Since this poster contains a lot of information, it was vital that the information be well organized. When you have a lot of information, the problem is to keep the poster from looking cluttered and difficult to read. This design which includes the decorative embellishments to the letters and all headings and subheadings was carefully worked out in advance before I did the poster.

Figure 15-4: Effective lettering on a poster.

The primary things you can do to insure the effectiveness of your letters are:

- ✔ Selecting a style of lettering that is entirely appropriate for the subject
- ✔ Making sure the style is easy to read
- ✔ Making the letters large enough so they can be read at a reasonable distance
- ✔ Organizing the information in order of importance so the main idea stands out and supporting information is a smaller size

Making the most of white space

If you've ever taken art classes, you may have studied what is called "negative space" and how important it is to composition. When I refer to white space, I am, of course, referring to the spaces that are left blank. Artists call this "negative space" as opposed to "positive space" which the images occupy. If you have a knowledge of how to work with negative space, apply that knowledge here.

Figure 15-5 shows you how to manage white space, especially when you don't have a lot of text to work with. This poster uses art images (the cartoon image of the artist and the stars) to create an eye-catching design.

Figure 15-5: Managing white space like a pro.

Follow these tips in making the most of the white space:

- ✔ Avoid leaving spaces that look too symmetrical. Symmetry is too easy to ignore. Strive to create a design that people won't ignore.
- ✔ Avoid spaces that are too much the same size. Strive to have a variety of sizes.
- ✔ Look at the way the space is designed in advertisements in the media. Gather ideas that you can use.

Making Large-Scale Letters

In the sections that follow, I describe for you a couple of ways to make large-scale letters.

The two-pencil method

If you don't have poster pens, one option is to draw the outlines of the letters and fill them in. An easy way that you can draw the outlines is to use two pencils that are taped together. The way this is done is to hold the points of the two pencils so they duplicate the pen angle. For example, if you are lettering Italic letters, a line between the two points of the pencils should be 45 degrees.

Look at Figure 15-6 to see how the two pencils are held for making Italic letters.

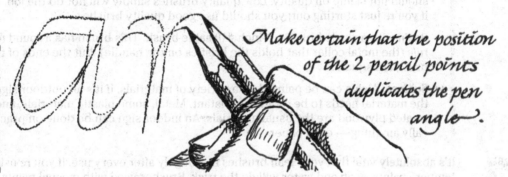

Figure 15-6:
Holding your
pencils
when using
the two-
pencil
method.

Make certain that the position of the 2 pencil points duplicates the pen angle.

The one thing this example does not show is the guide lines. You can calculate the distance between the guide lines by multiplying the distance between the pencil points by the number of pen widths in the normal letter height. Italic letters, for example, would need guide lines that are five times the distance between the pencil points.

Using standard size pencils, I calculate that the distance between guide lines should be about 2¾ inches. That would make the capital letters one and a half times that measurement which is 4⅛ inches — a pretty big letter.

The compass method

Another method that you can use that works similarly to the two-pencil method is to use a compass (the kind you use for drawing circles, not for finding north) which is designed so you can put pencil lead in both points. School compasses are not designed to do this. The only kind of compass that I have seen that is designed to do this is a draftsman's compass that allows you to exchange points.

The advantage that the compass gives you is you can adjust the distance between the points as far apart as you like. Simply use the distance between the points as the pen width of the letters you want to make.

Brushing on Letters for Signs

If you're interested in doing signs, you must learn to letter with a brush. Signs are all around us. Their purpose is mainly commercial. They are used for all kinds of things from identifying things like stores, office buildings, churches, parks, etc., to advertisng businesses and products, to giving us directions like road signs. Signs come in all

sizes — from the small sign outsde a public restroom to a large billboard type sign. The brush gives you a complete range of size and style. With the brush you are not restricted by the width of a pen. Also, and this is critical because most signs are displayed outdoors, the brush allows you to use waterproof and weatherproof paints.

To successfully brush letters onto signs, you need the right tools:

✔ **Paint:** The best paint for signs is sign painter's enamel, but you may want to practice with showcard poster paints that you can wash out with water.

✔ **Brush:** Good sign painting brushes are not cheap. In selecting brushes, you should not skimp on quality. Low quality brushes simply will not do the job. Even if you're just starting out, you should use good quality brushes.

Begin with a single brush, a ¼-inch #10 sable brush. This brush has a round *ferrule* (the metal collar that holds the bristles on the handle), but the ends of the brush are square.

✔ **Surface:** A sign can be painted on a variety of materials. If it's an outdoor sign, the material needs to be weather-resistant. Metal, some plastic materials, and treated plywood are the usual materials. An indoor sign can be done on practically anything — even paper.

It's absolutely vital that you clean brushes thoroughly after every use. If you're using tempera paints, soap and water will do the trick. Brushes used with enamel paints will have to be washed with paint thinner first and then soap and water. After you wash a brush, pinch the bristles just below the ferrule and run your fingers down to the end to squeeze out any excess water and to reshape the bristles. Brushes should be stored vertically on end in a cup or holder with the bristles pointing up. Good brushes will last for years if they are properly cared for.

Before you begin actually making your sign, get a feel for actually using the brush and paint:

1. **Hold the brush correctly:**

• Hold the brush between the thumb and index finger with the trademark up.

• Hold the brush almost perpendicular to the surface. (See Figure 15-7.) If the surface is flat, the brush will be held just about vertically above the surface. That way, the the flat edge of the brush duplicates the thicks and thins of the calligraphy pen.

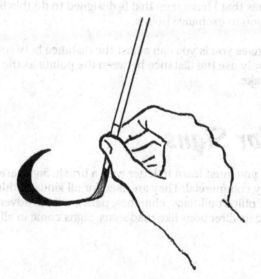

Figure 15-7: Holding the brush.

2. **Dip the brush into the paint and practice making strokes.**

3. **See how much paint is just the right amount for making smooth, clean strokes that are not too wet and not too dry.** The right amount of paint will give you total control of the application of paint. With too much paint the stroke will be uncontrollable; with too little, the stroke will be too dry and the paint will not flow smoothly from the brush.

4. **Make the letters uniform in thickness.** You have to twirl the brush slightly with your thumb and finger so that the flat part of the brush always follows the width of the letters. This requires a little practice but isn't really difficult to do.

Because the end of the brush is flat, you can use it to duplicate the thicks and thins of all the pen-lettered alphabets. The flat end of the brush will behave just like the chisel edge of a pen nib.

2. Dip the brush into the paint and practice making strokes.

3. See how much paint is just the right amount for making smooth, clean strokes that are not too wet and not too dry. The right amount of paint will give you total control of the application of paint. With too much paint the stroke will be unmanageable, with too little, the stroke will be too dry and the paint will not flow smoothly from the brush.

4. Make the letters uniform in thickness. You have to twist the brush slightly with your thumb and finger so that the flat part of the brush always follows the width of the letters. This requires a little practice but isn't really difficult to do.

Because the end of the brush is flat, you can use it to duplicate the thicks and thins of all the pen-lettered alphabets. The flat end of the brush will behave just like the chisel edge of a pen nib.

Chapter 16

Certificates

· ·

In This Chapter

▶ Looking at the materials you need

▶ Filling in names on preprinted certificates

▶ Creating a certificate from scratch

▶ Fixing mistakes

▶ Presenting your finished work

· ·

After people discover that you can do calligraphy, it's inevitable that you'll be asked to do certificates. The most common job you'll be asked to do is fill in names on preprinted certificates, which is a pretty easy job. In other cases, someone may ask you to create a hand-lettered, custom-designed certificate. In this case, you would have to design and create a one-of-a-kind certificate.

Although certificates are most often used to recognize achievement, to honor service, or recognize the completion of a training program or course of study, like a graduation diploma, certificates don't always have to be totally serious. A certificate can be humorous and unofficial, as well. In this chapter, I touch upon different kinds of certificate projects, from the simplest to the most demanding and from the serious to the sarcastic, and I give you plenty of pointers so you can do all kinds of certificates well (see Figure 16-1 for a couple of examples).

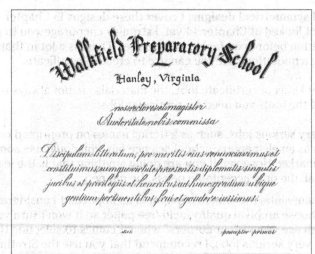
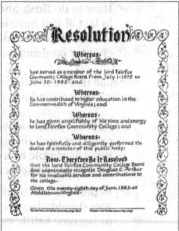

Figure 16-1:
Examples
of finished
certificates.

Not all certificates have to be dead-pan serious and formal. Figure 16-2 gives you an example of a certificate that I did just for fun — a diploma for a Master's degree from the college of hard knocks! The translation of the Latin phrase is "There's no free lunch."

Figure 16-2:
A master's
degree
from the
college
of hard
knocks.

Making Sure Your Materials and Skills Are in Order

To do certificates you need to know:

- **At least one alphabet really well:** If you know two or more alphabets, that is even better. Which alphabets are the best ones for certificates? I suggest you use these alphabets in the following ways:

 Italic, Bookhand, or Copperplate for the main text

 Roman, Blackletter, or Uncial for the titles

- **How to draw guide lines:** You can find out more about drawing guide lines in Chapter 3.

- **How to do flush and symmetrical designs:** I cover these designs in Chapter 14. In fact, if you have not looked at Chapter 14 yet, I strongly encourage you to go through that information before you tackle this chapter. There is a lot in that chapter on designing a quotation that you can use to create a certificate.

Because there are different kinds of certificate jobs, the materials are not always the same. Here's a rundown of the tools you need for particular jobs:

- **Pen:** For small, not very serious jobs, such as lettering names on preprinted certificates for such things as an elementary school science fair, you could use something as simple as a marker. However, if you are doing anything that is the least bit serious and official, the only acceptable pen is the dip pen.

- **Paper:** For official documents, the choice of paper is an important consideration. You should always choose archival quality, acid-free paper so it won't turn yellow or become brittle with age. Never "cut corners" when it comes to selecting the paper. For small, not very serious jobs, I recommend that you use the Strathmore or Pentalic paper I describe in Chapter 2.

In this chapter, I explain the basics of using a mock-up which you place underneath the real certificate to serve as a guide for your lettering. For that reason, my instructions assume that you will be using paper that is lightweight enough for you to see through.

You can get archival quality paper that is manufactured to resemble parchment. There are several brands available, and it is usually called "calligraphy parchment." The lighter weights of this paper are fairly translucent and are an excellent choice for a certificate.

Filling In Names on Prepared Certificates

How difficult can it be to write some names on preprinted certificates? It's not very difficult at all:

✔ **Prepare to use a spare.** Always ask for at least one extra certificate so you can test your pens to see which pen is the best choice. Unfortunately, many certificates are printed on paper that causes some inks to bleed. When this happens, you may have to resort to using a marker. Also some certificates are printed on a slick kind of paper that will cause your pen to skip or the ink to smear too easily. Experiment with your pens to see which one is best for the job.

✔ **Obtain the spelling and capitalization of names.** Make sure that you know the exact spelling and capitalization of all the names before you begin. I always request a written list to work from. Because you can spell and capitalize names in so many different ways, I just don't trust my own ability to get them right.

✔ **Use a simple technique to center names.** Normally names have to be centered on certificates, and some people are very good at doing this by eye, but not me. Here's the technique I use (find out more about this technique in Chapter 14):

1. **Letter all the names on another piece of paper.**

2. **Cut the names into individual strips.**

3. **Center the strips above or below (depending upon your preference) the space on the certificate where you plan to letter the name.** The easiest way to locate the center of a strip is to hold it up to a light and fold it so the first letter overlaps the last letter of the name. The fold is the center. You can find the center line of the certificate by just measuring it.

Working from Scratch

Creating a certificate from scratch may seem like a daunting task if you've never done anything like it before. However, I'm confident, if you already know how to do a couple alphabets and you've lettered some quotations (see Chapter 14), that you're ready to take the plunge. Making a certificate can be an exciting and rewarding challenge!

If you want the experience of making a certificate but no one has asked you to do one, you can always think of someone you know who deserves recognition and make one for that person. Your certificate could be a "World's Most Extraordinary" award for a boss, spouse, doctor, friend, babysitter, teacher, pastor, neighbor — you get the idea.

In the following sections, I make sure you get the right start and take all the right steps to make your certificate the best it can be. If you do make a mistake, however, I give some pointers on that as well (see "Fixing Mistakes," later in this chapter).

Although in this section I show you the simplest method for designing and creating a certificate, it doesn't mean that you'll get mediocre results. Your results will look totally professional in all respects. Just follow these steps to get started right:

1. **Make certain you have the exact wording for the certificate.** The wording needs to be one hundred percent accurate and the grammar, spelling, and punctuation

must be error-free. This is something that you cannot afford to make a mistake about. It could be incredibly embarrassing if, for example, a word was misspelled or a date was incorrect and no one noticed until after the certificate was presented. Sometimes, just to be absolutely certain that everything is correct, I have enlisted the help of an English teacher to proofread the wording for me.

2. **Make several preliminary sketches to develop an appropriate design for the certificate.** In selecting a design, take into consideration how formal the award is. A design for a high school graduation diploma should be more formal than a diploma for kindergarten graduation. A design for an award honoring a person at retirement for many years of service should look different from an award for a company's top sales representative.

Figure 16-3 shows three very basic designs for certificates – the basic symmetrical design, the symmetrical design with a curved title, and the same design with the addition of a border.

If this is your first experience making a certificate, I strongly recommend that you stick pretty close to one of these basic designs. You can become more adventuresome with your designs once you've mastered a basic certificate.

3. **Make a rough drawing that shows the wording and the placement of each line of writing as it will appear on the certificate.** Decide how you are going to give emphasis to the wording by the sizes, styles, and weight of the letters.

Think in terms of a hierarchy of emphasis. What is the most important thing to emphasize? What should be the most prominent line of text? What should be second, third, fourth, and so on? Create a visual order of emphasis by using different sizes, weights, and styles of letters. The most important words — usually the title — should be the largest and boldest letters. The least important should be the smallest and lightest. Generally:

> The title has the largest and boldest letters.
>
> The body of the certificate has the medium size and weight letters.
>
> The text for date and signatures is the smallest of all.
>
> When different alphabets are used together within the same design, the rule is that they are used in their historical order. For example, Roman, Uncial, and Blackletter should be used before Italic, Bookhand, or Copperplate.

Figure 16-3:
Three basic, traditional designs — a good starting place.

Creating a mock-up

Using a mock-up makes it easy to create a number of copies of the same certificate. This is especially helpful if you know you'll be called upon to produce a specific kind of certificate on a repeated basis. If you've already decided on a design for your certificate (if not, see the section, "Working from Scratch," above), you can begin to create

the mock-up. Just follow these steps (see Figure 16-4 for examples of two finished mock-ups):

1. **Letter all the lines of writing on a separate sheet of paper.** Use the same styles and sizes for the letters that you plan to have on the finished certificate — this is, after all, the mock-up. You can draw guide lines if you want to.

Don't be concerned at all about the placement of the lines of text on the page. Simply concentrate on good lettering with good spacing. If you intend to curve the title, go ahead and letter it as a straight line. After you create your mock-up, you can curve the title; just check out the section, "Curving the title" to discover a simple technique to get this done.

2. **Cut all the lines of text into strips.**

3. **Rule off guide lines for your design on another sheet that's exactly the same size of the finished certificate you're creating.**

4. **Attach the strips onto this sheet in their correct positions.**

Although the final product should always be done with a dip pen, the pen sizes that you use for the lettering on the mock-up need only be the same size as the dip pens you will use on the certificate. You don't have to use a dip pen for the mock-up. As long as the pen nibs are exactly the same size, you can use markers or a fountain pen if you feel more comfortable working with it.

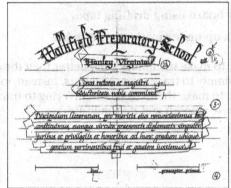 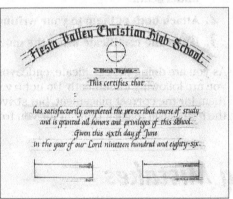

Figure 16-4:
Two mock-up examples.

Curving the title

If you want to curve one or more of the strips, here's a simple, almost fool-proof method you can use (Figure 16-5 shows you the curved title on a mock-up):

1. **Use a compass to draw an arc to represent the curved base line exactly the way you want it on your mock-up.**

2. **Take the strip and mark the center.**

3. **Trim away everything below the writing line (including the descenders).**

4. **Cut slits in between each of the letters, position the strip on the mock-up, and**

5. **Bend (carefully!) the strip to conform to the curve that you drew on the mock-up.**

6. **Tape it down when you have it correctly positioned.**

7. Darken all the guide lines on your mock-up by tracing over them with a marker.

Figure 16-5:
A curved title on a mock-up. Note the cropped *g*.

Lettering the actual certificate

After you create a mock-up (if you haven't yet, I highly recommend it — just check out "Creating a mock-up," above for details), the only thing you have left to do is letter the actual certificate:

1. **Place the blank certificate paper on top of the mock-up so the writing is visible underneath.**

2. **Attach both of them to your writing board using drafting tape.**

3. **Letter the certificate using the mock-up underneath as your guide.**

TIP

As you are doing the certificate, endeavor to make the letters even better than the ones you are following underneath. Do not try simply to trace over the letters. Instead, follow them for the correct placement, but strive to make them even better. Trying to trace the letters will make it difficult for you to use smooth and rhythmic strokes.

Fixing Mistakes

If you make a mistake lettering the certificate, it usually means that you must start over. However, in some instances, you can make minor corrections. Try to make a correction before you decide to throw your work away and start over. Remember, if you can't make a correction successfully, which means the correction must be invisible; you have to start over.

You can try to make a correction by using one of the following techniques:

✔ **Remove the error with a scrape.** A very small amount of "erasing" can sometimes be done by the following method:

 1. **Make sure the ink is completely dry.**

 2. **Use a new, clean, single-edge razor blade to gently scrape away the mistake.** Actually, you will be shaving away a very thin layer of the paper. This will only work on good quality paper that is thick enough to withstand the scraping.

 3. **Use a burnisher to smooth the paper where you scraped, if you successfully removed the mistake by scraping it.** Burnishing should enable you to letter on top of the correction.

- ✔ **Alter the letter to look like another.** Sometimes when you have made the wrong letter, you can alter it slightly by a combination of erasing and relettering. For example, the letter *r* can easily be changed into an *n*.

- ✔ **Put a design on top of the mistake.** For example, once when I finished lettering a quotation, much to my consternation, I discovered a drop of ink that had splattered near the bottom. I simply drew a small star on top of it and placed another star at the bottom so the two were perfectly balanced. They looked completely intentional. No one ever suspected that one of the stars covered a mistake!

With the widespread use of correction fluid, I feel compelled to add that you should never use correction fluid on a hand-lettered certificate. The only time it is acceptable to use correction fluid is when you are creating something that will be photocopied.

Adding spaces for signatures, dates, and seals

Certificates usually require dates and signatures. If you need to draw lines for these, the best implement for doing the job is a ruling pen (see Figure 16-6), which should be available at any store that sells drafting supplies. They're also available from John Neal Booksellers (see Chapter 2 about materials and supplies).

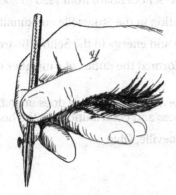

Figure 16-6:
Using a
ruling pen.

Ruling pens are really quite easy to use and give you a perfect line of very fine width which is perfect for a certificate. The ruling pen has a knob on the side for adjusting the width, and you fill it from the side. Always use the ruling pen with a straight edge.

If you've never used a ruling pen before, I encourage you to get one and try it. I think you'll be amazed at how perfect the lines are that you can draw with it.

Running for the border

A border around the edge of the certificate can sometimes be a highly effective part of your design. If you want to use a border, just make sure that it doesn't overpower the rest of your design. The best rule to follow when it comes to using a border is that an understated border is usually never a problem, but a border that is too wide or looks too dark and heavy will always spoil the design. See Chapter 17 for more on borders.

Resolutions

This is not about the kind of resolutions you make at New Year's but special kinds of certificates that are used to honor someone's service to an organization or community. Official resolutions are hardly ever preprinted (at least I know of none). They almost always have to be done by hand.

The form of the official resolution is simple:

- ✔ At the top is the word "Resolution."
- ✔ The text is a series of statements preceded by the word "Whereas."
- ✔ After each "Whereas" there is a comma.
- ✔ At the end of each Whereas statement there is a semi-colon and the word *and.*
- ✔ After the series of "Whereas" statements, a closing statement begins with the phrase "Now, Therefore Be It Resolved."

Here is an example of how a resolution might be worded:

Resolution

Whereas, John Smith has served the Stoneville School Board from 1995 to 2006; and

Whereas, he has contributed to public education in the Stoneville community; and

Whereas, he has given unselfishly of his time and energy to the School Board; and

Whereas, he has faithfully and diligently performed the duties of a member of this public body;

Now, Therefore Be It Resolved that the Stoneville School Board does unanimously recognize John Smith for his invaluable services and contributions to the board.

Given this _____ day of (month), (year), at Stoneville, Ohio.

Polishing Your Work with a Presentation Folder

When it comes time to deliver your finished work, it's important that you put some thought and preparation into how you're going to present it for final approval.

I like to make a nice, hinged folder with silk ribbons fixed in the corners to hold the finished certificate in place (see Figure 16-7). The folder can also have a ribbon tie on it, and on the outside of the folder you can put your business card or a decorative label that has your client's name and your name done in calligraphy. You can even place the folder on a lightweight display easel at the time of the "unveiling."

Having a presentation folder is not necessary by any means, but I believe it's to your advantage to show off your work in the best possible way. As they say, you have only one chance to make a first impression, and a presentation certainly has an element of making a first impression. It really helps if the client goes "Wow!" when he or she first sees what you have created.

The folder also allows you to keep the certificate out of view until just the right time to show it. If you are presenting the certificate to more than one person, you can make certain that you have everyone's attention and that everyone has a good vantage point before you lift the flap.

It never hurts to add a little dramatic flair whenever you present your artwork to a client. I have found that people love it; it highlights the value of your work and makes them feel important, too. Plus it's simple:

✔ Use mat board for the flap.

✔ Use ³⁄₁₆-inch thick, black Gator board for the backing of the folder.

✔ Use cloth decorator tape to secure the ribbons for the corners and to make a hinge at the top for the flap.

✔ Thread the ribbon ties through holes punched in the boards.

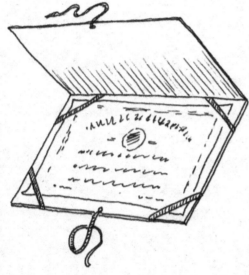

Figure 16-7:
The completed work in an elegant-looking presentation folder.

The folder idea allows you to keep the certificate out of view until just the right time to show it. If you are presenting the certificate to more than one person, you can make certain that you have everyone's attention and that everyone has a good vantage point before you lift the flap.

It never hurts to be a little dramatic than whenever you present your artwork to a client. I have found that people love it; it highlights the value of your work and makes them feel important, too. Plus it's simple:

- Use mat board for the flap.
- Use... the Black Outer board for the backing of the folder.
- Use cloth decorator tape to secure the ribbons for the corners and to make a hinge at the top for the flap.
- Thread the ribbon ties through holes punched in the boards.

Figure 16-7: The completed artwork in an elegant looking presentation folder.

Chapter 17

More Things to Do
with Your Calligraphy

In This Chapter

▶ Trying some doodles and drawings with the calligraphy pen

▶ Designing monograms

▶ Using different kinds of border designs

▶ Addressing envelopes

▶ Making plaques

▶ Using calligraphy in artwork

You can do so much with calligraphy. Entire books have been written on the subject of calligraphy projects, and I wish I could put an extensive description of the many projects you can do in just one book. But with quotes, posters, signs, certificates, invitations, works of art . . . there's virtually no limit to the number of ways that you can use calligraphy.

Although I can't describe every potential project for you, I can give you an idea of a few of the more popular projects that calligraphers enjoy. Use these ideas and examples for inspiration and try some of these projects or develop some ideas of your own — the possibilities are endless.

To do the projects in this chapter you should be proficient at lettering one or more alphabets and have the materials I discuss in Chapter 2.

Calligraphic Doodles and Drawings

Have you tried doodling with the broad-edge pen? Because of the way the nib makes thick and thin strokes, you can use the pen to produce some very interesting drawings.

Pen drawings can be combined with calligraphy in many different ways. They can add interest to an address on an envelope, or they can illustrate a narrative. Pen drawings add interest and a touch of personality wherever they are used. Figure 17-1 gives you a sampling of some calligraphic doodles.

Figure 17-1:
A few doodles with the broad-edge pen.

Some people have a real knack for pen doodling and others do not. Granted, drawing with the pen isn't for everyone, but for some people it's tremendous fun. If you've never thought of drawing with the calligraphy pen, give it a try. Just keep these tips in mind:

✔ **Use the thicks and thins to enhance the doodle or drawing.** The best doodles are the ones where the placement of the thicks and thins is an important element in making the drawing look right. So, as you work with the pen, think about whether you want a line to be thick or thin. Turn the paper so you'll be able to draw at the angle that will enable you to make the thicks and thins where you want them. Manipulate the pen so you can begin a stroke thick and end it thin.

✔ **Don't worry about rules on pen angle.** In fact, broad-edge pen drawing requires that you change the angle for each part of the drawing so you can control where you make the thicks and thins.

✔ **Begin with a sketch.** Sketch your doodles lightly with a pencil first and then develop them in pen. Don't just trace over your pencil sketch; instead, give careful thought to how you're going to make each stroke — make each stroke count.

Monograms

Monograms are extremely popular. Primarily, they are used on stationery, but they can be used anywhere you want to use them. Monograms are quite popular as a design for programs, napkins, and so on, especially at weddings. For more information on the subject of weddings, please check out Chapter 18.

Making a nice monogram takes at least two steps:

1. **Sketch a lot of designs to see which letter styles look best.**

2. **Letter the final version of the design.**

A monogram usually has three capital letters with the letter in the middle being the largest and most prominent. The letters on either side are smaller. The large center letter is the initial of the last name. The two smaller letters on either side are given names. (For a wedding, these would be the initials of the first names of the bride and groom.)

The best monogram designs are worked out through a process of discovery and elimination through sketching and re-sketching until you arrive at a good design which is visually pleasing. If you've never done a monogram before, it can be a time-consuming process. The more experience you have in making monograms, the easier it becomes.

A simple shortcut that you can use is to make a letter in the center which has straight sides. That way you can position letters on both sides close to the center letter, and the three letters will look like a single unit. Capital letters with straight sides are made similar to Blackletter (see Chapter 8) with simple diamond, vertical, and diagonal strokes.

Figure 17-2 shows three examples of monograms where the center letters have straight sides. Notice in the example that the smaller letters were done with a different size nib than the large letters.

Figure 17-2: Examples of monograms.

A Potpourri of Border Designs

Borders are not really a separate project. You use borders as design elements in other projects. You can use borders with just about anything that you do in calligraphy. Of course, some things definitely look better than others with borders on them. Other things would look odd with a border. For example, maps should always have borders, but name tags should never have them.

Still wondering when you should use a border with your calligraphy? The answer is simple: Use a border whenever you think it will enhance the appearance of your calligraphy. You're the judge. There's no rule — not even for maps and name tags.

Borders can be official looking or whimsical or anything in between. The border can go around all four sides or just run down one side or be only at the top and bottom. Using borders means that you have a lot of choices.

There do seem to be a few border designs that calligraphers use more than others. And, there's a reason they're so popular — they look good and they're not difficult to do. These are the ones I want to show you.

Check out these three kinds of borders and see which ones strike your fancy:

- Drawn with the broad pen
- Drawn with a ruling pen
- Drawn in a fine line with a pointed nib

Borders drawn with the broad pen usually have a darker overall appearance than borders drawn with a fine line. Those drawn with a ruling pen have straight lines. Figure 17-3 gives you an idea of the contrast between borders drawn with a broad pen and straight-line borders drawn with a ruling pen.

Borders drawn with a sharp-pointed drawing pen give you the advantage of coloring them in. Figure 17-4 shows a border which was drawn with a sharp-pointed pen. This is one time when waterproof India ink is called for. If you outline the design in waterproof ink, you can fill it in with watercolor.

A
Potpourri

Figure 17-3:
Borders
drawn with
the calligra-
phy pen and
ruling pen.

How do you determine how wide or narrow to make a border? It has to be done entirely by eye. There are no rules. Just use what looks good to you. This "do it by eye" approach also applies to deciding what size letters to use and what size guide lines to draw. The purpose of making preliminary sketches is to try things out and decide what you think looks best.

Figure 17-4:
A border
that was
drawn with
a sharp-
pointed pen.

Because all borders must have a uniform look to them, it is important to sketch them before you draw them with the pen. The sketch usually involves measuring so that the design can be repeated at regular intervals.

If you are creating a mock-up that will be used underneath your final work as a guide, the border sketch is all you need. It can be darkened so it will be easy for you to see it and follow the lines. That is the case with the example in Figure 17-5.

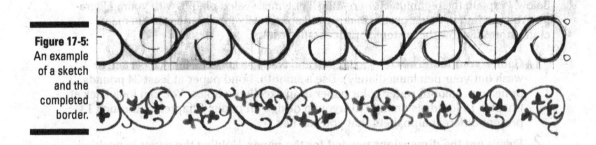

Figure 17-5: An example of a sketch and the completed border.

Addressing Envelopes

Addressing envelopes gives you a great opportunity to use flourishes and embellishments. You can use more flourishes on the envelope than you ever would dare to use on a letter inside the envelope. An envelope that has been addressed in calligraphy makes a truly positive impression on the recipient.

The simplest way to address an envelope is to use a sheet with guide lines drawn on it which you slip inside the envelope. The paper on the envelope should be thin enough for you to see the guide lines. Follow these lines when you write the address on the outside.

Don't overdo the flourishes. Think of the person's name and address as a unit. Use flourishes to pull the design together, not to make it look fragmented.

Figure 17-6 gives you a couple of examples of envelopes addressed using calligraphy. The example on the left also incorporates a small watercolor picture.

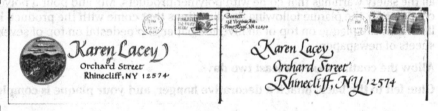

Figure 17-6: Envelopes addressed in calligraphic writing.

Plaques

A really interesting and fun thing to do with your calligraphy is make commemorative plaques. Anything from a favorite saying or recipe to an award can be made into a nice plaque. Plaques make fantastic gifts. I had a student once who gave plaques to everyone on her Christmas list — she said that she had a "plaque-a-thon."

Basically a plaque is a piece of wood with beveled edges and a flat surface on which a piece of paper has been mounted. The best plaques have a permanent, clear coating which seals everything in. You can usually find unfinished wood plaques at hobby and crafts stores.

Below, I explain the technique for creating a polymer sealed-plaque with your calligraphy. You can find polymer products designed specifically for this purpose in many crafts stores. Follow these steps for successful results:

1. **Gather your materials.** Use a dip pen and waterproof India ink (be certain to wash out your pen immediately). Use a smooth, bond paper at least 24 pounds or heavier. Smooth water color paper is an excellent choice. You can look back at Chapter 16 for ideas on how to layout a design on paper. Chapters 4 through 13 present different alphabets that you can use.

2. **Figure out the dimensions needed for the paper.** Holding the paper in position with one hand, press down on the paper with the thumb of your other hand where the edge of the plaque is. This should make an impression in the paper of the front surface area of the plaque. Do the calligraphy inside this area, cut it out, and have it ready. In this instance, measuring is not a practical way to size the paper, because the rectangular surfaces of plaques are frequently out of square. Also, you may want to work on plaques that are oval or heart-shaped.

3. **Prepare the plaque.** Sand the plaque really well and then paint or stain the entire front surface and sides. You don't have to paint the back, but you should paint or stain the entire front. A mistake that some people make is not to paint the area that the paper is going to cover. That is a mistake because the paper often becomes transparent enough for you to see the contrast between the painted and unpainted areas.

4. **Attach the paper.** When the paint is dry, attach the paper to the front of the plaque using white glue applied to the back of the paper with a stiff brush. This is the tricky part — work fast!

5. **Seal the deal.** After the glue has dried, the surface must be sealed. Apply a coat of sealer such as modge-podge over everything except the back. A second coat is a precaution worth the time and effort.

 There are some safety precautions with this step. Be especially careful to follow all the safety warnings that come with polymer products. Mix and pour a polymer coating over the plaque following the directions that come with the product. I like to set the plaque on top of an inverted paper cup pedestal on top of several sheets of newspaper.

6. **Allow the coating to set at least two days.**

7. **Glue felt to the back, attach a decorative hanger, and your plaque is complete.**

The important thing about doing plaques is to be careful and take your time. Don't rush the process. Set up a work space and work step by step, and make small plaques at first until you have mastered the technique.

Combining Calligraphy and Other Art Media

In Asian art, calligraphy has been considered a fine art as opposed to being merely a craft. Using calligraphy as part of paintings has been a tradition in Chinese and Japanese art for centuries. In Western art, the tradition has been to view calligraphy not as a fine art but merely as a craft. Fortunately, that predjudice against calligraphy is dissolving. If you do any kind of art at all, I encourage you to feel free to incorporate calligraphy into your art, whether it be drawing, painting, or printmaking.

You don't have to just incorporate calligraphy into art; you can also create art where the letters themselves are the design elements. In other words, calligraphy is not

incorporated into a design; calligraphy is the design. Figure 17-7 is an example of this kind of design.

Figure 17-7: A design made with the letters.

Calligraphy can be used with computer art. You might be wondering why the letters in Figure 17-7 aren't black, so I'll tell you my trick. First, I drew the letters with a pen. They were originally done in black ink on white paper. Then I scanned and manipulated them using a graphics editor with my computer.

Figure 17-8 shows how calligraphy can be used to create perspective in the painting.

When you use calligraphy either as art or incorporate it into art, you should keep the following in mind:

- ✔ In order to make letters look three dimensional, you'll need to make sure they have at least three colors or tones — the highlights, mid-tones, and shadows. I call this the "rule of three."

- ✔ Learn to do calligraphy with a brush. Refer to Chapter 14 for an introduction to using a brush for calligraphy.

- ✔ For pen work that you want to tint with watercolor, you must use waterproof inks. Just be extremely careful that the ink doesn't dry in your pen. I recommend that you have a container of water nearby where you can douse your pen immediately after you use it.

- ✔ If you want to paint a background design or picture that is supposed to look like it is behind the calligraphy, it is usually better to do the calligraphy first. That way when you do the painting around the calligraphy, you can leave a small amount of white space or even soften the colors between the letters and the painting.

This last example is a detail of a mural which was painted on a wall in a school's media center (Figure 17-9). It was a really ambitious project. The entire mural was over seven feet tall and over twenty feet long. It took me the better part of a year to complete this project. This is an example which shows that calligraphy doesn't have to be small; it can be used on a large scale.

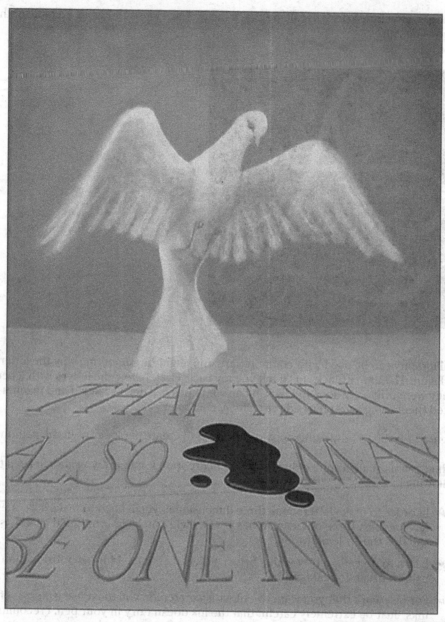

Figure 17-8:
Calligraphy
in an oil
painting
where it is a
vital part of
the image.

The illustration shows a part of the center portion where you see extensive use of calligraphy. There are two detailed maps and over a hundred names of historical figures on this mural. Several alphabets were used, and some of the letters are Greek.

Considerable research and preliminary sketching was done before the actual painting began. Many of the sketches were projected onto the wall so that all the proportions would be correct.

This mural employs several design elements and techniques which you can use in your own art work. They include:

✔ The entire wall was painted a solid dark red as a ground color. Using a dark ground color can help create a dramatic image and intresting color effects. It provides a contrast that enhances the illusion of light in the painting. If you use this idea in doing calligraphy, you can make the letters appear to jump out at you.

✔ In order to keep this large, complex design from looking too "busy" and disjointed, a strong underlying geometric design was used throughout. Geometry, especially if you use a lot of diagonals, is an easy way you can create an interesting, cohesive design.

✔ Depth and perspective were created by using overlapping shapes, linear perspective with vanishing points, and using color spatially — bright, vivid colors projecting forward and dull, pale colors receding backward. These are ideas you can use in any art where you want to create the illusion of depth.

✔ Variations in texture were used throughout. Many novices tend to want to smooth everything out. Allow some brush strokes and pen work to show. Use texture.

✔ The ribbon effect creates a rhythmic movement that helps create interest and ties the design together visually. If you like this effect, feel free to take the idea and use it.

✔ The dove in the lower center is the same image that I had used in the painting shown in Figure 17-8. Don't be afraid to re-use images you've drawn or painted before.

✔ A key element here is that the calligraphy does not look like it's simply added on top of an image. The calligraphy is a necessary part of the imagery. If you were to take the calligraphy away, the art would flop. When you use calligraphy in your own art, strive to make it an integral part of the design.

Figure 17-9:
A detail of a mural where calligraphy was used extensively.

In order to keep this large, complex design from looking too "busy" and disjointed, a strong underlying geometric design was used throughout. Geometry, especially if you use a lot of diagonals, is an easy way you can create an interesting, cohesive design.

Depth and perspective were created by using overlapping shapes. Linear perspective with vanishing points, and using color spatially — bright, vivid colors projecting forward and dull, pale colors receding backward. These are ideas you can use in any art where you want to create the illusion of depth.

Variations in texture were used throughout. Many novices tend to want to smooth everything out. Allow some brush strokes and pen work to show the texture.

The ribbon effect creates a rhythmic movement that helps create interest and ties the design together visually. If you like this effect, feel free to take the idea and use it.

The dove in the lower center is the same image that I had used in the painting shown in Figure 12-8. Don't be afraid to re-use images you've drawn or painted before.

A key element here is that the calligraphy does not look like it's simply tacked on top of an image. The calligraphy is a necessary part of the imagery. If you were to take the calligraphy away, the artwork would flop. When you use calligraphy in your own art, strive to make it an integral part of the design.

Figure 12-9:
A detail of a mural where calligraphy was used extensively throughout the image.

Part V
The Part of Tens

The 5th Wave — By Rich Tennant

In his later years, Captain Hook gave up on chasing Peter Pan and took up calligraphy.

In this part . . .

Once they've covered the fundamentals, most calligraphy teachers say farewell, wish you luck, and leave you to try to figure out how you can apply your calligraphy skills. But this book doesn't leave you without giving you some directions on possible ways that you can begin to put your skills to use. You can use this part of the book to get some practical ideas for applying and profiting from your calligraphy abilities.

Weddings provide one of the greatest opportunities for you to do calligraphy. Therefore, Part V begins by describing ten ways you can use calligraphy for a wedding. Whether you're thinking about using calligraphy for your own wedding or for the wedding of someone else or even if you're looking for ways to market your calligraphy, these ten tips get you started.

Next is a selection of ten, fun alphabets that will give your calligraphy a true international flavor. One very practical way that you can use these is for restaurant menus. This part of the book concludes with my ten tips for making money doing calligraphy. These tips are based on my own experience in building a successful art business. They work.

As a calligrapher, you have unique skills. People are amazed at what you can do. These skills can open doors for you to fun and exciting and even unusual jobs.

Chapter 18

Ten Ways to Use Your Calligraphy for Weddings

One of the most popular uses for calligraphy is for weddings. Over the years I have had several students enroll in my classes solely to learn how to do calligraphy for their weddings. Calligraphy really adds an elegant and personal touch to a wedding and can be used on almost any paper product you use for a wedding, from invitations and envelopes to programs, menus, and more.

Whether you're interested because you are getting married yourself or you're thinking about doing wedding calligraphy for others, this chapter should give you enough information to get started in the right direction. Plus, because the most popular lettering styles for weddings are Italic (and variations of it such as scroll and flourished), Blackletter/Old English, and Copperplate, you need only flip to Chapters 6, 8, and 13, respectively to discover how to draw these alphabets.

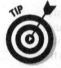

Doing all the calligraphy for a wedding can be a monumental job. You may want to start small by doing only one thing for the wedding.

Doing calligraphy for weddings can be quite a lucrative way to make money with your calligraphy. People are always getting married, and they all want their weddings to be special. If you want to check out more ways to make money with calligraphy, see Chapter 20.

The Invitation

The invitation is the first thing that comes to most people's minds when they think about doing calligraphy for a wedding. Although it's certainly a very important item, the invitation by itself is not the most challenging part of doing calligraphy for a wedding. The reason is simple, you usually only have to do one "master" invitation which will be reproduced by a commercial printer. You don't have to do each of the invitations by hand.

Nevertheless, you do need to follow some tips to be sure your invitation is up to snuff:

- **The design and wording of the invitation must be absolutely flawless.** You cannot afford to have any glitches here. Make certain that the wording, spelling, and punctuation meets all the rules of etiquette that apply.

- **Make certain that your calligraphy is the best that you can do.**

- **Create a great design.** When you design the invitation, you can follow the traditional form. You can even do a little research and see how commercially produced invitations are designed and follow that format. However, one of the exciting things about a hand-lettered invitation is that it can be unique. It does not have to look like a commercially produced invitation at all.

- **Find a unique focus.** One of the things that a calligrapher can do, that you can't find in a commercially produced invitation, is produce a design based on a wedding theme. For example, if the theme of the wedding is the uniting of two families of different cultures or faiths, this theme can be represented in the design of the invitation by incorporating symbols of the two cultures or faiths.

- **Think about the "look" not the words first.** When you're designing an invitation, the temptation is to think of the wording first and then think about how the words can be arranged. A better way to approach this, is to think of the overall "look" of the invitation first. After you have worked out a good design that you are pleased with, you can think about the actual words used on the invitation.

 Even if there is not a theme, per se, every wedding has a style that can be reflected in the style of the invitation. Is the wedding formal? Informal? What are the colors that the members of the wedding party will be wearing? The answers to these questions will tell you something about the style that should be reflected in the design of the invitation.

 A wedding theme can be shown through a border design, an illuminated letter, or a subtle background image. The border does not have to go around all four sides of the text; it can be a single bar down one side or at the top and bottom. You can be very creative.

- **Feel free to use color.** If you want to use colors on the invitation, that's possible too. You may have to hand-tint each invitation after it has been printed, but that's not especially difficult if you use watercolor colored pencils. These pencils look and work just like regular colored pencils except you can go over the color with a wet brush, and they turn into watercolor paint! They are especially useful whenever you want complete control of where the color goes and how much water you want to use. After all, you can't flood the invitations with water. You'll have to use a very delicate touch with the wet brush.

Whenever you are creating a master that will be reproduced, you can always work larger than the final copy will be. Working larger makes it much easier, corrections are easier, and you can use correction fluid, too.

When you work larger, just make certain that the proportions are exactly the same. You may want to get a proportional scale which will make the measurement conversions simple and easy — and with no mistakes. Proportional scales are cheap and available at stores that sell commercial artist's materials.

When you have created a master that's ready to go to the printer, you have some choices about how it will be printed. The invitation can be printed flat by a photo-offset process or with raised letters by thermography. Even though your master should be done in black ink on white paper, you can select different colors for the ink and paper. Both photo-offset printing and thermography are less expensive then engraved invitations.

The Outer Envelope, Inner Envelope, and Reception Card

Now comes the challenging part of doing calligraphy for a wedding! The reception card will require another master and will be printed in the same manner as the invitation, but the two envelopes must be done entirely by hand. If the mailing list is long, this can be a truly challenging task.

Before a final choice is made for the paper and envelopes, you should test them to see how your pens will perform. You don't want to order envelopes and discover after you receive them that your pen will not work on the paper. Ask the printer for a sample that you can write on.

You should give careful thought to exactly how you are going to address the envelopes. What style lettering will you use? Will there be any flourishes or embellishments? What size pen will you use? Will the left margin of the address be vertical or slanted?

In considering the style of lettering for the envelopes, remember that the style of the lettering should be the same as style used on the invitation. For example, you do not want an invitation that's done in Copperplate (Chapter 13) sent in an envelope addressed in Italic (Chapter 6).

One point that you really need to consider is that an address with many flourishes or embellishments will not be difficult if you have only a small number of envelopes to address, but a lot of embellishments can become overwhelming if there are many names and addresses.

The style in which you do the addresses needs to be simple enough that you can do the entire list all in the same style without having the task become too big to handle.

It is completely acceptable to use a fountain pen for addressing these envelopes, and that is what most professional calligraphers will use for this job. You do not have to use a dip pen because of the large number that has to be done. Because fountain pen ink is not waterproof and there is the possibility that the address might become smudged in the mail, it is important that you spray the outside envelope with a clear protective coating. A couple of very light coats of spray will do the job.

Sometimes you can use a template with dark guide lines that you can slip inside the envelope. You can use this method only if your are able to see the guide lines well enough through the paper to write the address on the outside. I usually draw a box with lines for the recipient's address.

If the paper of the envelope is too thick or too dark or has a liner so you are unable to see a template that is inserted inside, you will have to make a stencil which you lay on top of the envelope.

Make the stencil from heavy card-stock, and make cut-outs in it for the lines of the address. Lay the stencil on the envelope and draw pencil lines very lightly. Then letter the address. When the ink is dry, you can use a white eraser to erase the pencil lines. The white eraser will remove the pencil lines cleanly without scuffing the paper or the calligraphy.

Ideally, the sender's address will be printed on the flap of the outside envelope. If you are also doing the sender's address by hand, you may want to use different size nibs for the two addresses if you think it will look good.

Announcements

In addition to the invitation, many people send out wedding announcements. The announcement announces the marriage but does not invite the person to the wedding.

Announcements are used when the wedding ceremony is small with only a few invited guests or there are a number of friends and relatives who live at a distance and would be unable to attend. This is sometimes the case when a couple decides to have their wedding in some romantic and exotic location.

Announcements are another thing that can be done in calligraphy. Like the invitation, a master is done with black ink on white paper and is reproduced by a printer in whatever color is desirable.

The one thing that you can try to do with the design of the announcement that is not necessarily part of designing the invitation is to communicate a sense of the place where the wedding will take place. For example a small sketch of the church where the wedding will be held can be used, or, if a wedding will take place somewhere like Hawaii, the design of the announcement may incorporate examples of local flora from the area. This is something unique that can be incorporated into the design only when it's custom-designed.

Monograms

Monograms are very popular. They can be used on any of the paper items from envelopes to napkins. The monogram is something that is both personal and is also full of stylistic effect.

Check out Chapter 17 for more on how to design a monogram.

The monogram can be any series of initials. It can be one, two, three or more letters. A standard joined monogram would have the surname in the center with the bride's and groom's first initials on either side.

The monogram can be designed so that the letters appear to be woven together. This can be done by making flourishes that tie the letters together. Monograms like this usually require a lot of work to develop.

Monograms can be printed, but they can also be embossed. Although embossing can be expensive if done commercially, embossing can actually be done pretty simply by hand. There are numerous books available which explain the simple process of embossing by hand. If this is something you would like to try, do a little research and try a few experiments to see if, indeed, this is something you want to do.

Program or Order of Service

Many people like to have a program the ushers can give to the guests who attend the ceremony. This is another opportunity where you can use calligraphy.

The program can be a single sheet with a title on one side and the actual program listed on the other side. Figure 18-1 shows an example of a wedding program.

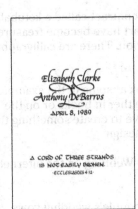

Figure 18-1:
A wedding
program.

Placecards, Table Numbers, and Favor Tags

At the reception you can find more things that can be done in calligraphy. These include the placecards, the table numbers, and the favor tags.

The favor tags can be commercially reproduced from a master that you design, but the place cards and table numbers will all have to be done individually by hand.

When place cards are done in calligraphy, they will add such a personal touch of elegance that many guests will want to take their cards home with them after the reception.

Menus

If a meal is served at the reception, the menu can be done in calligraphy. This menu should reflect the style or theme of the wedding.

One thing to keep in mind is a menu should always be simple and easy to read. It may have a monogram design but it is best to steer away from flourishes and embellishments on the menu. A menu is definitely not the place to show off your flourishes. Keep the menu simple and elegant.

Some of the older guests may have vision problems. Keep them in mind when you are designing the menu. You want to make certain that the letters are large enough and clear enough to be read easily by everyone while still maintaining the style of the wedding. If all the other calligraphy was extremely fancy and some of the letters could be confused with other letters, you may want to make some small modifications in the letters to make ceratin they are clearly legible.

There may also be a bar menu that you may do in calligraphy. The same rules for legibility are true for this menu as well.

A Marriage Certificate

Some people feel that wedding certificates are outdated. Not many couples have wedding certificates today. I think that's probably because the certificates that are available commercially are so unattractive, impersonal, and, for lack of a better word, hokey. The artist/calligrapher, however, can create something that will truly be a beautiful, treasured keepsake.

It's a Jewish tradition for the couple to receive a marriage contract called a ketubah. The Quakers have a similar tradition. These works of folk art have become treasured family heirlooms handed down from generation to generation. There are calligraphers today who specialize in doing ketubah.

If you do a marriage certificate, do a little research and look at some of the examples from history. Then look for some contemporary versions either in books or on the Internet. Use this research to develop your own ideas. Strive to create something that follows the tradition but is definitely contemporary in its design.

An excellent place to go to see examples is the Calligraphy WebRing on the Internet. The address is www.studioarts.net/calligring.

The first part of the text of a marriage certificate can be a couple's wedding vows, favorite poem, or a verse. The second part would have the names, the date, and the location of the event. Finally, there are customarily spaces for the bride, groom, officiant, and witnesses to sign at the church or reception.

The custom-designed wedding certificate can be more than just a certificate that is lettered in fancy calligraphy. It can incorporate art, painting, and design which will reflect the style or theme of the wedding. When it comes to doing a wedding certificate, you should design something that will truly be a beautiful and treasured keepsake of the event.

A Wedding Guest Book

Wedding guest books are also something that have become a little passé. Many people today prefer to have the guests sign a photograph of the couple. The photograph is normally displayed at the wedding and is put in a large mat for all the guests to sign.

Nevertheless, if a wedding book is something that the couple wants, the book can be inscribed in calligraphy.

Many people who are interested in calligraphy are also interested in bookbinding. If you have this knowledge and skill, you can even create a handmade guest book. That way you could design everything from the cover to the pages. Such a book could be a true work of art.

Thank You Notes

Although the bride must write the thank you notes by hand, the note paper and envelopes can be custom-designed. The use of a monogram is certainly appropriate here. Also, if there was any kind of border design used on the invitation, that same design can be repeated on the thank you note stationery.

Again, a master is made with black ink on white paper which is taken to a printer and reproduced in quantity.

Speaking of thanks . . . a person I want to thank for her help in gathering the information on weddings is my daughter-in-law, Linda Bennett, who is a wedding consultant in Poughkeepsie, New York.

Chapter 19

Ten Fun Alphabets

There must be tens of thousands of different alphabets. It would be impossible to count them all. If anyone doubts the truth of that statement, all he or she has to do is look at how many fonts can be downloaded onto a computer. In spite of the incredible number of alphabets, nearly all of them are variations of the six basic alphabets.

And guess what? In this book, you can check out how to do those six basic alphabets: Italic (see Chapter 6), Blackletter (see Chapter 8), Roman (see Chapter 9), Bookhand (see Chapter 10), Uncial (see Chapter 11), and Copperplate (see Chapter 13). When you know those six, you can turn them into thousands!

Once you see how this works, you might be inspired to create your own alphabets. Who knows, you might just create a new variation that will become popular with other calligraphers.

Even if you don't create an entirely new variation, you can still develop your own style of doing the alphabets that are widely accepted. Being an artist myself, I have always encouraged individual expression. That applies to calligraphy just like any other kind of art.

As you experiment with the alphabets in this chapter, you will notice that I have not shown guide lines with these alphabets. Nor have I shown the sequence or direction of the strokes. If you have studied the alphabets in the rest of this book, I am confident you can figure out the strokes just by a close examination of the letters. If you're able to do that, then you're no neophyte — you're well past the basics.

Nearly Persian

This is an alphabet that is based on a famous typeface (font) called Legend. It is a variation of Italic. Like Italic the pen angle is 45 degrees and the letters have just a small amount of slant to them. There are lots of flourishes and swashes.

Draw the capitals and ascenders tall. The descenders are long, but the body of the letters is short (only about 3 pen widths). This is a fun alphabet that always looks fantastic wherever it is used.

Aa Bb Cc Dd Ee Ff Gg

Hh Ii Jj Kk Ll Mm Nn

Oo Pp Qq Rr Ss Tt Uu

Vv Ww Xx Yy Zz

Pseudo-Chinese

This is a very simple looking alphabet that can be a real challenge to the calligrapher. This alphabet isn't easy because the pen angle constantly changes from one stroke to another. It would almost help to be ambidextrous to do this alphabet well. It took me three attempts to produce what you see here.

These letters are a variation of Roman. The height is 3 pen widths.

ABCDEFG
HIJKLMNO
PQRSTUV
WXYZ

Hebrew-esque

It's fun to try to duplicate the look of other alphabets. This alphabet is supposed to
look like Hebrew.

It is a variation of the roan alphabet. The pen angle is as close to 0 as you can manage.
That means that the pen will be pointing straight out to the side. The height of these
letters is 5 to 7 pen widths.

ABCDEFGHI
KLMNOPQRS
TUVWXYZ

French Ronde

This alphabet which is a variation of Bookhand, is very popular and not difficult to do. There are many versions of Ronde, of which this is one. It is an elegant and pretty style which is especially appropriate if you're doing calligraphy for a wedding.

The pen angle is 30 degrees and the height of the letter body is 5 or 6 pen widths.

Aa Bb Cc Dd Ee Ff
Gg Hh Ii Jj Kk Ll
Mm Nn Oo Pp Qq
Rr Ss Tt Uu Vv
Ww Xx Yy Zz

Old German (aka Fraktur)

It's obvious that this alphabet is a variation of Blackletter. This variation is created by curving the strokes and adding little curlicues to the ends of the strokes.

The curlicues are fun to make. While the ink is still wet, turn the nib up on a corner and draw the curved shape.

The pen angle is 55 degrees and the x-height (the height of the letter body) is 4 pen widths.

Aa Bb Cc Dd Ee Ff Gg
Hh Ii Jj Kk Ll Mm Nn
Oo Pp Qq Rr Ss Tt
Uu Vv Ww Xx Yy Zz

It's Greek to Me

This is another Roman variation that duplicates the style of the Greek alphabet. The letter height is 8 pen widths and the pen angle is very flat (the pen points directly back towards you).

A B C D E F G H I J
K L M N O P Q R
S T U V W X Y Z

Digital

This version of digital letters is a variation of the Roman alphabet. The calligraphy pen is really not well suited for this kind of letter. The letter height is 8 pen widths. The pen angle is 45 degrees.

ABCDEFGHIJ
KLMNOPQR
STUVWXYZ

Upside-Down Letters

I'm not sure what purpose this alphabet serves except it's just for fun. Kids get a real kick out of seeing this alphabet.

The alphabet is a hodge-podge of letters, numbers, and symbols. The idea is that they still look like letters, numbers, or symbols when they are turned upside down. If you write a message using these letters, it will look like gibberish if you try to read it upside-down.

At the bottom is a secret message which you can read by turning this book upside down.

Funky Letters

I wondered if it was possible to create an alphabet based on mistakes that I have seen students make. The Funky Letters are what I came up with. This is a variation of Italic. The letter height is five pen widths and the pen angle is 55 degrees.

Aa Bb Cc Dd Ee Ff Gg Hh Ii
Jj Kk Ll Mm Nn Oo Pp Qq
Rr Ss Tt Uu Vv Ww Xx Yy Zz

Chapter 20

Ten Tips for Making Money Using Your Calligraphy

● ●

In This Chapter

▶ Setting yourself up to attract clients

▶ Setting your prices and generating sales

▶ Going through ordering from start to finish

▶ Keeping records

● ●

Have you given any thought to the possibility of making an income with your calligraphy?

If you're thinking about selling your calligraphy, it almost goes without saying, but the first thing to do is make certain that your calligraphy is actually good enough so that people will be willing to pay for it.

Do people already express an interst in buying some calligraphy from you? Do they ever ask you how much something costs? Do they ever ask you to do some calligraphy for them? Any of these things is a good indicator that your work is extremely saleable. If people don't ask any of these things, it doesn't mean that you can't sell your work. Maybe you just need to show your work more. Take every opportunity to show your work. Don't be shy!

Having your own calligraphy business offers some incredible advantages. When you own the business, you're the boss, you can set your own hours, and take vacations when you choose. But more than that, you're in control of your own products so you are not hampered by product availability, back orders, etc.What's more, you get to work from home. You can even be with your children while youre working. Working from home will give you all kinds of tax advantages.

If you think you want to make some money with your calligraphy, I give you plenty of tips in this chapter to get you started in the right direction.

Make a List

It's important in any business enterprise to identify your market, and calligraphy is no different. Who are your prospective clients? Ask yourself, who would be most likely to buy my calligraphy? To what group of people will my work appeal the most? When you can answer those questions, you can begin to target your advertising to reach your market.

Some of the places that you should put on your list are: schools, libraries, hospitals, clubs, youth organizations (they like to give lots of awards), the police and fire departments (they like to give out awards too), chambers of commerce, churches, restaurants, wedding coordinaters, and any businesses that have wedding-related products and services.

It should also go without saying that whenever you talk to anyone about your calligraphy, you should be warm, friendly, and polite. Always wear a smile and have a positive attitude. Be professional in your manner and appearance.

This is sometimes neglected by artsy types, but it's vital in the business world. It's called good salesmanship. There are some inspiring books on this subject. Two books in particular that I can recommend to anyone who wants to market their calligraphy are *Sales Prospecting For Dummies* By Tom Hopkins and *Business Plans Kit For Dummies*, 2nd Edition By Steven D. Peterson, Peter E. Jaret, Barbara Findlay Schenck. Both books are published by Wiley.

A Business Card That Sizzles

Design your own business card and make it sizzle! Don't use a cheap ready-made card. An impressive business card is essential, because your business card will be seen as an example of the calligraphy that you can do. It may be the first example of your work that people get to see.

Do some research. Look at the designs of other cards. What designs really appeal to you? Use those designs as ideas for your own card.

When you decide on a design and are ready to create the master, make it three times larger than the actual card will be printed. Your printer can reduce it to the correct size.

Order at least 2,000 and then make it a point to give them all out within a month or less! You can leave cards with everyone you meet and even mail them out. Put a card in the envelope with every piece of mail you send out — including your bills!

If you are on a tight budget, you can create your first cards on a computer that has a scanner and the software to print business cards. This is an inexpensive way to get started and also gives you the opportunity to do a little experimenting with the design of your card. Even if you start off using computer printed cards, plan to get "real" business cards before too long. Business people can tell the difference.

A Portfolio That Impresses

Create an impressive portfolio of several samples of the kinds of the calligraphy that you can do. Remember that one purpose of the portfolio is to show prospects possibilities.

If you use a good quality photo album, you can add photos of new work as you do it. A great portfolio is something that will take you a while to develop. At first you can simply make up a couple samples to use. Then as you get commissions, you can put photos of actual commissioned work in the portfolio. When I was selling my art as my full-time income, I was constantly revising and improving the contents of my portfolio.

Photos of actual commissions are a much more powerful advertisement than samples you make up just to fill out your portfolio.

In addition to a portfolio, you might design a simple, eye-catching brochure.

I sold two kinds of artwork — portraits and calligraphy. I had two separate portfolios. At first, my samples were just a few things that I made up as examples. After a while, my portfolios were filled entirely with photos of commissioned work. At that point, I had more orders than I could handle!

Never Work for Free

I always advise people from the very start, *never* do any work for free (with the exception of close relatives). Charge people something, even if it's just a very little amount to cover materials. The important thing here is that people understand from the beginning that you are in business and that your work may be inexpensive, but it's not free. If you do work at no charge for one person, another person may expect free work also, and that can lead to misunderstandings.

To get started, I suggest that you charge very, very low prices. I realize that some people may disagree with me on this, but the point is you want to create a reputation for doing good work and you want your work to be seen. You want the public to learn about you. For that reason, start cheap!

You can tell people that your prices are low at this time because you're just starting out and you want to get established. That encourages them not to wait to order. I would say that anything in the $5 to $50 range is what I would call a cheap price.

I began by contacting friends. I wanted to give them the best price, so I started with them. I also didn't want to waste my low, start-up prices on what could potentially be big commissions later. You might say that I practiced on my friends.

When you see that it is time to raise your prices, don't do it suddenly without informing your previous clients and your potential clients. I always gave a 30-day notice before raising my prices. I also raised my prices in increments.

When I first began selling head and shoulder pastel portraits my price was $30. A month later, I raised the price to $60. Six months after that, I raised the price to $95. When I retired from doing portraits, I was getting much more than that for a pastel portrait (and that was 20 years ago). I started selling my calligraphy after I had already established myself as an artist.

Reproductions

If you have some calligraphy work that you feel would be suitable for notecards, you may consider creating a set of cards that you can wholesale to card and gift shops. Check with a printer on the cost of printing notecards. If the cost is too high, you can mount photos on plain paper stock. Also, there is computer software that will enable you to produce photo-quality reproductions of your work.

Show It Before You Deliver It

Every time you complete a job, you can show the finished work to other people and, by all means, don't forget to photograph it for your portfolio. This is essentially how I started.

As soon as I completed a commission (unless it was to be given by the client as a surprise), I would show it to all my friends before I delivered it. I usually would have two or three new commissions lined up by doing this. The result was that my business rapidly began to snowball.

Ask people to give you referrals. Say something like, "Who do you know that might also be interested in having me do some art?" When you call a referral, begin the conversation

by introducing yourself and telling them that the referring person suggested that you call. When a referral buys from you, send the referring person a little gift or thank you card. I have heard of sales people who have made a fortune using this very simple strategy.

To get a prospect who is not a friend of yours to look at your work, I would say, "I am an artist who specializes in calligraphy. A lot of people like yourself have been very interested in my work, and I'd like for you to see my artwork, too. When would you have ten minutes for me to drop by?"

Reassure them that you are only interested in setting an appointment for them to see your work. You are not necessarily expecting them to buy at that time.

While a prospect is looking at your portfolio, you can point to a specific example and ask, "Have you ever thought that you might like to have something like this for your office, home, or business? Have you ever thought that you would like to present an award like this one?"

Taking the Order

I recommend that at the time you take an order, you ask for a deposit. This encourages people to be prompt in paying you when the work is completed. I always asked for a 50 percent deposit when the order was placed and the balance due on delivery. I also explained that many people preferred this method because it broke the cost into two payments.

I also recommend that you guarantee that people will be satisfied with your work or you will do it over. Only rarely did I have to do work twice to satisfy the client.

One word of caution! You might encounter a person who is extremely "picky" and will never be satisfied no matter what you do. When I ran into a picky client, I found that it was best in the long run to gracefully and tactfully return their deposit and apologize for not being able to produce what they were looking for.

When you take an order, make detailed notes and draw a rough sketch of exactly what the client is looking for. This will also help you remember. I found that it was best not to show my rough notes or preliminary sketches to the client (unless they asked to see them). I found that it was merely confusing to nonartists.

Always do your absolutely best work. Don't be sloppy or hasty. When you are ready to deliver the final product, be confident that you have done a good job and it's worth the price you are charging. The attitude that you have at the time of the presentation of your work is all-important. Be positive and enthusiastic. Frequently, I would say to the client, "I think you're really going to like this!"

Finalizing the Sale

When it comes time to deliver your work to the client, make certain that you are in control of the presentation. There should be no interruptions or distractions. No one who is not directly involved in the approval of the work should be there when you do the presentation. A few times as I was just starting out and was still "wet behind the ears," I would make my presentation to my client when the client had a friend visiting. More than once, it was the friend who would be a real "downer" and interject criticism.

I always tried to make my presentations as dramatic as possible. Frequently, I would have their piece on an easel with a satin cloth covering it. Once they were seated in just the

right place and I had created a sense of positve expectancy, I would have an actual "unveiling!" Believe it or not, I would actually even say, "Voila!"

Once you are established and want to raise your prices, devise a formula that you can use for all work. Calligraphy work was priced according to the number of letters plus any additional design elements.

When people ask you for a price quote, don't hesitate or try to avoid answering. You may want to ask for more details before you give them a price, but when you know exactly what the job is, give them a precise quote!

I am often asked by beginners what I suggest they should charge as a price per letter. That's a difficult question to answer specifically, because there are so many variables. A good benchmark for a beginner is to start no lower than five cents per character and go no higher than twenty cents.

Offer Matting and Framing

If you provide matting and framing, you can increase your profits. You can quote people a price for your work either framed and unframed.

Matting and framing are truly an art form themselves. Tinted mats and decorative frames can really enhance the appearance of a piece of calligraphy. I would recommend that everyone do some reading about the various techniques of mat cutting and framing.

It is helpful to know something about archival framing so that the work will not be damaged over time by a mat or mounting board that that is not acid-free. Many clients will ask about these things.

There are mail-order businesses who will sell mats and frames to you at discount prices. I ordered my frames and mats pre-cut from a wholesale supplier who shipped to me within a couple days. The name of the supplier I used was Graphic Dimensions. The URL is www.pictureframes.com. Assembly was simple and required few tools. A lot of clients really appreciate this added service.

Do It Legally

Finally, it is vital that you keep accurate records and all your receipts for expenditures. Make certain that you comply with all the laws. In most states, you will be required to collect sales tax. Of course, you also must pay income tax. Therefore, keep an accurate record of all your financial transactions. There is some great computer software for keeping these records.

One question that may have come to your mind is will you need to get a business license? Unfortunately, that is a question that I can't answer. Local laws can vary from location to location, and I am certainly not qualified to offer legal advice. Two things I can say. First, if you are working from your home, the only license you will probably need (and I emphasize *probably*) is a sales tax permit. Second, be careful about who you ask about licenses. Ask the wrong person and you may wind up being told that you have to pay for a license you don't really need to have. Regardless, before you make a move, consult your Secretary of State's Web site — you can find a fountain of information there to get you started in the right direction. Other professionals, such as lawyers and accountants can also be helpful.

Appendix

Practice Pages

*T*hroughout this book, I've provided you with opportunities to practice the strokes, the letters, and combining of letters for all of the alphabets, but a little more practice hones your skill and perfects your technique. So, in this appendix, I provide you with ample space to trace and copy basic strokes, lowercase letters, and capital letters, as well as trace and copy words for all of the alphabets covered in this book. The more practice you do the better your technique!

Of course, although I don't recommend it, you can write directly in the book — I've put all the practice on just one side of the page to minimize bleed through. Enough practice for one of you may not be enough practice for another, so I suggest photocopying these pages so you can practice as much as you like, downloading the practice pages from www.dummies.com/go/calligraphy, or paperclip paper over each page to get in all the practice you can. Regardless of which route you choose, the word of the day is *practice, practice, practice!*

For the most effective practice:

1. **Trace over the letters that are gray.**

2. **Draw the letters freehand in the blank lines that follow each line of gray letters.**

3. **Compare your freehand practice to the models in the appropriate chapters.**

Be sure you check back to Chapter 4 for the Italic alphabet, Chapter 8 for Blackletter, Chapter 9 for Classical Roman, Chapter 10 for Manuscript, Chapter 11 for Uncial and Celtic letters, and Chapter 13 for Copperplate. These chapters will give you the measurements you need to follow when using your basic tools for calligraphy:

✔ **Calligraphy pen**

✔ **Nib width**

✔ **Pen angle**

✔ **Height**

Practice Pages

In This Appendix
- Booting up on the Blackletter alphabet
- Making letters with Manuscript
- Unleashing your Celtic self within in...
- Creating letters with Copperplate

hroughout this book I've provided you with opportunities to practice the strokes, the letters, and continuing exercises for all of the alphabets, but a little more practice hones your skill and perfects your technique. So, in this appendix, I provide you with ample space to trace and copy basic strokes, lowercase letters, and capital letters, as well as trace and copy words for all of the alphabets covered in this book. The more practice you do, the better your technique.

Of course, although I don't recommend it, you can write directly in the book. As you put all the practice on just one side of the page to minimize bleed-through. Proper practice for one of you may not be enough practice for another, so I suggest photocopying these pages so you can practice as much as you like, downloading the practice pages from www.dummies.com/go/calligraphy, or preserving paper over each page to get at the practice you can. Regardless of which route you choose, the two of the day is practice, practice, practice!

For the most effective practice:

1. Trace over the letters that are gray.

2. Draw the letters freehand in the blank lines that follow each line of gray letters.

3. Compare your freehand practice to the models in the appropriate chapter.

Be sure you check back to Chapter 4 for the Italic alphabet, Chapter 5 for Blackletter, Chapter 9 for Classical Roman, Chapter 10 for Manuscript, Chapter 11 for Uncial and Celtic letters, and Chapter 13 for Copperplate. These chapters will save you the measurements you need to follow when using your basic tools for calligraphy:

- Calligraphy pen
- Nib width
- Pen angle
- Height

Italic

a b c d

e f g h

i j k l

m n o

p q r s

t u w

v x y z

aaa bbb ccc

ddd eee fff

ggg hhh iii jjj

kkk lll nnn

mmm ooo

ppp qqq rrr

sss ttt uuu

vvv www

xxx yyy zzz

Arthur Betty Caroline

Doug Edna Fredrick

George Heather Ira Jason

Karen Lindsey Matthew

Nicky Ophelia Pixie

Quincy Rose Sharon Troy

Ulysses Violet Wesley

Xerxes Yvonne Zelda

July 4, 1776 / October 12, 1492

July 14, 1789 / November 5, 1605

From Treasure Island,

His stories were what frightened people worst of all. Dreadful stories they were-- about hanging, and walking the plank, and storms at sea, and the Dry Tortugas, and wild deeds and places on the Spanish Main. By

his own account he must have lived
his life among some of the wicked-
est men that God ever allowed
upon the sea, and the language in
which he told these stories shocked
our plain country people almost as
much as the crimes he described.

Blackletter

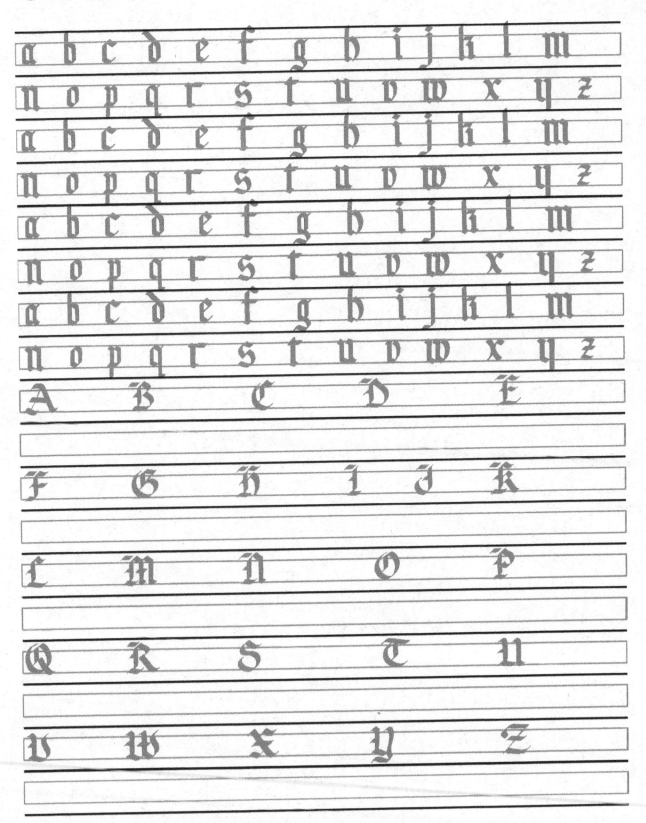

a b c d e f g h i j k l m
n o p q r s t u v w x y z
a b c d e f g h i j k l m
n o p q r s t u v w x y z
a b c d e f g h i j k l m
n o p q r s t u v w x y z
a b c d e f g h i j k l m
n o p q r s t u v w x y z

A B C D E

F G H I J K

L M N O P

Q R S T U

V W X Y Z

Blackletter

Academy Bureau Certificate Department

Enterprise Federal Government Holy Institute

Judge King Lord Militia Notice Office

Public Quality Royalty Society Turkey

Unite Virtue War X-ray Year Zero

Arch Birth Cone Dune End Fish Game

Home Inn Jump Kick Lucid Mix Nib

Often Peace Quiz Ram Sew Tally Usage

Victor Win Xenia Yellow Zone

Psalmus 23

Dominus regit me, et nihil mihi deerit.

In loco pascuae ibi me collocavit, super

aquam refectionis educavit me; animam

meam convertit, deduxit me super semi⁄

tas iustitiae, propter nomen suum.

Nam et si ambulavero in medio umbrae

mortis, non timebo mala, quoniam tu

mecum es: virga tua et baculus tuus

286 Appendix Practice Pages

Classical Roman

ART BIOLOGY COMPUTER

DATA EDUCATION FIXED

GYMNASIUM HEALTHFUL

INSTRUCTOR JURISPRUDENCE

KNIT LAW MATH NOTES

ORGAN POET QUIZ REVIEW

SCIENCE TESTS UNIT VAIL

WORK XI YOGA ZOO

ACE BAR CAN DID

EVEN FIG GO HILT

JAM KIND LUCKY

MY NOW OX PIT

QUAIL RUN SET TASK

URN VIM YELP ZAP

AA A BB B

CC C DD D

EE E FF F

GG G HH H

II I JJ J KK K

LL L MM M

NN N OO O

PP P QQ Q

RR R SS S TT T

UU U VV V

WW W XX X

YY Y ZZ Z

A B A R
C D C D
E F E F
G H G H
I J I K
K L J M
M N L O
O P N Q
P R S R
R S T U
U V V W
W X X Y
Y Z Z

Manuscript

a a a b b b
c c c d d d
e e e f f f
g g g h h h
i i i j j j
k k k l l l
m m m n n n
o o o p p p
q q q r r r
s s s t t t
u u u v v v
w w w x x x
y y y z z z

Manuscript

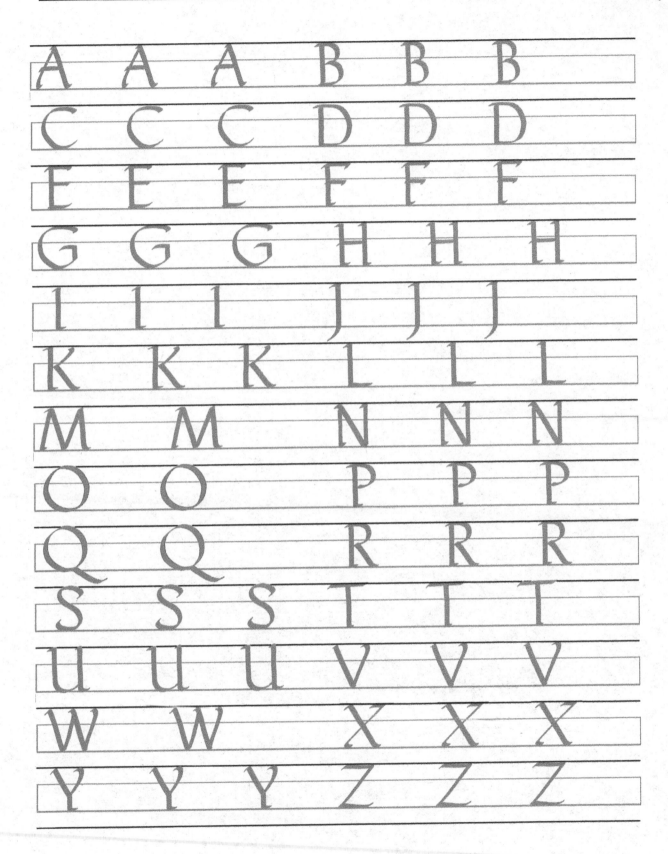

America Belgium Canada

Denmark England Fiji

Germany Honduras Ice-

land Japan Kenya Latvia

Malawi Norway Oman

Pakistan Qatar Rwanda



Serbia Tanzania Ukraine

Venezuela Wonderland

Xanadu Yemen Zimbabwe

This is a narrow version of this

alphabet. It is quite useful and

looks good too!

Uncial

A A B B
C C d d
E E F F
G G h h
I I J J
K K L L
M M N N
O O p p
q q R R
S S T T
U U V V
W W X X
Y Y Z Z

Appendix: Practice Pages 285

A QUICK BROWN FOX

JUMPS OVER THE LAZY

DOG. PACK MY BOX

WITH FIVE DOZEN LAC-

QUER JUGS.

AN IRISH BLESSING

MAY THE ROAD RISE TO

MEET YOU ❖ MAY THE

WIND ALWAYS BE AT YOUR

BACK ❖ MAY THE SUN

SHINE WARM UPON YOUR

FACE ❖ THE RAINS FALL

SOFT UPON YOUR FIELDS

AND UNTIL WE MEET

AGAIN, MAY GOD HOLD

YOU IN THE PALM OF HIS

HAND

Copperplate

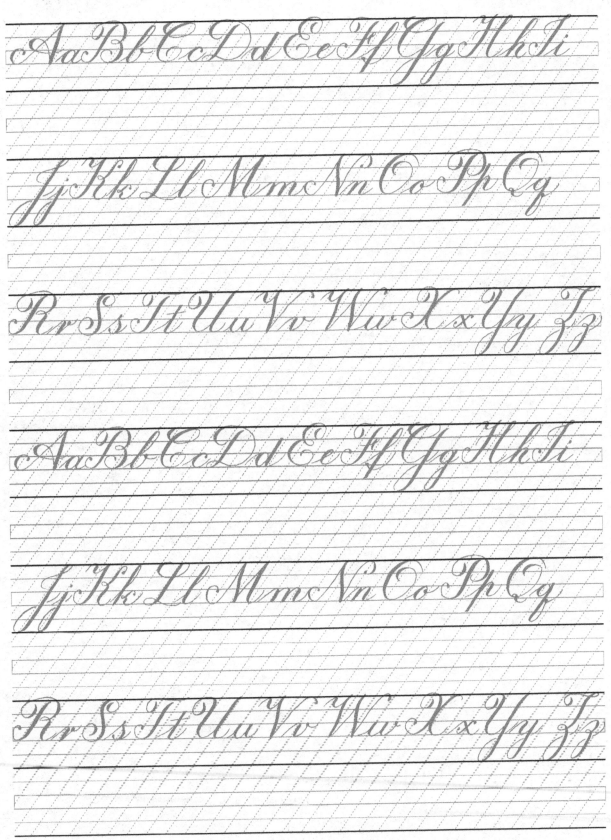

Copperplate

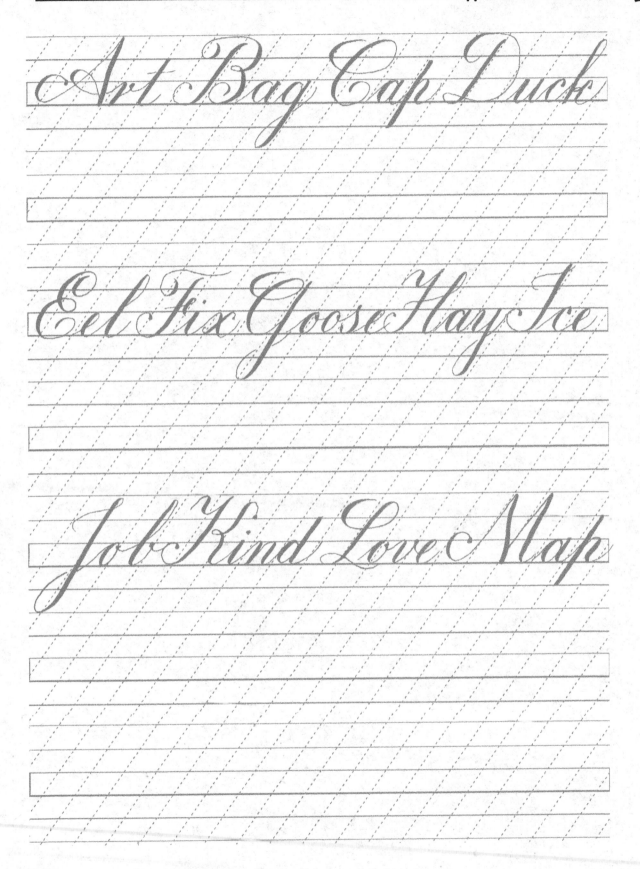

Art Bag Cap Duck

Eel Fix Goose Hay Ice

Job Kind Love Map

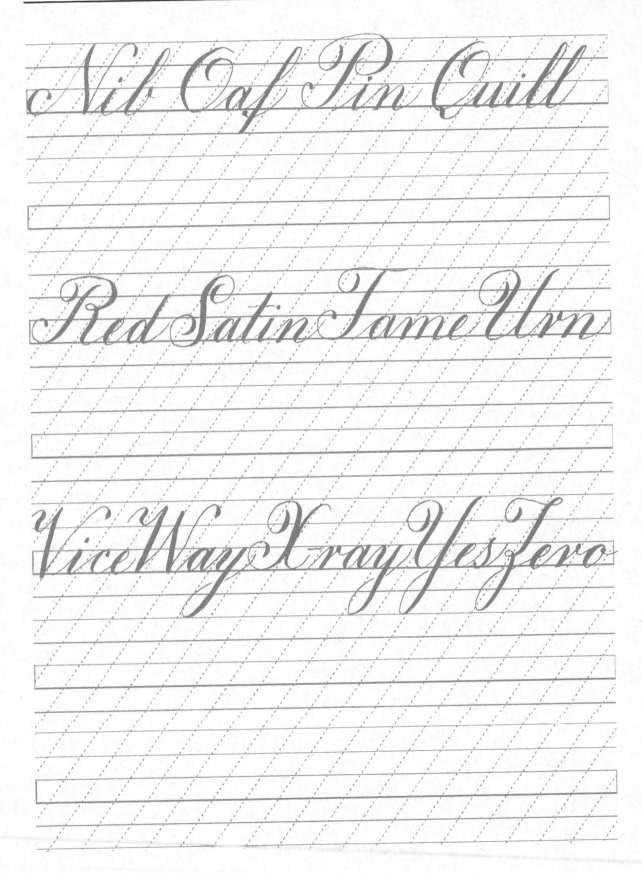

Nib Oaf Pin Quill

Red Satin Tame Urn

Vice Way Xray Yes Zero

"When, in the course of human

events, it becomes necessary for

one people to dissolve the political

bonds which have connected them

with another, and to assume

among the powers of the earth,

the separate and equal station

to which the laws of nature and

of nature's God entitle them, a

decent respect to the opinions of

mankind requires that they

should declare the causes...

Index

Practice Exercise Index

• *General Practice Exercises* •

warm-up exercises, 38
thick and thin lines, 31
doodles, 31

• *Practice Exercises by Alphabet* •

Blackletter capitals
 capitals, 265
 circular capitals (*c, g, o, q, t*), 104
 flag-flying capitals (*b, d, e, f, h, i, j, k, l, m, n, p, r, u, v, w, y*), 103
 four remaining capitals (*a, s, x, z*), 104
 whole words with capitals, 105, 267–269
Blackletter lowercase
 four secondary basic strokes, 94
 letters with main vertical stroke (*l, i, j, h, t, f, k*), 96
 letters that have an *o* shape (*o, a, b, d, g, q, p*), 98
 letters than have a *u* or *n* shape (*u, n, m, w, y, v,*), 99
 lowercase alphabet, 101, 265
 open-sided letters (*c, e, r*), 101
 remaining three letters (*s, x, z*), 101
 three primary basic strokes, 93
Blackletter numerals, 105
Classical Roman alphabet, 275
Classical Roman (with calligraphy pen)
 plus sign (45-degree pen angle), 116
 plus sign (20-degree pen angle), 116
 three kinds of serifs, 121
 whole words, 119, 273
Classical Roman (with pen)
 letters ½ as wide as they are tall (*b, r, e, f, s, l, p*), 111
 letters ¾ as wide as they are tall (*a, h, k, n, t, u, v, x, y, z*), 110
 letters as wide as they are tall (*o, c, g, d, q*), 109
 narrow letters (*j, i*), 112
 two wide letters (*m, w*), 113
 whole words, 113, 271
Copperplate capital letters with the *a* shape
 a, 178
 m, 178
 n, 179
Copperplate capital letters *h* and *k*
 h, 182
 k, 183

Copperplate capital letters with the *i* shape
 i, 175
 f, 175
 g, 175
 j, 176
 t, 176
Copperplate capital letters with the *o* shape
 o, 181
 q, 181
 c, 182
Copperplate capital letters with the *p* shape
 p, 177
 b, 177
 r, 177
 d, 177
Copperplate capital letters with the *u* shape
 u, 180
 y, 181
Copperplate capital letters with the *v* shape
 v, 179
 w, 180
Copperplate general exercises
 controlling pressure, 163
 squaring basic stroke 2, 165
 ten basic strokes, 164
Copperplate lowercase and capitals, 293
Copperplate lowercase letters with the *c* shape
 c, 170
 e, 170
Copperplate lowercase letters with the *i* shape
 i, 171
 j, 171
 u, 172
 w, 172
 t, 172
Copperplate lowercase letters with the *l* shape
 l, 170
 b, 171
Copperplate lowercase letters with the *n* shape,
 n, 166
 m, 166
 h, 167
 p, 167
 y, 167
 v, 167
Copperplate lowercase letters with the *o* shape
 o, 168
 a, 168
 g, 168
 d, 169
 q, 169

● *Practice Exercises for Whole Words* ●

Notes

Notes

BUSINESS, CAREERS & PERSONAL FINANCE

0-7645-9847-3

0-7645-2431-3

Also available:

- Business Plans Kit For Dummies
 0-7645-9794-9
- Economics For Dummies
 0-7645-5726-2
- Grant Writing For Dummies
 0-7645-8416-2
- Home Buying For Dummies
 0-7645-5331-3
- Managing For Dummies
 0-7645-1771-6
- Marketing For Dummies
 0-7645-5600-2

- Personal Finance For Dummies
 0-7645-2590-5*
- Resumes For Dummies
 0-7645-5471-9
- Selling For Dummies
 0-7645-5363-1
- Six Sigma For Dummies
 0-7645-6798-5
- Small Business Kit For Dummies
 0-7645-5984-2
- Starting an eBay Business For Dummies
 0-7645-6924-4
- Your Dream Career For Dummies
 0-7645-9795-7

HOME & BUSINESS COMPUTER BASICS

0-470-05432-8

0-471-75421-8

Also available:

- Cleaning Windows Vista For Dummies
 0-471-78293-9
- Excel 2007 For Dummies
 0-470-03737-7
- Mac OS X Tiger For Dummies
 0-7645-7675-5
- MacBook For Dummies
 0-470-04859-X
- Macs For Dummies
 0-470-04849-2
- Office 2007 For Dummies
 0-470-00923-3

- Outlook 2007 For Dummies
 0-470-03830-6
- PCs For Dummies
 0-7645-8958-X
- Salesforce.com For Dummies
 0-470-04893-X
- Upgrading & Fixing Laptops For Dummies
 0-7645-8959-8
- Word 2007 For Dummies
 0-470-03658-3
- Quicken 2007 For Dummies
 0-470-04600-7

FOOD, HOME, GARDEN, HOBBIES, MUSIC & PETS

0-7645-8404-9

0-7645-9904-6

Also available:

- Candy Making For Dummies
 0-7645-9734-5
- Card Games For Dummies
 0-7645-9910-0
- Crocheting For Dummies
 0-7645-4151-X
- Dog Training For Dummies
 0-7645-8418-9
- Healthy Carb Cookbook For Dummies
 0-7645-8476-6
- Home Maintenance For Dummies
 0-7645-5215-5

- Horses For Dummies
 0-7645-9797-3
- Jewelry Making & Beading For Dummies
 0-7645-2571-9
- Orchids For Dummies
 0-7645-6759-4
- Puppies For Dummies
 0-7645-5255-4
- Rock Guitar For Dummies
 0-7645-5356-9
- Sewing For Dummies
 0-7645-6847-7
- Singing For Dummies
 0-7645-2475-5

INTERNET & DIGITAL MEDIA

0-470-04529-9

0-470-04894-8

Also available:

- Blogging For Dummies
 0-471-77084-1
- Digital Photography For Dummies
 0-7645-9802-3
- Digital Photography All-in-One Desk Reference For Dummies
 0-470-03743-1
- Digital SLR Cameras and Photography For Dummies
 0-7645-9803-1
- eBay Business All-in-One Desk Reference For Dummies
 0-7645-8438-3
- HDTV For Dummies
 0-470-09673-X

- Home Entertainment PCs For Dummies
 0-470-05523-5
- MySpace For Dummies
 0-470-09529-6
- Search Engine Optimization For Dummies
 0-471-97998-8
- Skype For Dummies
 0-470-04891-3
- The Internet For Dummies
 0-7645-8996-2
- Wiring Your Digital Home For Dummies
 0-471-91830-X

* Separate Canadian edition also available
† Separate U.K. edition also available

Available wherever books are sold. For more information or to order direct: U.S. customers visit www.dummies.com or call 1-877-762-2974.
U.K. customers visit www.wileyeurope.com or call 0800 243407. Canadian customers visit www.wiley.ca or call 1-800-567-4797.

SPORTS, FITNESS, PARENTING, RELIGION & SPIRITUALITY

0-471-76871-5

0-7645-7841-3

Also available:
- Catholicism For Dummies
 0-7645-5391-7
- Exercise Balls For Dummies
 0-7615 5623-1
- Fitness For Dummies
 0-7645-7851-0
- Football For Dummies
 0-7645-3936-1
- Judaism For Dummies
 0-7645-5299-6
- Potty Training For Dummies
 0-7645-5417-4
- Buddhism For Dummies
 0-7645-5359-3

- Pregnancy For Dummies
 0-7645-4483-7 †
- Ten Minute Tone-Ups For Dummies
 0-7645-7207 5
- NASCAR For Dummies
 0-7645-7681-X
- Religion For Dummies
 0-7645-5264-3
- Soccer For Dummies
 0-7645-5229-5
- Women in the Bible For Dummies
 0-7645-8475-8

TRAVEL

0-7645-7749-2

0-7645-6945-7

Also available:
- Alaska For Dummies
 0-7645-7746-8
- Cruise Vacations For Dummies
 0-7645-6941-4
- England For Dummies
 0-7645-4276-1
- Europe For Dummies
 0-7645-7529-5
- Germany For Dummies
 0-7645-7823-5
- Hawaii For Dummies
 0-7645-7402-7

- Italy For Dummies
 0-7645-7386-1
- Las Vegas For Dummies
 0-7645-7382-9
- London For Dummies
 0-7645-4277-X
- Paris For Dummies
 0-7645-7630-5
- RV Vacations For Dummies
 0-7645-4442-X
- Walt Disney World & Orlando
 For Dummies
 0-7645-9660-8

GRAPHICS, DESIGN & WEB DEVELOPMENT

0-7645-8815-X

0-7645-9571-7

Also available:
- 3D Game Animation For Dummies
 0-7645-8789-7
- AutoCAD 2006 For Dummies
 0-7645-8925-3
- Building a Web Site For Dummies
 0-7645-7144-3
- Creating Web Pages For Dummies
 0-470-08030-2
- Creating Web Pages All-in-One Desk
 Reference For Dummies
 0-7645-4345-8
- Dreamweaver 8 For Dummies
 0-7645-9649-7

- InDesign CS2 For Dummies
 0-7645-9572-5
- Macromedia Flash 8 For Dummies
 0-7645-9691-8
- Photoshop CS2 and Digital
 Photography For Dummies
 0-7645-9580-6
- Photoshop Elements 4 For Dummies
 0-471-77483-9
- Syndicating Web Sites with RSS Feeds
 For Dummies
 0-7645-8848-6
- Yahoo! SiteBuilder For Dummies
 0-7645-9800-7

NETWORKING, SECURITY, PROGRAMMING & DATABASES

0-7645-7728-X

0-471-74940-0

Also available:
- Access 2007 For Dummies
 0-470-04612-0
- ASP.NET 2 For Dummies
 0-7645-7907-X
- C# 2005 For Dummies
 0-7645-9704-3
- Hacking For Dummies
 0-470-05235-X
- Hacking Wireless Networks
 For Dummies
 0-7645-9730-2
- Java For Dummies
 0-470-08716-1

- Microsoft SQL Server 2005 For Dummies
 0-7645-7755-7
- Networking All-in-One Desk Reference
 For Dummies
 0-7645-9939-9
- Preventing Identity Theft For Dummies
 0-7645-7336-5
- Telecom For Dummies
 0-471-77085-X
- Visual Studio 2005 All-in-One Desk
 Reference For Dummies
 0-7645-9775-2
- XML For Dummies
 0-7645-8845-1

WILEY

HEALTH & SELF-HELP

0-7645-8450-2

0-7645-4149-8

Also available:

- Bipolar Disorder For Dummies
 0-7645-8451-0
- Chemotherapy and Radiation
 For Dummies
 0-7645-7832-4
- Controlling Cholesterol For Dummies
 0-7645-5440-9
- Diabetes For Dummies
 0-7645-6820-5* †
- Divorce For Dummies
 0-7645-8417-0 †

- Fibromyalgia For Dummies
 0-7645-5441-7
- Low-Calorie Dieting For Dummies
 0-7645-9905-4
- Meditation For Dummies
 0-471-77774-9
- Osteoporosis For Dummies
 0-7645-7621-6
- Overcoming Anxiety For Dummies
 0-7645-5447-6
- Reiki For Dummies
 0-7645-9907-0
- Stress Management For Dummies
 0-7645-5144-2

EDUCATION, HISTORY, REFERENCE & TEST PREPARATION

0-7645-8381-6

0-7645-9554-7

Also available:

- The ACT For Dummies
 0-7645-9652-7
- Algebra For Dummies
 0-7645-5325-9
- Algebra Workbook For Dummies
 0-7645-8467-7
- Astronomy For Dummies
 0-7645-8465-0
- Calculus For Dummies
 0-7645-2498-4
- Chemistry For Dummies
 0-7645-5430-1
- Forensics For Dummies
 0-7645-5580-4

- Freemasons For Dummies
 0-7645-9796-5
- French For Dummies
 0-7645-5193-0
- Geometry For Dummies
 0-7645-5324-0
- Organic Chemistry I For Dummies
 0-7645-6902-3
- The SAT I For Dummies
 0-7645-7193-1
- Spanish For Dummies
 0-7645-5194-9
- Statistics For Dummies
 0-7645-5423-9

Get smart @ dummies.com®

- **Find a full list of Dummies titles**
- **Look into loads of FREE on-site articles**
- **Sign up for FREE eTips e-mailed to you weekly**
- **See what other products carry the Dummies name**
- **Shop directly from the Dummies bookstore**
- **Enter to win new prizes every month!**

* **Separate Canadian edition also available**
† **Separate U.K. edition also available**

Available wherever books are sold. For more information or to order direct: U.S. customers visit www.dummies.com or call 1-877-762-2974.
U.K. customers visit www.wileyeurope.com or call 0800 243407. Canadian customers visit www.wiley.ca or call 1-800-567-4797.

Do More with Dummies

Tickle my ribs!

Grilling FOR DUMMIES

12" x 12" kit
Value $10

Scrapbooking Basics FOR DUMMIES

Quilting Notions FOR DUMMIES

Sewing Patterns DUMMIES

Cocktail Kit FOR DUMMIES

Poker FOR DUMMIES

Golf FOR DUMMIES

Pilates Workout FOR DUMMIES

'80s Pop Music FOR DUMMIES

'70s Soul Music FOR DUMMIES

Wall & Ceiling Repair Kit FOR DUMMIES

Tarot Deck & Book Set FOR DUMMIES

Sudoku FOR DUMMIES the Game

Texas Hold 'em FOR DUMMIES

**Instructional DVDs • Music Compilations
Games & Novelties • Culinary Kits
Crafts & Sewing Patterns
Home Improvement/DIY Kits • and more!**

Check out the Dummies Specialty Shop at www.dummies.com for more information!

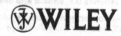